BetterPhoto BASICS

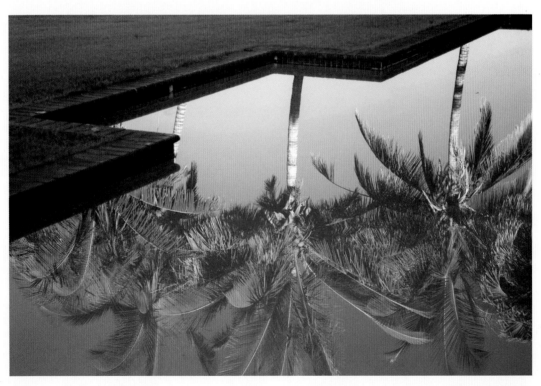

Photo © Jim Miotke

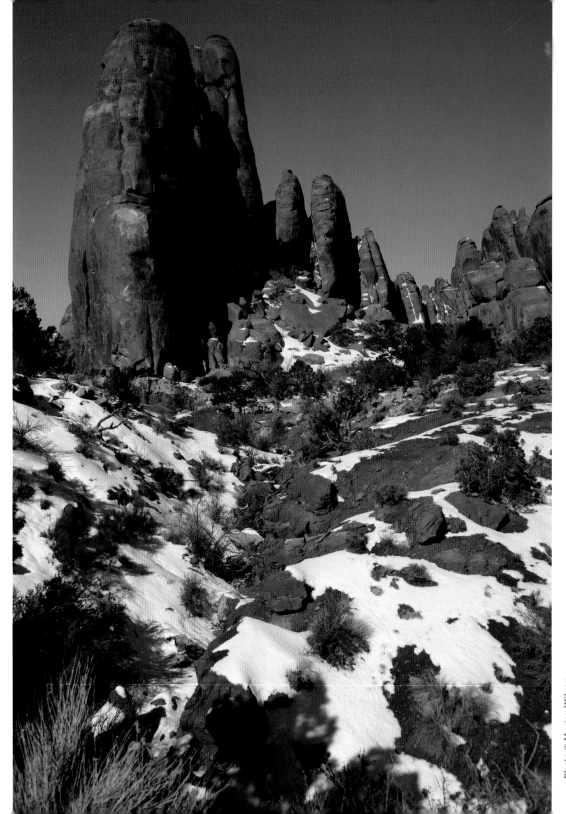

Jim Miotke

BetterPhoto
BASICS

The Absolute Beginner's Guide to Taking Photos Like the Pros

AMPHOTO BOOKS

an imprint of The Crown Publishing Group
New York

Image p. 6, top © Jim Miotke
Image p. 8, top © Lewis Kemper
Image p. 9, middle © Connie J. Bagot

Published in the United States by Amphoto Books,
an imprint of the Crown Publishing Group,
a division of Random House, Inc., New York.
www.crownpublishing.com
www.amphotobooks.com

AMPHOTO BOOKS and the Amphoto Books
logo are trademarks of Random House, Inc.

Library of Congress Control Number: 2009931351

ISBN 978-0-8174-0502-1

Printed in China

Design by Vera Thamsir Fong

13

This book is dedicated to everyone
who dreams of living a more creative life.

———————————

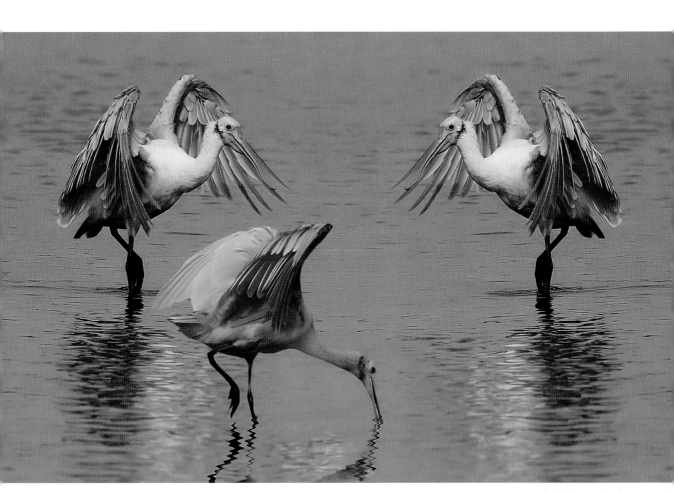

CONTENTS

STEP 4: MASTER THE LIGHT TO TAKE YOUR PHOTOS FURTHER 129

STEP 5: APERTURE, SHUTTER SPEED, AND FOCAL LENGTH 147

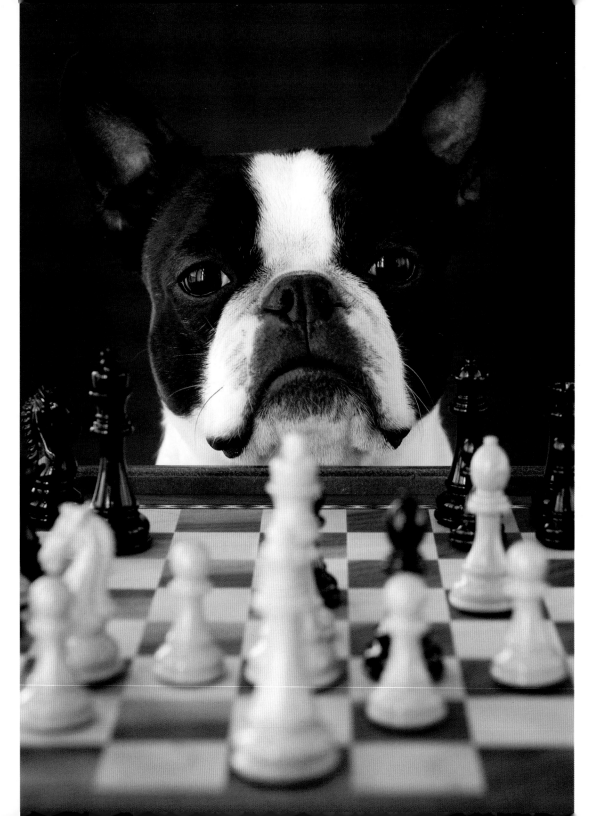

INTRODUCTION

People have a funny attitude about taking photos. On the one hand, most people think photography is so easy anyone can do it. On the other hand, when we take a few bad photos, we call ourselves bad photographers. The truth is that if you can press a button, you can take great pictures. It's as simple as that. All you need to know are the simple tips, guidelines, and techniques that you will find throughout this book.

For those who are totally new to photography, this book starts from the absolute beginning, showing you how to point, shoot, and have fun. If you have already been shooting a bit, you are probably reading this book because you are frustrated with unsatisfying results. You have come to the right place. Here you'll find the tools to consistently create better photos. Perhaps you are interested in getting better photos of your kids. Maybe you'd like to take photographs of your products to load onto your business Web site or blog. Or maybe you feel nothing is left to photograph, when in fact you are presented with photo-worthy sights every day—a neighbor's new puppy, a beautiful flower, a breathtaking sunset. And if you find that your photos don't do justice to the magic and beauty you witness—the puppy is blurry, the sunset is small and dull, the flower has lost its vibrancy—then trust me, it doesn't have to be this way. You can improve your photos in no time.

One of my top goals when writing this book was to keep you awake. If you want a big, thick textbook on photography, you can find a number of them at your local library or bookstore; just be prepared to spend hours sifting through details. This book, on the other hand, is meant to be quick and fun, with tips you can use to start taking better pictures right away. The advice and techniques were derived from years of practice, and you'll also find tricks of the trade that only experienced photographers usually know about. These secrets will help you cut corners, save time, and get interesting, artistic, pleasing pictures time after time.

If you already have a camera, you can start right away with whatever model you have on hand. Especially in the beginning (Steps 2 through 5), it doesn't matter whether you have a camera that allows you to do nothing more than point and shoot or a camera that gives you more creative options. Steps 6 and 7 get a little more advanced, requiring the ability and willingness to control aperture and shutter speed.

By the way, most authors classify readers by the kind of camera they use: (a) point-and-shoot; or (b) DSLR (digital single lens reflex . . . you know, those big, bulky cameras that allow you to use a variety of lenses). DSLR cameras, however, can be used in a "point and shoot," automatic, or semi-automatic mode, and many compact digital cameras now feature such things as Aperture Priority, Shutter Priority, and an extensive ISO range—features that previously were exclusive to DSLR cameras. It has less to do with what camera you use and more to do with the "mode" in which you choose to work—your skill level and comfort in taking creative control into your own hands. You may be able to point and shoot or do more

For this funny image, Debra Harder got down very low and shot through the chess pieces, creating a wonderful foreground to compliment her subject in the background. Photo © Debra Harder

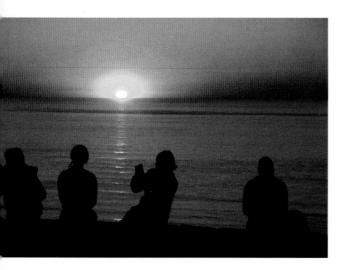

There are many tricks for making sunsets much more appealing to a viewer (someone who wasn't there to witness the scene in all its glory). One is to silhouette a recognizable shape in the foreground, giving the image a sense of depth and unique visual appeal. Photo © Jim Miotke

advanced, creative techniques right now, with the camera you currently own. You'll find out where you're at and what you can do while reading this book. If you're in the market for a new camera, by the way, check out the brief buyer's guide on page 208.

Even though the title of this book suggests otherwise, true photographers do not "take" photos; they "make" photos. It's not about casually grabbing pictures with the aid of an all-powerful super camera. Making photos is much more creatively rewarding. In fact, you won't find an easier, more enjoyable hobby with as many ways to creatively express yourself than photography. What's more, photography allows you to record details of your life. We take pictures so we can e-mail them to friends and family, frame them, put them in albums, maybe even make our own postcards or photograph a friend's wedding. For the most part, though, we take pictures to help us remember our most special moments. Whatever your

photographic goals, this book will show you the easy path to achieving them.

I have been into photography since I was a wee little one. As a kid, I used disc cameras, 110 Instamatics, and other point-and-shoots for fun snapshots. Sometime around 1984, I bought my first professional camera and began seriously exploring the art of photography. I took classes, went to workshops, and studied as many photography books as I could. Most important, I took as many pictures as possible and carefully analyzed the results. After a brief stint of trying to write the Great American Novel (i.e., staring at a blank page for four years), I found myself running my own photography business near Carmel, California, specializing in wedding photography and portraiture. I was soon selling stock photography as well and writing articles that focused on photographic technique.

In the spring of 1996, I founded BetterPhoto. com, a Web site designed to encourage, inspire, and educate people who love to take pictures. The

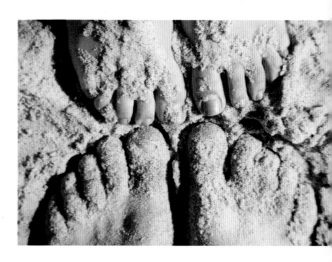

You don't need to travel far away or go on expensive vacations to create fun family photos. Sometimes the answer is as near as your own feet. While we have many photos of our family from this day at the beach, my wife and I most enjoy this simple composition of our own four feet. Photo © Jim Miotke

site now receives over half a million unique visitors each month and features online photography classes, Web sites for photographers, beautiful photo galleries, a thriving photo contest, and help with all aspects of photography. BetterPhoto's mission is to help millions of people say "YES!" to their creative dreams, so I sincerely hope that this book helps you unleash your creative side within.

Three Excuses to Banish Immediately

Excuse 1: My photos never turn out the way I want, so what's the point?
Maybe you missed a shot because you didn't react quickly enough, or perhaps you hit the wrong button. Sometimes the camera focuses on the wrong thing; other times, photos come out too dark or too light. Even the best cameras sometimes misread a scene. That's where this book comes in, with easy tips and techniques to help you get better photos, more often.

Excuse 2: There's too much software and technology involved.
It can be intimidating to learn new things. Whether it's using a computer to print your images, or using Photoshop to remove red-eye, the software side of photography can be time-consuming, frustrating, and difficult. The truth is that software is your friend and the more quality time you invest in it, the more time it saves you in the long run. Nine times out of ten, the issue is not one of difficulty but rather one of familiarity. Once you roll up your sleeves and try it, you will likely find that the task was much easier than you had imagined.

Excuse 3: It takes too much time to get really good.
For most of us, time is tight. We have to go to work or school. Some of us have kids, others have pets that need to be walked (or, as in my case, laps provided for sleeping upon). And it's true that to get really good in photography, you have to make time to practice. However, I wrote this book with people just like you in mind. Turn to any page and you'll find a tip you can use right away, and immediately see results. And if you try even just a handful of the tips in the book, putting them into practice, you'll be well on your way to making dramatic photographs before you say, "BetterPhoto.com rocks!" (Note: I did not say this book would be without the occasional, shameless plug, did I?)

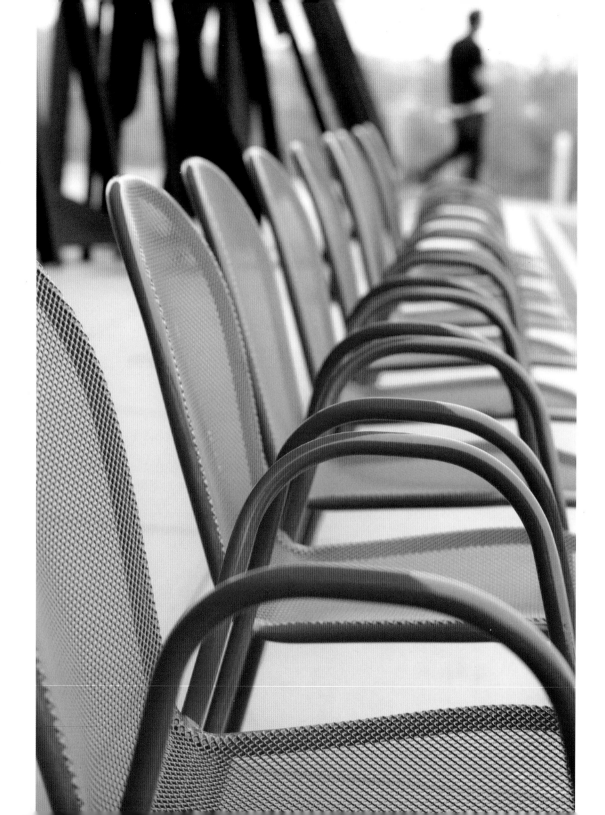

GETTING READY:
A Snapshot of the Art

Although many past masters and countless struggling students have suffered their way through learning photography, your path can be as easy or difficult as you want to make it. Whether you like to photograph nature, landscapes, flowers, the places you visit, your children, your pets, or any other subject, deciding what you most enjoy shooting will play a big part in determining what photography means to you.

At the Olympic Sculpture Park in Seattle, you can walk around (and photograph) some of the most beautiful works of art. When leading a group of photographers on a tour of Seattle, we were entering the park when we noticed these red chairs at the park's cafe. They provided a perfect opportunity for creating all kinds of interesting imagery. We spent twenty minutes photographing these chairs, captivated before we even got to the sculptures that the park is famous for. © Jim Miotke

What Photography Is Really All About

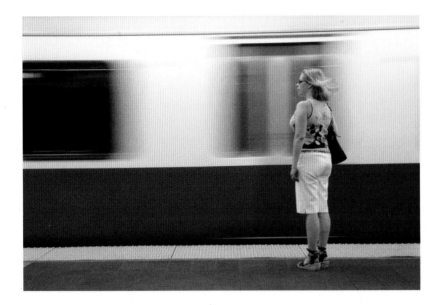

This image with intentional blur is the kind of fun you can have with photography. Of course, it also doesn't hurt to have a gorgeous, charming, saintly spouse willing to be your model. Photo © Jim Miotke

Photography is about life. It's about capturing the look on your daughter's face as she opens a birthday present or rides a bicycle for the very first time. It's the adorable snapshot of your dog when he was a puppy that you still have taped to your refrigerator door. Photographs are about metaphorically stopping the clock, making your ever-changing world stand still. When you capture a moment or the essence of a person, a place, or a thing, you have created something extraordinary. Making images not only satisfies creative impulses, it enriches your experience of life. Photography is also about:

- Getting out and really appreciating nature.
- Being more observant of your surroundings.
- Seeing the world more artistically as you learn to notice things like light, color, shadows, and reflections.
- Sharing your experiences with others, whether friends or your grandchildren.

Getting great shots is not about luck, software, or cameras. Sure, you have to be in the right place at the right time to catch the beautiful sunset, or the fascinating close-up of a butterfly. However, you are the one who decides to look for the colorful butterflies. You set aside time to enjoy the sunrises and sunsets. And you bring the camera along each time you head out into the world.

Many photographers get distracted by gadgets, gazing hour after hour into catalogs and analyzing the bells and whistles of various cameras. While it's true that excellent equipment plays a part in picture quality, buying a great camera does not mean you'll end up with great photos. As much as having a good camera helps, the true art is within you. That little black box does not take pictures by itself.

Great photography is simply about being ready to take a picture when an opportunity presents itself. It's about seeing the world with fresh insight, and following a few simple guidelines when you go out shooting. That's what this book is about.

Six Myths about Photography

Myth 1: Photography takes you away from the action.
Some people say they prefer living life instead of taking pictures of it. That's missing the point. Photography gets you more involved in your environment. Most of all, it gets you out of the house and into the sunlight, where a lot of what I call "present-moment living" happens in the first place.

Myth 2: Photography is too technical and difficult.
Many people think of themselves as bad photographers because they don't understand all the technical details. This myth is perpetuated by the fact that most photography books are overly technical and there is a bias toward shooting in the fully manual exposure mode. But in fact, there's no need to get overly technical or shoot in the "M" mode. Understanding only a few simple tips will make an enormous difference in the quality of your photos, even if you choose to shoot in a semi-automatic mode, relying upon the technology of your camera to handle most of the technical details.

Myth 3: You need a degree in photography.
A master of fine arts is not necessary to become an excellent photographer. Just learn a few basics, pick up your camera, and get out there shooting—that's all that is required.

Myth 4: You don't need to learn anything—the camera does it all for you.
It is tempting to think the camera is responsible for great photos. Don't believe that lie. Even if your camera can automatically flash, focus, and expose with a will of its own, you are still in the driver's seat.

Myth 5: You need an expensive camera.
It's true that high-quality equipment offers more creative control and generally makes it easier to make great photos. Instead of maxing out your credit card, however, you can make the most of what you have until you can no longer stand the limitations of your current camera and are ready to upgrade.

Myth 6: Great photographers are born artists.
Anyone can develop talent by practicing and paying attention to results. Take it from me. When I started photography, I had the artistic capability of a log. I chopped off people's heads, forgot to take the cap off the lens, and shot an unbelievable number of rejects. I took it upon myself to learn how to get better pictures each time I reached for my camera. And that is what you are about to learn.

What to Shoot

Are you more inspired by wildlife or serene landscapes? Pictures of your travels or portraits of friends and family? Each subject area has unlimited possibilities—which keeps photography new and exciting. Let's take a look at some common categories of subjects.

Nature

If you enjoy being outdoors, photography is the ultimate excuse to justify all that time breathing in fresh mountain air, enjoying chirping birds, and relaxing to colorful sunsets! It also encourages us to observe and engage with nature more deeply.

Landscapes

Landscape photography includes practically any outdoor scene—from mountain peaks to high alpine lakes, waterfalls, seascapes, big red barns, even city scenes like buildings, street signs, and views of entire cities (called cityscapes).

Wildlife and birds

Shooting animals in the wild gives you the thrill of both tracking animals and of "getting the shot." Extreme purists only shoot subjects found in the wild after a long period of tracking or waiting patiently. Or, you might enjoy photographing animals at a zoo or wildlife refuge. Choose whichever path works best for you.

Pets

Great photos—like any great works of art—are more likely to be inspired when we work with subjects we love. For many people, that means their pets. Pets can, however, be challenging to photograph. Check out the specific tips on page 104.

Macro subjects

Macro subjects are things you can see with the naked eye—as opposed to microscopic subjects, which can only be seen under extreme magnification. With macro, we get extremely close to objects and, in the process, see them in totally new ways. Macro mode, or a macro lens if you have a digital SLR, can quickly become a photographer's best friend. When all else fails—when the light is not ideal for landscapes or your scene has too many distractions—you can always turn to macro photography as your ace in the hole.

People

Most of us love to snap pictures of our family and friends, but why not learn tips and shortcuts to make them better? Flipping through albums filled with compelling and unique photos of people is enormously satisfying at any age.

Travel

Visiting far-off lands can open wellsprings of inspiration, making even ordinary places suddenly become fascinating. One minute you will be shooting the interior of an abbey, the next you might be snapping a candid of an old shopkeeper, a playful child, or a friendly fellow tourist. Keep my tips in mind and your photos will be more satisfying, engaging, and fun for others to view.

And that's not all—the categories of potential subjects abound. You may enjoy photographing architecture, abstract images, still-life photos, bicycles, doors, windows, barns, weddings, sports, events, graphic design elements such as lines and circles, photojournalistic subjects, even the food at your favorite restaurant.

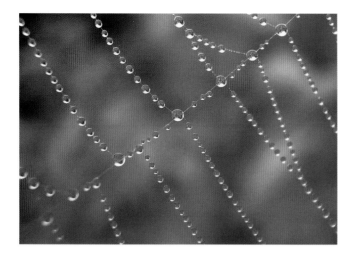

For this nature shot, Guy Biechele got outside early and was rewarded with soft light and early-morning dew on this spiderweb. The blurred jewelweed blossoms in the background provide wonderful color. If you are not blessed with water droplets as Guy was here, simply bring a small sprayer bottle with you and add your own mist. Photo © Guy D. Biechele

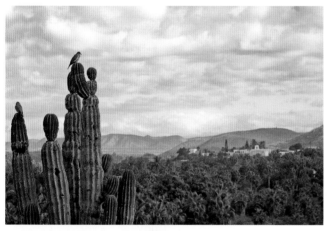

While searching for a unique way to frame the town in this landscape shot, Alvaro Colindres saw an interesting cluster of cacti with bird activity and slowly inched closer until he could get enough detail to take the shot. Photo © Alvaro Colindres

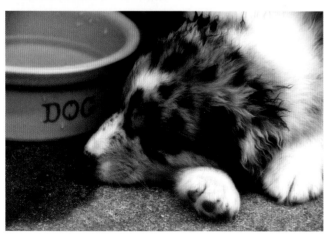

Sibylle Basel took this pet photo the first day her dog, Casey, was at her house, after he had been playing so hard that he fell asleep. Photography allows us to capture images that are both beautiful expressions and soulful mementos for years to come. Photo © Sibylle Basel

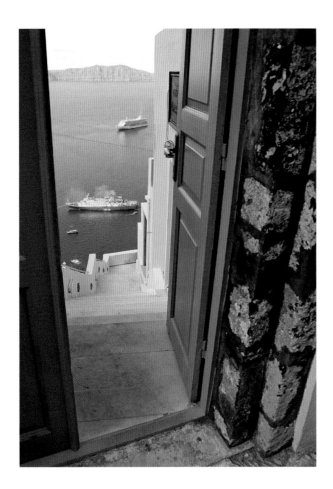

When she took this travel photo, left, Kathe Nealon and her husband were on a cruise to the Greek Islands, celebrating their thirtieth wedding anniversary. As they walked around Santorini, she saw a green door that was closed—so she opened it, and this fabulous sight appeared. Photo © Kathe Nealon

While looking for inspiration, Fran Saunders almost walked by this abandoned rowboat, below, but then said to herself, "If you don't turn around and shoot that boat, you are going to kick yourself." So, back she went, walking around it and shooting several points of view. Photo © Fran Saunders

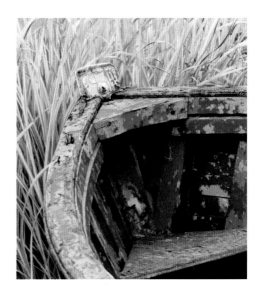

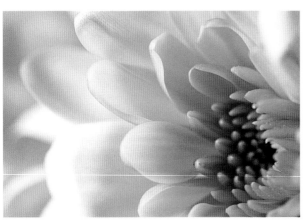

For this macro image, left, Sarah Christian "worked" a softly-lit flower many ways, moving around until she got just the angle she wanted. Photo © Sarah Christian

Finding Inspiration in Uninspiring Places

Feel like you live in an area where there's nothing good to photograph? The truth is, almost any location offers ample material. It's more about *when* you shoot than where you shoot. Any place can appear almost magical in early morning or late evening hours. But if you still find yourself feeling like there isn't one single interesting thing to shoot, give these tips a try.

- **Start shooting anyway.** Activity and inspiration go hand in hand. When you feel stuck, just get out the door and start shooting anyway! Once you have your camera out and are trying different things, you will likely feel more excited by what is around you.

- **Go somewhere new.** Take a day trip to your nearest zoo, tourist attraction, park, garden, nursery, or aquarium. Going to a new location can help you think in a more creative way. And if you know you're not likely to be back anytime soon, you'll feel more compelled to leave procrastination behind and seize the day!

- **Look around you.** Make a habit of noticing things. Nice hands, interesting designs, lovely light, simple backgrounds, bold colors—or anything else that strikes your fancy. For example, whenever you see the color red, consider how it may work in a photo. Colors like red, orange, and purple are less common and stand out, offering potential subject matter to photograph.

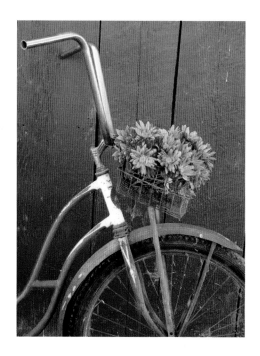

When searching for photo opportunities, always remember to turn around and look behind you. Jacqueline Rogers did this and noticed the fresh flowers in the wire basket of this old bicycle, leaning against a barn wall. The color of the flowers and the contrast between old and new, and fresh and forgotten, caught her attention. It pays to try new things, take breaks, and look around you.
Photo © Jacqueline Rogers

Welcome to Your Camera

Whether you use an iPhone, a basic point-and-shoot, a more expensive compact, or a digital SLR (DSLR), you'll find it helpful to know your way around the camera. This section will point you in the right direction, showing you the basic buttons on the major camera types. For a precise description of your particular camera model, I recommend studying the first few pages of your camera manual.

iPhone

Camera phones are quickly becoming the most popular camera category. Though it doesn't offer a lot of control, it can still be used to take lots of photos using the tips in this book.

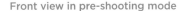

Where to turn ⟶ If you have a basic iPhone, you'll benefit from Steps 1–4, and 7.

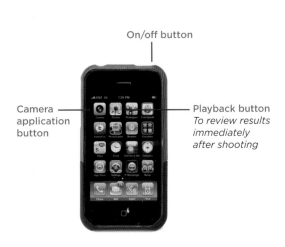

On/off button

Camera application button

Playback button
To review results immediately after shooting

Front view in pre-shooting mode

Shutter release

Front view in shooting mode

Basic Point-and-Shoot

The basic point-and-shoot doesn't allow many adjustments, such as control over aperture and shutter speed, but, like camera phones, can be used for many of the basic techniques in this book.

..

Where to turn ———▪ If you have a basic point-and-shoot, you'll benefit from Steps 1–4, and 7.

..

Top view

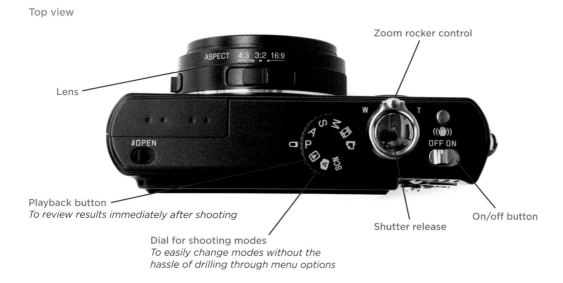

Zoom rocker control

Lens

Playback button
To review results immediately after shooting

Dial for shooting modes
To easily change modes without the hassle of drilling through menu options

Shutter release

On/off button

Back view

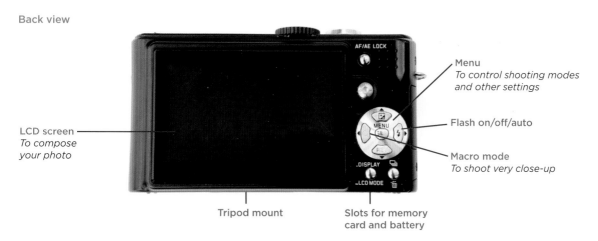

Menu
To control shooting modes and other settings

Flash on/off/auto

LCD screen
To compose your photo

Macro mode
To shoot very close-up

Tripod mount

Slots for memory card and battery

High-End Compact

High-end compact cameras allow much more control over the various options, such as exposure settings, but still fit in your pocket or handbag. Also, these cameras are more likely to be able to capture Camera Raw files.

...

Where to turn ⟶ If you have a high-end compact, you'll benefit from Steps 1–7.

...

Top view

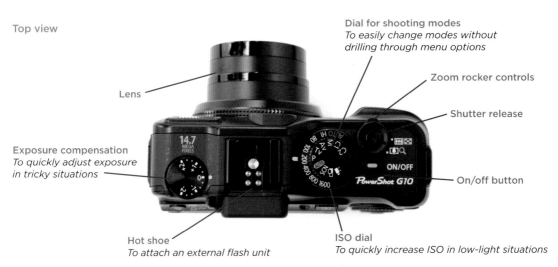

Dial for shooting modes
To easily change modes without drilling through menu options

Zoom rocker controls

Lens

Shutter release

Exposure compensation
To quickly adjust exposure in tricky situations

On/off button

Hot shoe
To attach an external flash unit

ISO dial
To quickly increase ISO in low-light situations

Back view

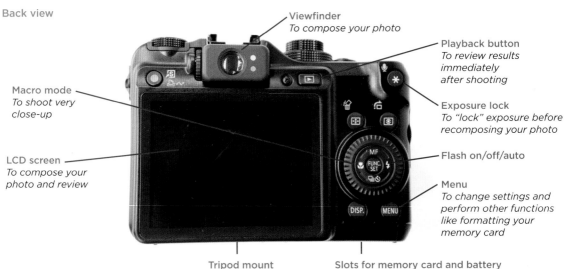

Viewfinder
To compose your photo

Playback button
To review results immediately after shooting

Macro mode
To shoot very close-up

Exposure lock
To "lock" exposure before recomposing your photo

LCD screen
To compose your photo and review

Flash on/off/auto

Menu
To change settings and perform other functions like formatting your memory card

Tripod mount

Slots for memory card and battery

DSLR

The digital single lens reflex (DSLR) camera offers the most control and more scalability, but is much bigger and bulkier. This kind of camera will continue to be a good tool as you grow as a photographer, allowing you to use specialized lenses, sophisticated lighting options, and much more.

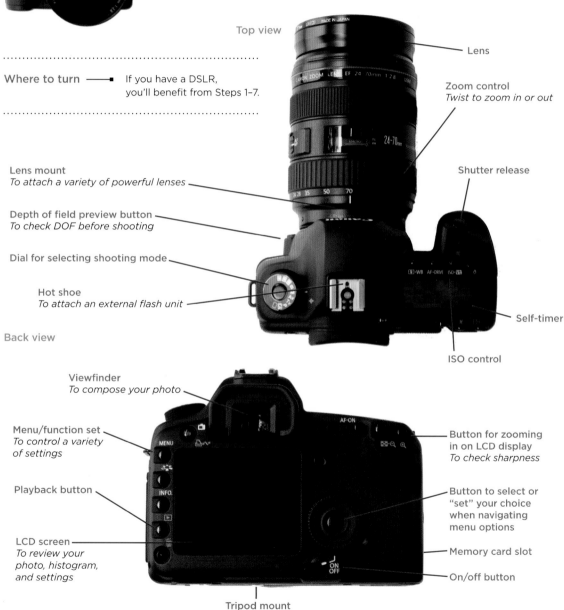

Top view

Where to turn ———▶ If you have a DSLR, you'll benefit from Steps 1–7.

Lens

Zoom control
Twist to zoom in or out

Lens mount
To attach a variety of powerful lenses

Depth of field preview button
To check DOF before shooting

Dial for selecting shooting mode

Hot shoe
To attach an external flash unit

Shutter release

Self-timer

ISO control

Back view

Viewfinder
To compose your photo

Menu/function set
To control a variety of settings

Playback button

LCD screen
To review your photo, histogram, and settings

Button for zooming in on LCD display
To check sharpness

Button to select or "set" your choice when navigating menu options

Memory card slot

On/off button

Tripod mount

STEP 1:
Meet Your Camera Modes

Whether you consider yourself a beginner or a more intermediate photographer, it's important to understand the basic settings and *shooting modes* your camera has to offer. These may differ a bit between camera makes and models, but in general, many of today's cameras share similar features. This chapter introduces the most basic ones—often found on point-and-shoot cameras (starting on page 28). The final part of the chapter introduces more advanced controls, usually found on higher-end point-and-shoots and DSLRs (see page 36). For a quick chart of common point-and-shoot setting icons, see page 216 at the back of the book.

For this image of her Amaryllis Picotte, Jacqueline McAbery used natural light from the window as her only light source and got very close to her subject, experimenting with several different positions until she captured this beautiful macro shot. © Jacqueline McAbery

Portrait Mode

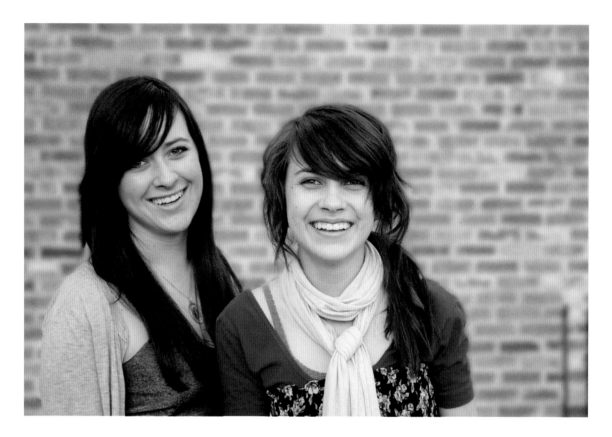

Portrait mode, indicated by a head or profile, is the best setting for taking portraits of people during the day. In technical terms, portrait mode tells the camera to use a large *aperture*, or lens opening creating what's called a *shallow depth of field*. All this is done in an effort to make sure your subject stays crisply in focus while the background is blurred. The resulting effect is that the subject pops out from the background. This is called *isolating your subject* and allows you to focus the viewer's attention on your subject in the foreground. On some cameras, Portrait mode also activates *continuous drive*, which means the camera will keep taking shots in rapid succession as long as you're pressing down the shutter button.

This helps ensure that you get at least one good shot without your subject blinking, for example.

Portrait mode is excellent for photographing people, but it can also be used any time you are photographing a stationary subject that you want to stand out from its background, whether a beautiful autumn tree or a vase of flowers.

In this engaging photo of the spirited friendship between sisters, the subjects pop sharply against a blurred background. This is the kind of effect you'll get using Portrait shooting mode. Photo © Jim Miotke

 # Landscape/Infinity Mode

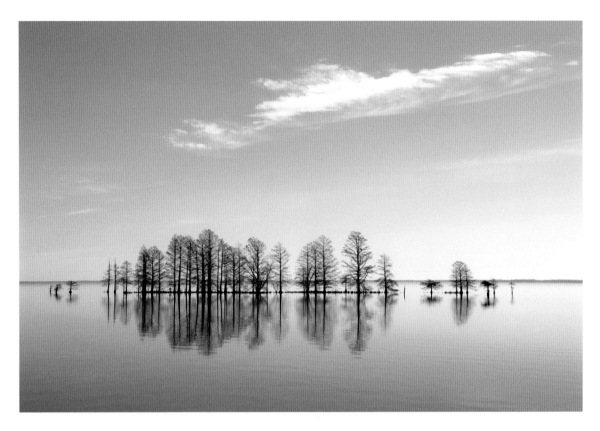

Landscape mode is indicated by an icon of mountains. This is the best setting for shooting faraway landscape settings and vistas. Behind the scenes, Landscape mode (also called Infinity mode) tells the camera to use a small aperture (lens opening), which creates a deep *depth of field* and puts everything in the picture in focus. This is great for shooting beautiful mountains, for example, or the Italian countryside, because it means that everything in the photo will be sharp, from the flowers in the foreground to the crumbling palazzo in the distance.

Use Landscape mode to take faraway vistas, such as this beautiful shot of Lake Mattamuskeet in North Carolina by Mary Lou Dickson. Mary Lou was drawn to this image by the trees silhouetted in the midday sun, the color of the sky, and the cloud, which adds balance and visual interest. Photo © Mary Lou Dickson

🌷 Macro Mode

Macro mode is almost always indicated by a flower. Use Macro mode when you want to shoot something small close-up, such as a flower, a ladybug, a piece of jewelry, or a stamp. Cameras have limits on how close they can be to an object and still focus correctly, so you may want to check your manual for your own camera's limit. Most point-and-shoots can be used in Macro mode from about $1\frac{1}{2}$ inches to 1 foot from an object. (Note: The opposite of Macro mode is often designated with an icon of mountains. This is just meant to mean "non-macro" and this mountain icon is not to be confused with the mountain icon used to select Landscape shooting mode, mentioned on page 29.)

Macro mode is perfect for close-up shots of flowers, like this rose captured by Jon Lamrouex during a short walk to the mailbox. The purple background is a flowering bush nearby. After a light rain on an overcast day is a fantastic time to capture spring flowers. Photo © Jon Lamrouex

TIP

When the light is less than ideal for landscapes, you can get great shots with your Macro mode (or macro lens on a DSLR). Overcast days can be excellent for close-up, macro photography.

⚡ Sports Mode/ 🧒 Kids and Pets Mode

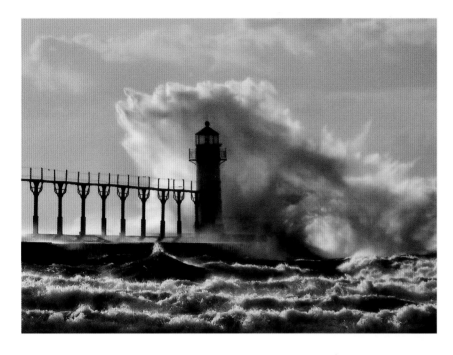

Sports mode will help you freeze action, such as in Jacqualyn Volker's dramatic photo of the ocean. Photo © Jacqualyn A. Volker

Sports mode is usually indicated by a running figure. This is the mode for freezing action, perfect for photographing a subject in motion.

While sports mode is obviously handy for photographing sports, it can actually be used to shoot *any* subject in motion, from your kids running in the backyard to waves crashing on the ocean or a kitten chasing after a ball of yarn. This mode tells the camera to use a fast shutter speed, which means the camera takes the shot very quickly, decreasing the possibility of blur. In some cameras, Sports mode also activates continuous drive, so you can take several pictures just by holding down the shutter button. Because it often tends not to utilize the flash, Sports mode works best in bright conditions.

Kids and Pets mode, indicated by a child and often an animal, is essentially a "light" version of Sports mode, also aimed at freezing action (since children and pets are usually in motion).

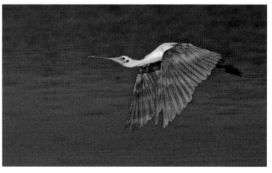

Mary Rafferty Iacofano captured this stunning image of a spoonbill in midflight at J. N. Ding Darling National Wildlife Refuge at Sanibel Island, Florida. Photo © Mary Rafferty Iacofano

 # Night Mode/Night Portrait Mode

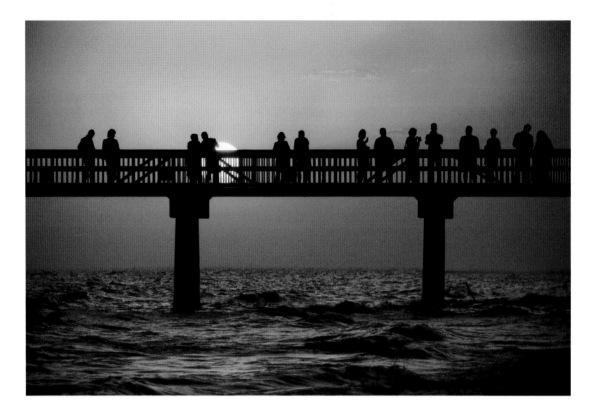

Most cameras have two night modes: a general Night mode, indicated by a moon or star and a building, and a Night Portrait mode, with an icon of a moon or star and a person. Both settings do similar things. They use a slower shutter speed—meaning that the camera takes longer to capture the shot, thus letting in more natural light and allowing background detail to appear. Usually, these modes also fire the flash so people in the foreground get illuminated.

Some cameras have a Night "Snapshot" mode, which does not use flash and instead increases the camera's *ISO*, or sensitivity to light, so you don't need a tripod. The end result is that rather than getting an overly lit person in front of a dark black background, you'll capture a more natural shot with some detail preserved in the background.

Some cameras also have a Sunset mode, indicated by an icon of the setting sun. This causes the camera to use a small aperture, or lens opening, to keep everything in focus, from the close foreground to the distant sunset. It also causes the camera to increase color saturation to produce warmer tones.

Because shots in all of these modes are taken more slowly, it's important to use a tripod whenever possible.

Susan Patton made this silhouette at sunset at Fort Myers Beach, Florida. Waiting for just the right moment, Susan was able to capture the colorful sky and the interesting shape of the pier. Photo © Susan Patton

⁂ Indoor Mode

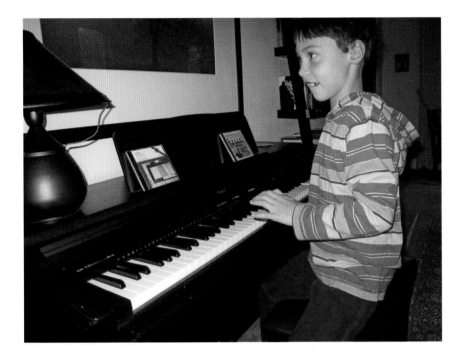

When you want to take a photo in a low-light situation, such as indoors, you have a choice. You can use the flash, which creates that "flashy" effect. Or, you can turn your flash off and use only available light, which means the camera will need more time to take the photo and you'll likely end up with a blurry image. The answer to this problem is Indoor mode.

Indoor mode allows you to shoot sharper images in lower-light situations, such as inside on an overcast afternoon, without using a flash. It does this by increasing the ISO, which is the sensitivity of the camera's film sensor to light. (See page 134 for more about ISO.) This means the camera can take the photo more quickly because it needs less light for the same effect, leaving less chance for blur.

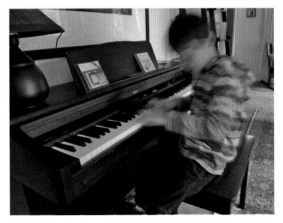

When photographing my son playing around on the piano, my first attempts resulted in blurry photos. Indoor mode increases the camera's sensitivity to light and forces the flash to fire, allowing you to capture sharper photos indoors. The result is an image that is reasonably well-lit and, best of all, in focus. Both photos © Jim Miotke

☂〰 Beach Mode/ ⛄ Snow Mode

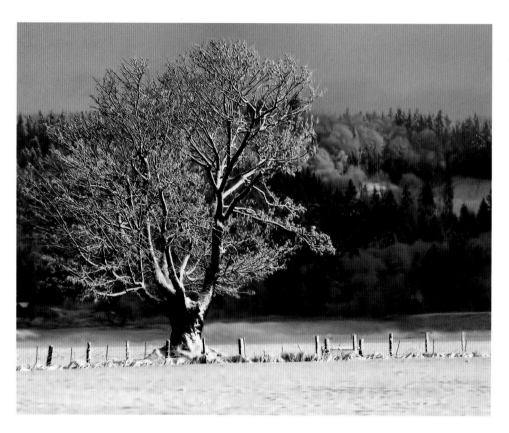

When your point-and-shoot camera takes an image, it must decide how much light to let in so both dark and light areas of the scene are exposed correctly. It does this by reviewing the scene and then using an average. But in some scenes, the light areas are so extreme that they throw the rest of the scene off—such as with beach and snow scenes. The superbright areas of sand or snow trick the camera into letting very little light in, leaving other parts of the image—such as your daughter building her first sandcastle—too dark. The answers to this problem are the Beach and Snow modes, which are very similar. They tell the camera to ignore the bright background and expose only for the subject, letting in just the right amount of light to perfectly expose your daughter. In addition, they may increase saturation or tinker with your white balance settings to make sure you end up with pleasing, warm tones in the photo.

One year in the Northwest, winter was especially frigid. Sue Cole got in her Jeep and drove for miles, taking shots of the snowfall. After several hours and many shots, she came across this grand old oak tree covered with show. The light created a perfect-picture moment. Often a scene like this, with lots of bright whites, would trick the camera into underexposure, leaving the image too dark. Using her camera controls like an expert, though, Sue made a beautiful—and correctly exposed—winter landscape. Photo © Sue C. Cole

✳ Fireworks Mode

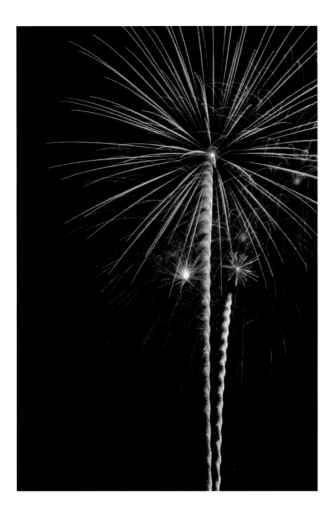

Fireworks are superfun to photograph. All you need is a tripod, a remote or self-timer (so you can take the picture without touching your camera), and a way to slow the shutter speed to 8 or so seconds. Fireworks mode offers one way to do just that. Photo © Jim Miotke

Fireworks mode, indicated by a symbol of fireworks, is designed to help you photograph (you guessed it) fireworks. It does this by slowing the shutter speed down to let in more light, and turning off the flash.

Because the camera takes photos more slowly in Fireworks mode, it is essential to use a tripod or set the camera on something firm. You'll also want to use the self-timer or a remote release to avoid touching the camera and causing camera shake (see page 60 for more on camera shake).

Since Fireworks mode slows the camera down, it can also be used for a variety of creative techniques, such as purposefully capturing the blur of a moving object. Why do this? Blur can be a creative way to convey motion, such as in the shot of my wife standing by the subway on page 16. As above, it's important to use a tripod and keep the camera very still so only the subject will move and blur—not the rest of the photo.

Fully Automatic Mode/Program Mode/ Manual Mode

Before composing this off-center portrait (using the Rule of Thirds, which we'll talk about in the next chapter), I set my camera in the semiautomatic Program mode and selected a fast shutter speed, making the background nice and blurry.
Photo © Jim Miotke

Here are some more advanced modes usually found on higher-end point-and-shoots and DSLRs. Where the fully Automatic mode makes all the decisions for you, Program ("P") mode can be either fully or semi-automatic: it can select all your settings for you or let you get more involved. Automatic mode calculates exposure settings that will result in a correct exposure—where the image is not too bright or too dark. All you have to do is point and shoot, and you'll likely end up with good exposures. It is a fine place to start for beginners, because you can focus on learning basic composition while the camera sets the exposure for you.

If you choose to take a more active role, the "P" mode allows you to shift exposure settings to what you want. This will require some understanding of shutter speed (see page 150). If the "P" mode gives you a fast shutter speed but you prefer a slow one, you can dial it down, all the while ensuring that you'll still end up with a correctly exposed photo. Furthermore, the "P" mode will not cause your camera to automatically fire the flash. If you're like me and you prefer to decide when to use the flash, you'll appreciate this semi-automatic "P" Program mode.

Manual ("M") Mode

Manual ("M") mode is for Masochists. In Manual, primarily seen in DSLRs, the camera does nothing and *you* make all of the decisions, setting your aperture and shutter speed for each shot. Although this mode is often recommended to beginning students, I don't recommend it. I prefer that my students get at least a few keepers even while they are learning. Learning photography is more fun that way. I only use the fully manual "M" mode when shooting with my studio lighting set-up in my studio. At all other times, I shoot in semi-automatic "P" mode and recommend students do the same.

Aperture Priority Mode/
Shutter Speed Priority Mode

In addition to "P" (see page 36), there are two other very handy (and creative) shooting modes found mainly on DSLRs: Aperture Priority ("A") and Shutter Speed Priority ("S" or "Tv").

Both of these modes allow you to take control of one setting (aperture or shutter speed) and the camera will automatically set the other for a correct exposure. For example, Aperture Priority requires you to change the aperture only; the camera then automatically selects the shutter speed for a correct exposure. If you increase the *f*-stop number (for a smaller aperture), the shutter speed will automatically get slower. If you decrease the *f*-stop number (for a larger aperture), the shutter

speed will get faster. The same is true for Shutter Speed Priority. If you slow the shutter speed, the aperture will automatically get larger; if you speed it up, the aperture will get smaller.

For more on aperture and shutter speed, see page 147-151 and the tips in Step 5.

This image was captured while the photographer was hanging from the side of a cable car on the hills of San Francisco. She used Shutter Speed Priority, selecting a relatively fast shutter speed (and the image stabilizer feature described on page 63) to get a sharp photo while shooting from this jostling cable car. Photo © Kathy Blank

⚡ Flash On/ ⚡ Flash Off/ ⚡A Auto Flash

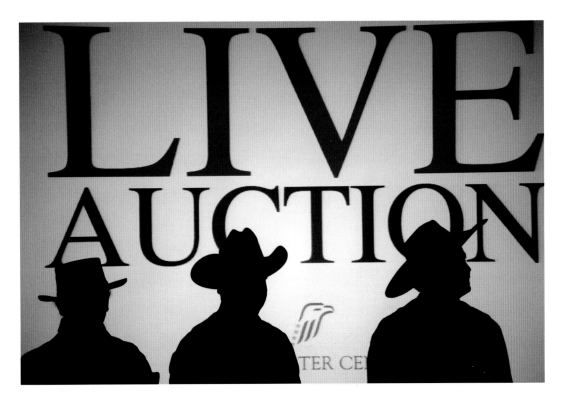

Flash settings are usually noted by a lightning bolt with an arrow pointing down. You may think your camera knows exactly when to use its flash—and it's true that you can leave your camera on "auto flash." However, you'll get much more professional results if you learn to control the flash yourself. This book is full of ideas on when to use your flash, and when to turn it off.

 "Auto flash" lets the camera decide when to use the flash.

 Forces the **flash on** when you want to provide additional "fill light."

⚡ Forces the **flash off** when you want to rely on available light, as in the example on this page, or when photographing portraits outside with the subject just inside a door or a window.

Attending an auction, I wanted to capture a silhouette of these three auctioneers against a back-lit sign. If I allowed the flash to fire—as it likely would have in the Auto Flash mode—my three subjects would have been illuminated and the sign would have been darker. Since this was not the effect I wanted, I turned my flash to the "forced off" position and temporarily zoomed in to fill my frame with the bright sign. With the bright sign filling my composition, I took an exposure reading, locked in the settings, and then zoomed back out to create this silhouette. Photo © Jim Miotke

STEP 2:
Forty Absolutely Easy Tips to Instantly Improve Your Photos

Camera manufacturers make photography sound so easy that anybody can do it. They call their products "automatic" and tell you that, with their camera, taking pictures is a snap. As Kodak first started telling people about a hundred years ago, you press the button and we do the rest.

For the most part, it's true that taking snapshots is easy. The problem comes when, instead of taking mere snapshots, you want to take great pictures, photos that illicit a "Wow!" from your viewer. Photography may not require a PhD, but we all need a little training before we can create beautiful photographs time and time again.

Thankfully, this need not be difficult. Get only a handful tips and tricks under your belt and you'll be making better pictures all the time. This chapter is filled with exactly that: specific, practical tips on composition, sharpness, light, and timing that will help you create better photos right away.

Dawn Schwack took this image while on a nine-hour boat tour in Kenai Fjords National Park in Seward, Alaska. Photo © Dawn L. Schwack

Take Charge of Your Composition

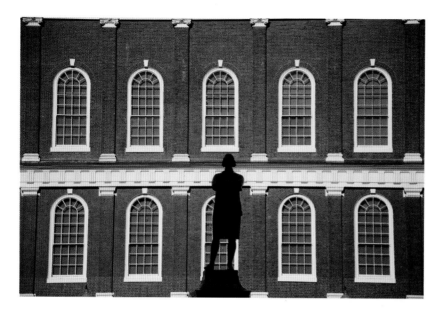

When I first started shooting, I had a difficult time with the notion of composition—the art of arranging objects in a photo. I thought, How can I decide what to include or exclude in a picture? The world is the world, not some figment of my imagination—right?

I discovered, however, that I had quite a bit of control. By simply changing my point of view or position, I could capture a completely different photo. By moving a little to the left or right, or up or down, I aligned objects or made elements work with each other in surprising new ways.

As a photographer, you decide what to include in the photo, where to place it, and how much of the picture the subject occupies. More important, you also decide what to leave out of the photo. You decide what is in the foreground (the area in front of the subject) and what is in the background (the area behind your subject).

Don't just accept the world as you first see it. Move around, experiment, and explore how you can change each scene right before your eyes.

I was drawn to this building and the bright blue sky, but my image above ended up a little bit boring. I then noticed a statue across the way and positioned myself opposite it, so I could use it as a silhouetted shape against the building. Notice how the statue in the top image acts as counterpoint to the symmetry of the building. I took time to see the building from a different point of view, and was rewarded with a more creative composition. Both photos © Jim Miotke

Choose One (and Only One) Subject

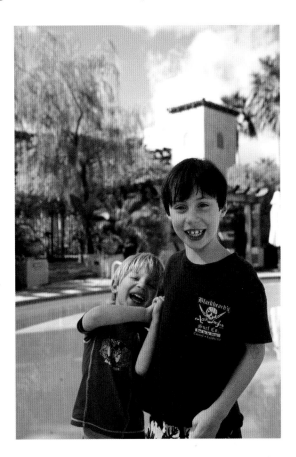

The first step in making a photo is choosing your subject. What is the one thing that attracts your attention to the scene?

This decision often involves making sacrifices. As much as you may wish to include everything in the picture, selecting one main subject and letting go of other elements will make it a better composition. For example, let's say you are taking a picture of your spouse standing in front of a beautiful view. You can take the standard snapshot, where the natural attractions are off in the distance and your spouse is a tiny figure waving at the camera. It is much better, though, to think about your scene and make a decision. Is your subject your spouse, or the view? If you want a portrait of your spouse, make her bigger in the picture. Zoom in, walk closer, or have her walk closer to you. If, on the other hand, the landscape is what you want to capture, then focus your efforts on that view. Either way, make a decision about what you most want to photograph.

I liked the overall scene in the first photo, but what I really wanted to convey was the happiness of my two sons. Here, they are extremely small, and one might ask, "What's the subject?" Remember, even when your subject appears big to your naked eye, it can look miniscule in a photograph. For the second photo, I asked the boys to come closer and did a much better job of capturing what I wanted. You will always get far more impact by first deciding what the "star" of your photo is, and then working to make that star the focus of your composition. Both photos © Jim Miotke

Keep It Simple

Instead of trying to squeeze everything into your picture, be selective and let go of anything that will distract the viewer from your main subject.

Watch your borders and recompose if any-thing—a telephone wire, a distracting sign, some kind of debris—adds clutter to the composition. Even if no distracting elements surround your subject, too much blank "negative" space can also be a problem. If you realize the background is distracting, reposition yourself or your subject, or zoom in, until you find a background that gives your subject the attention it deserves.

If you really want to include other objects in your photograph, simply take more pictures, with each focusing on a different subject. Nine times out of ten, a clean, simple composition is bound to have more "Wow!" impact than a busy one.

Notice how this portrait is improved by simply removing the clutter in the background, as shown in the shot above. With less extra elements to distract the viewer's eye, the top photo becomes far more pleasing and successful. Both photos © Jim Miotke

Fill the Frame

One of the simplest ways to make a stronger composition is to move in closer to fill the frame with your main subject. You can do this by zooming in or, if you are using a DSLR, using a telephoto lens. If you don't have enough telephoto power, simply walk as close as you can to your subject. Getting closer is a surefire way to make your photo have more impact.

Each time you take a picture, move in closer for another shot. Fill more of the frame with your subject. Even if you think you are close, try moving or zooming in closer. You will be surprised at how often that tiny viewfinder tricks you into thinking you are already close enough. By making your subject appear bigger and take up more of the photo, you will eliminate distracting objects on the sidelines and help viewers better understand and appreciate your picture.

Jennifer Jones photographed this three-month-old baby by laying her on a rug near a large open window and standing over her while a second person kept the baby laughing. By filling the frame and eliminating any distracting background, Jennifer focused our attention on the delightful subject. Photo © Jennifer Jones

Get Even Closer

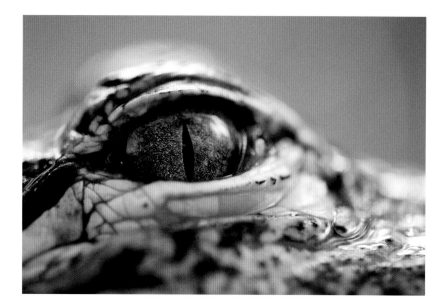

Have you ever known people who try to fit too many words into one conversation? They include every detail of a story and, in the process, lose your attention. On the other hand, some people choose their words carefully. They resist the urge to share every little thing and instead focus on only the pertinent details, letting the listener's imagination fill in the rest. When such people speak, others listen.

In the same way, a photograph that focuses on one well-chosen, interesting detail can be more interesting, fresh, and evocative. Let go of that urge to get everything in and concentrate on a detail, such as an intricate carving, the talons on a bird, or a child's tiny hand holding her father's pinky finger. By simply *suggesting* the entire scene instead of actually photographing all of it, you can take photos that create more impact.

Moving in closer is an especially helpful trick when the sky is overcast or rainy. By keeping the sky out of the picture, you avoid a dull background that will distract your viewer from the main subject.

These close-ups will be softly lit from the overcast sky, and the results can be quite stunning.

Each of these photos is effective in its own way. The image above fills the frame with the subject and grabs your attention, while the second, top, is even more unique. The viewer will stick around, wondering what kind of animal that eye belongs to. Always take a moment to photograph one or more "storytelling details" within an overall scene. You'll end up with several powerful photos of each subject. Both photos © Jim Miotke

Place Your Subject Off-Center

Most people automatically center their subject in every picture. But photography is not archery, and aiming to get your subject in the exact center is not always the best idea. Simply placing your subject a bit off-center can add an amazing vitality to your photos.

Rather then always putting your subject in the middle, try consciously placing it wherever it looks best. For example:

- Reposition yourself or your camera until your subject is off-center.
- Balance the various elements in the picture against one another.
- Place your subject according to the Rule of Thirds (see page 49).

If you are using a point-and-shoot, or a DSLR on "program" mode, don't forget to center the subject first and lock your autofocus, then recompose the image (see page 64 to learn how to do this).

Here's another cool tip. If your subject is moving or looking off to one side, you can make the photo feel peaceful or more mysterious simply by placing the subject in a different spot. If your subject is looking into the photo, so viewers can see what he or she is looking at, the photo will feel balanced and comfortable. On the other hand, if you position your subject near the edge, looking outside the picture, the viewer will feel mystery and tension. This also applies to moving subjects. If your subject is moving into the picture, viewers will feel more comfortable.

Celeste McWilliams positioned this little girl on the left so that her head, which is looking slightly toward the right, would face into the photo for a more balanced composition. Photo © Celeste McWilliams

Place Your Subject in the Upper Third

Whether or not you position your subject off-center on the horizontal axis, *be sure to position him or her off-center* on the vertical axis, so the eyes are in the top third of the frame. Centering the eyes on the vertical axis is one of the most common mistakes people make. We almost all do it, and we need to break that habit. What a waste of space up there in the top third! Viewers will feel more connected and engaged when they view portraits with the eyes positioned higher in the composition, one third down from the top edge.

When I captured this photo of my son at left, I mistakenly positioned his eyes exactly in the vertical center. Note all the unused negative space in the top part of the photo. The second photo shown above, with his eyes in the upper third, is much stronger. Both photos © Jim Miotke

Use the Rule of Thirds

The rule of thirds is an ancient design principle that offers a quick, easy way to add interest and vitality to any picture. With this technique, you take off-center subject placement one step further.

Instead of placing your subject in the exact center of your photo, place it one third from the top or bottom and one third from the right or left edge. The effect is subtle but amazing, and you will instantly notice a big improvement in your pictures.

To use the Rule of Thirds, take any picture and imagine drawing four lines across it. Draw two lines on the horizontal axis and two lines on the vertical axis, each one third of the distance from the edge—like a tic-tac-toe game.

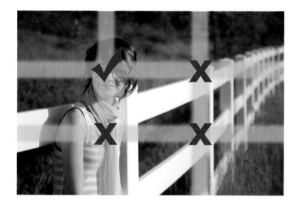

When composing your scene, position your subject at one of the four intersections of lines—which intersection depends largely on what is going on in the scene. For example, if there are distracting telephone wires above your subject, place the subject on one of the upper two positions to get rid of the wires. If you notice an object in the upper-right corner that could balance your subject or give it additional meaning, place your central subject in the lower-left position.

In the first version at left, my subject is centered and the viewer's experience is diminished. The eye has nowhere to go but into the center, and then it's left there to lose interest and drift off. By simply changing the composition and placing my subject on one of the Rule of Thirds intersections, or "sweet spots" shown in the middle version, I made this image more unique and graphically balanced. The final image is shown at top. Both photos © Jim Miotke

Get Down Low—or Up High

Many people are surprised that their photos of small subjects, such as flowers, children, pets, and so on, turn out boring. This is often caused by shooting from a typical human height.

Next time, try altering your point of view. For some shots, get high and point down at your subject. For others, get down low and point up. Looking up at your subject will make it seem dramatic and impressive. Looking slightly down on people you're photographing can create a flattering effect by minimizing double chins, among other things. And, when photographing kids and pets, get down and shoot from their eye level for more engaging results.

Notice how the image above—for which I got down low—is stronger than the one at left. It provides a greater sense of connection, since we are down at her eye level. Both photos © Jim Miotke

Know Where to Put the Horizon

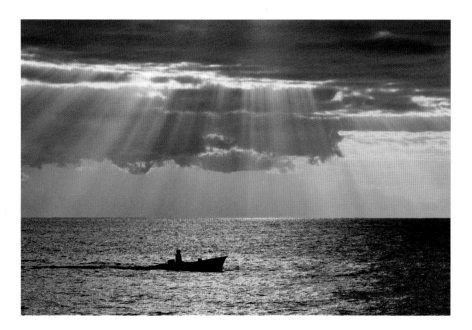

Whether you choose a horizontal or a vertical orientation, try to keep the horizon perfectly level, because even the slightest tilt can distract the viewer. (If you do happen to skew the horizon a bit on a photo you love, just crop the image afterward on your computer (see page 190) to realign the horizon.)

When you look at a scene through your camera, take a careful second glance at the edges to make sure the horizon is level. You could use a small bubble level on your tripod or camera, but I find that looking carefully through the viewfinder serves the purpose just as well.

Most picture-takers put the horizon right in the middle, but this is another easy thing to improve. Use the Rule of Thirds and place the horizon line on the upper or lower third dividing line. You can even be more extreme and place it extremely low or high. To decide which will work better, simply ask yourself, "Which is more attractive and interesting—the sky, or the

land/sea in the foreground?" If it's the sky, place the horizon low; if it's the foreground, place it high.

In this image above, Beverly Burke placed the horizon near the middle of the composition; it is also slightly tilted. The second image, top, with the horizon near the lower third and the gorgeous sky taking up more of the frame, is more dynamic and balanced. Both photos © Beverly Burke

Choose Your Background

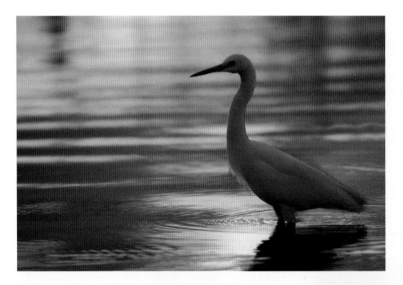

I changed my point of view three times in this series of photos, all in search of the right background. In the first image, bottom, it's difficult to see the heron against the dark background. For the second image, below, I tiptoed closer and got down low so the beautiful sunset illuminated the background. Although this works well as a wide scenic, I still wanted a simple image that clearly conveyed the amazing beauty of the moment. I carefully moved closer and lower, and zoomed in. The third one, shown at left, is my favorite. The simple warm background, combined with close proximity and a low point of view, makes for an image with far more impact. All photos © Jim Miotke

Having a simple, uncluttered, nondistracting background will allow the subject to pop! Ideally, your background should be:
- Simple
- Even-toned (without any bright spots)

If you can find a background with these two characteristics, you will be way ahead of the game.

The first step is simply to be aware when your background is cluttered. Once you are aware of this, you can take simple steps to choose a better one. Often you can eliminate the clutter by zooming in or walking closer. Sometimes all you need to do is move a bit to the right or left, or up or down. It only takes a few seconds, and is much faster than removing the background clutter later on your computer. Other times, you might be able to actually change the background yourself, as I did for the table-top still life, opposite.

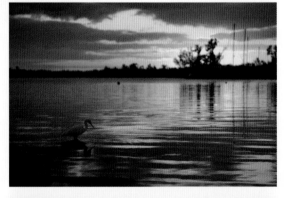

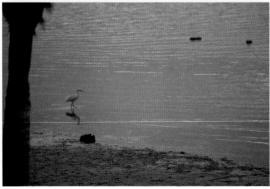

This simple loaf of bread was part of a great meal my wife and I enjoyed on vacation in Arizona. As I had my camera, I took a picture of the bread and our colorful drinks, top right. When I reviewed the image, though, it looked cluttered, so I removed a couple extra elements, placed my napkin under the bread and drinks as a makeshift background, and zoomed in closer, bottom right. This did the trick. In the final photo above, the subject stands out, no longer competing with the surrounding elements. All photos © Jim Miotke

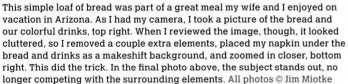

Include a Foreground Object

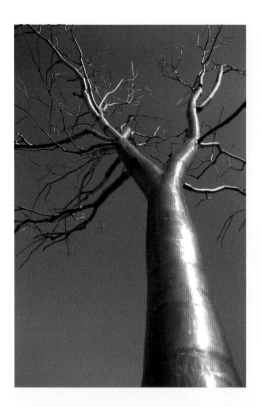

When presented with a beautiful landscape, most people simply take a picture and leave, and are later disappointed. Although the scene felt majestic and spiritually refreshing at the time, these feelings are lost when conveyed via the camera. One trick professional nature and landscape photographers use is to include an object in front of your scene (in the *foreground*).

Look for an object that will add interest and meaning to your photo. Then position yourself so the object is in the foreground, keeping the distance landscape in the background. This will create a sense of depth and give the viewer something to enjoy both in the foreground and background. The best photos, in fact, have a foreground, a middle ground, and a background. Compose your landscapes with foreground objects and watch how many people "ohhhh" and "ahhhh." In a landscape shot, you'll want deep depth of field, so select Landscape mode, or if your camera allows, Aperture Priority mode and a large *f*-stop number. If you are using a DSLR, use a wide-angle lens for this type of shot.

TIP

Wondering where to focus in a landscape image like this? It's simple. Whether you're using a point-and-shoot or a DSLR camera, focus on a point one third of the way into your scene. This usually means temporarily centering your composition on an object one third of the way into the scene, pressing your shutter button halfway to lock focus, and holding the button in this position. Then recompose and finish pressing the shutter button all the way down.

TIP

If using a DSLR, use the "depth of field preview" button (see page 154) to make sure your foreground objects are acceptably sharp. Here's another trick for DSLR users: I often focus on my main foreground object and then turn off my autofocus and manually push the focus out a bit further into the scene. Since depth of field reaches both into the foreground and into the background beyond your focal point, doing this will help you make the best use of your depth of field, with both the closest and the farthest subjects in perfect focus.

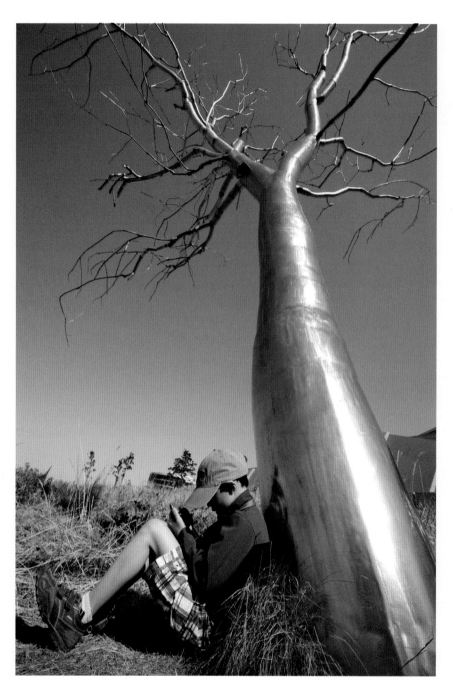

This sculpture in Seattle's Olympic Sculpture Park looks just like a real tree... until you get close. For my first photo of this silver tree, opposite, I simply aimed up and shot. Fortunately, my son decided it was the perfect place to play his video game. As soon as I saw him, I changed my composition to include him in the foreground, resulting in a much more dynamic photo. Both photos © Jim Miotke

Turn Your Camera

Give your photo albums and slideshows some variety by shooting in both vertical and horizontal orientations. It sounds simple, but most people continually shoot in the horizontal, or landscape, orientation. Why not turn the camera and try shooting vertical, portrait-style images as well?

In general, choose the format that best fits your subject. Vertical works well for portraits; horizontal can be more effective for landscapes. Don't stop there, though. With each of your favorite scenes, take at least one picture in each orientation to see which you like better.

Sometimes your subject may fit equally well into both horizontal and vertical orientations. Does one tell a different story, or provide a more unique or startling impression of your subject? Either way, as long as you are trying both orientations, your collection of images will show a pleasing degree of variety.

Horizontal photographs often convey a serene, relaxed feeling, while vertical photos feel more active and dynamic. In this pair of images, the energy of the vertical orientation is accentuated by the strong pattern of lines, which draw our eyes deep into the photo toward a payoff: the out-of-focus man in red. With any scene, shoot at least one photo in each orientation and carefully study the results to understand how your choice affected the shot. Both photos © Jim Miotke

Frame Your Subject

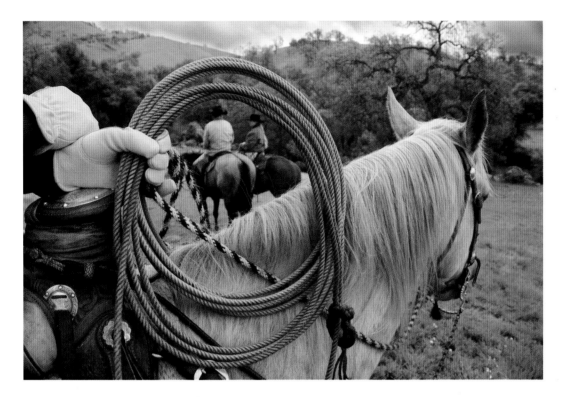

Another powerful compositional trick that you can use to add pizzazz and punch to your photos is something called *framing*.

Take a look around your house. If you have art on the walls, odds are likely that the picture is surrounded by some kind of border. If it's a really nice image, perhaps you have it surrounded by a big white matte, which is itself wrapped by a golden or dark wood or metal frame. Why do we do this with our pictures? Because it makes the subject seem more important. It causes the viewer to subconsciously regard the image as more worthy of his or her attention. It's an amazing thing. Even a rather dull image can appear more important when it's set off by a nice frame.

In the same way a large matted frame can add value and significance to artwork, framing your subject within your composition can make it appear more important.

When composing, look for some kind of bounding compositional object. If you notice one, place your subject within it to hold a viewer's eye a bit longer. Move around until you can photograph from a perspective where your subject is perfectly placed inside the framing object. This little trick can be used to wow a lot of people when they view your pictures.

I asked a rancher to hold up his rope and then quickly positioned myself so it framed the riders and horses in the distance. Don't be afraid to ask others to help. You'll be surprised at how often people are happy to help you achieve your photographic goals. Photo © Jim Miotke

Avoid Getting More than You Bargained For

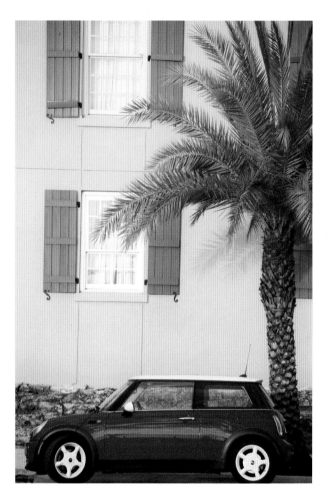

DSLR viewfinders don't show you the entire scene your camera will capture. In other words, the picture may include more than what you saw when looking through the viewfinder. Point-and-shoot cameras will often do the same thing, especially if you use the optical viewfinder instead of the LCD.

If you have "live view" functionality with your LCD, using it to review your composition before you shoot should do the trick. If not, you can quickly compensate for this problem by simply zooming in just a hair before you take any picture. This way, you are assured of actually photographing what you intended and not unconsciously including stray elements along the edges.

If you forget to keep this in mind when shooting, you can fix the problem after the fact by cropping your picture in Photoshop or a similar program (see page 190).

When I noticed this red Mini, I quickly saw an image in my head where its wheels were perfectly set on the edge of the photo. But after I reviewed the first image in the LCD screen, I was reminded that the viewfinder doesn't show everything the camera will record. Before shooting the second image, shown above, I simply zoomed in a bit after composing my photo exactly the way I wanted it. Both photos © Jim Miotke

Tell a Story with Your Photograph

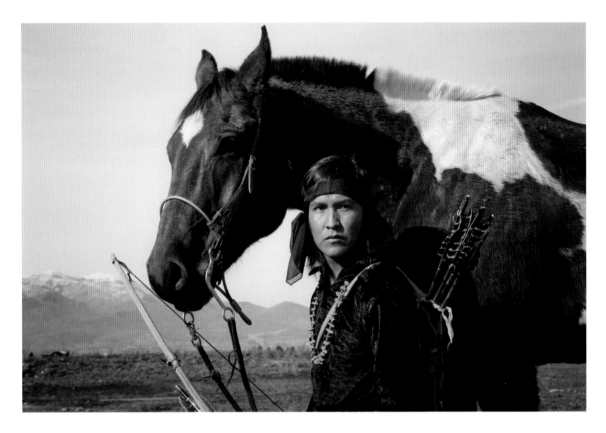

Photography is more than just a way to record moments; it can also be a wonderful storytelling medium. You can capture not only a moment in time, but an idea, quality, or way of life.

Even though you only have a split second to tell your tale, look for ways to express an entire story in each picture. Look for a central character—the "star" of your photo—as well as supporting characters. Look for relationships between various elements that interact with dynamic energy. Make sure your background complements the drama of the main character and doesn't compete with it. These are just a few ways to stir feelings of curiosity and mystery for your viewer. Storytelling photos—images that make the viewer wonder, think, and question—are satisfying to take and to review again and again.

Cindy Hamilton's photo is not only an example of great composition and lighting, it also has a wonderful storytelling quality. It makes you want to know more about the subject and his story. The sense of deep purpose behind the man's eyes—along with the magnificent supporting character (the horse)—draws the viewer in.
Photo © Cindy Hamilton

Hold Still

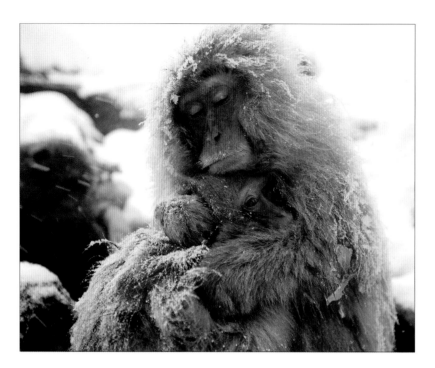

Have you ever opened up a photo you were so excited about, only to find out it was blurry? Whether you realize it or not, your hands shake a tiny bit whenever you take a photograph. They are especially likely to move when you push a camera's shutter button. This almost unnoticeable, involuntary vibration is called *camera shake*.

Camera shake is most likely to cause problems when lighting is dim and the camera needs more time to take the picture. The more time the camera needs, the more likely it (or the subject) will move while taking the photo, and the more likely you will end up with a blurry image. Blur usually occurs when you are:

- shooting indoors without a flash;
- shooting in the evening or early morning, when the light is dim;
- shooting when your subject is moving;
- shooting with a lens at maximum zoom; or

- using a low ISO number (see page 134 for more on ISO).

The best way to avoid camera shake is to use a tripod. If you don't have a tripod, set your camera against something flat and firm, like a table, wall, or railing. If you are using a camera that allows you to change ISO (or "film speed"), switch to a faster ISO for low-light situations, such as ISO 400, 800, or as high as it will go. Check out more tips for taking sharp photos on pages 61-67.

The first thing that probably caught your eye in Anne Young's picture was the love and affection conveyed in that warm embrace. But did you also notice how crisp and sharp the subjects are? Anne took this image in Jigokudani Wild Monkey Park, in Japan, where she spent five days following the monkeys, just waiting for this shot. Photo © Anne Young

Use a Good Tripod

The benefits of using a tripod far outweigh any inconvenience. Your tripod is the ultimate "image-stabilization" device, opening up a wellspring of shooting opportunities when light is low and greatly increasing your percentage of "keepers" versus blurry rejects. Tripods also allow you to get cool special effects, such as night scenes, fireworks, and flowing waterfalls.

When photographing fast-moving subjects, you may be fine hand-holding the camera, but for nature, landscape, flowers, macro, and so many other subjects, there is no better way to get sharp—and creative—photos.

If you find using a tripod very frustrating, your tripod might just be a stinker. Did it cost less than $90? Do you have to screw a bolt to attach and remove the camera? Such tripods often make the job too cumbersome. Save up and get a professional-level tripod (I like Bogen/Manfrotto and Gitzo). It will cost more, but it will be one of the best investments you make in your photographic hobby.

My one exception to the rule: If you must travel light and cannot justify carrying a big tripod, you can buy a mini tripod that is supercompact and incredibly light. Some, like the Joby Gorillapod, can be attached to objects like trees branches, poles, fences, and so on. These are more limited than full-height tripods, but they are better than nothing when you need to pack light.

While on vacation in Annecy, France, Cindy Hamilton bought a geranium, set up her tripod (a real necessity with macro!), and shot away. Her percentage of great shots was hugely increased by the fact that she was using a tripod.
Photo © Cindy Hamilton

Use the Self-Timer

Contrary to popular belief, the self-timer is for much more than simply taking self-portraits. It also provides a way to trigger the shutter button without touching the camera. By removing the possibility of your hands shaking the camera as you shoot, you will get sharper, clearer results, especially in low-light conditions.

In the photo above, for example, the low light required a long exposure (meaning the camera needed a longer time to record the image). I would not have been able to get a sharp photo if I had pressed the button or touched the camera, even with it securely placed on a tripod.

To make full use of your self-timer, start by mounting the camera securely on a tripod or, in a pinch, resting it on a firm, flat surface. Look through the viewfinder to compose your photo, set the self-timer to fire the shot, and step back. If you're shooting a stationary subject and have a little more time to think, you can compose first, before attaching the camera to your tripod. Move around, looking through your viewfinder until you find a view you like. Then set up your tripod with this view in mind.

Although it's another minor expense, a remote release is even better than the self-timer, since you won't have to wait several seconds between each exposure.

While photographing Monterey's Fisherman's Wharf in California in these dim twilight conditions, I used a DSLR, a tripod, and a self-timer to get the shot. It was just after sunset and the sky was taking on a gorgeous periwinkle glow. The lights on the wharf had just turned on and the ocean waves washed up and down the shore. Since the image would have been blurry if the camera moved at all during exposure, I made a long exposure while keeping my hands off the camera. Using a slow shutter speed (such as 15 seconds), I rendered the shoreline waves as a soft, foglike blur. Combined with the lovely colors of the sky and the wharf lights, this made for a supercreative (and superfun) exposure. Photo © Jim Miotke

Five More Tips for Taking Sharp Photos

The light was not great on the day Graham Sher took this shot of the Brooklyn Bridge in New York City, so he used a tripod to steady his camera as much as possible. Also note his excellent use of framing in his composition (see page 57 for more on framing).
Photo © Graham Sher

Here are more tips and techniques for crystal-clear results!

1. **Hold your camera steady.** If you use the LCD screen to compose each scene, holding your camera way out in front, you may be increasing the likelihood of blurry results. Instead, press the camera lightly against your face, keeping your elbows in close to your body. If you're using a DSLR, firmly grasp the handgrip of your camera with one hand and cradle the lens with the other.

2. **Make a "human tripod."** Make a tripod out of your body by stabilizing yourself against a wall or resting your elbows on a table. Try it out: lean against a wall, spread your legs slightly, hold steady, and breathe deep before shooting. Often, this will do the trick.

3. **Press halfway and pause.** Don't press the button down in one motion. Press halfway, confirm that the focus in sharp, then press the button all the way.

4. **Shoot in the continuous mode.** Shooting in this "motor drive" mode often increases the likelihood of getting one great, sharp shot, especially if your subject is moving (more about continuous mode on page 75).

5. **Use Image Stabilization.** If your camera offers Image Stabilization, be sure you have it turned on. This will often help you get sharper photos when the light is somewhat low. The only time you want to turn Image Stabilization off is when you have your camera securely on a tripod. In that case, the Image Stabilization might actually add blur instead of preventing it.

Focus on Your Subject

The most important part of the photo—your subject—should come across sharp and clear. Focusing on your subject involves two simple steps:

- Clearly identifying your subject, and
- Controlling the focusing mechanism of your camera.

Most automatic cameras focus on whatever is in the center of the viewfinder. The problem comes when you want to place your subject anywhere else in the photo. The camera will still focus on whatever is in the center, and your subject will end up blurry. But there's an easy trick to fix this, called *locking your autofocus*. Your camera may do it differently, but most work something like this:

1. Identify the main subject of your photo and put it in the center of your frame (even if you don't want it positioned there in the final photo).

2. Press the shutter button down *halfway*. Some cameras will give you an indication when the scene is in focus, such as a solid green light or a beeping sound.

3. While still holding the button halfway down, move your camera to recompose your scene however you want it.

4. Finish taking the picture by pressing the shutter button all the way down.

Most cameras are, by default, designed to focus on whatever is in the center of the photo. In the first photo, opposite, the camera focused on a rhododendron bush in the background. To set the focus on the subjects, I temporarily moved my camera so the girl was centered, pressed the shutter button halfway to lock the focus, returned to my original composition, and took the picture above. Both photos © Jim Miotke

Focus on What Is Most Interesting

Both of these images are charming, but notice how the one at left leads you directly and quickly to the subject's beautiful eyes. The photographer, Jennifer Jones, had seated the girl in a chair in open shade. Although the image below is adorable, the other image invites us to engage even more with the subject. It's amazing, but sometimes even a smile can compete with the main attraction of your photo! Both photos © Jennifer Jones

With every scene, you have amazing creative power available to you. Is the most important part of your photo the eyes of your subject? Is it sunlight dancing on the water of a lake? Is it the wonderful facial expression of a street vendor in France? Whatever it is, hone your focus on that spot. If necessary, you can even try creative options, such as asking your subject to change positions. The key is to think about your scene before rushing to capture it. When you take the time to respond to your subject in a thoughtful and emotional way, you give yourself a chance to identify the one thing you find most interesting.

Here's an extra tip. When taking portraits of people or animals, be sure the eyes are in sharp focus. Whatever else is in the photo, the eyes should be the absolute sharpest part. Be brave! Ask your model to move into a new pose, or move yourself to get different versions of a shot. Often

the second or third (or fourth) pose will open up a whole new way of looking at the subject, and will result in a photo with "that special something" you hadn't expected.

Don't Get Too Close

When attempting to get a close-up portrait of my pet bird, I got too close. You can see that the items in the background below are in focus but the bird is blurry. Switching to the Macro mode, left, I moved in superclose and, even when only a couple inches away from my bird, the camera was still able to get the subject in focus. Both photos © Jim Miotke

Most cameras will not focus properly when you get too close to your subject. To ensure that this does not happen, learn your camera's closest focusing distance. This can range from just a few centimeters to a couple of yards or more. Consult your manual to find out how close you can get. Then take measures to keep this amount of space between you and your subject.

You may find that using the Macro mode on your camera does the trick and allows you to get as close as you need to be. Otherwise, you will simply have to move farther away from your subject until the camera allows you to take the picture or you are able to get a perfectly in-focus subject.

Turn Off Your Flash

Have you noticed how flash often produces an unnatural, unflattering effect? The light is flat and harsh and frequently makes people look pale and washed out. To add insult to injury, the tiny flashes built into most point-and-shoots rarely live up to our expectations. Instead, they give people and pets the red-eye (or yellow-eye, or green-eye) effect. Sometimes they delay exposure and make you miss the special moment. Other times, they trick your camera into taking an improperly exposed, dark picture.

Try turning off your flash and using natural light instead, which creates a much softer, more pleasing look. When you're taking a portrait of a person, for example, using a nice, soft natural light will capture delicate skin tones and features and will be more flattering than flash. A bright, overcast day works especially well for this. Again, never forego a photo op just because the sky is cloudy and overcast. See the opposite page for more on where to find the best natural light.

Before you press the shutter button, think twice about the effect the flash will have on your subject. If you have the slightest doubt, shoot the scene both with and without flash. This will allow you to choose your favorite photo after reviewing the results, and learn firsthand what works best.

The photo at left was shot with flash and looks harsh and unnatural. The photo above was captured with soft, warm, natural light. Both photos © Jim Miotke

Find Great Outdoor Light

Great portraits can be a breeze as long as you work with the right kind of light. Even though studio lighting equipment can be both pricey and a bit tricky, you can get started making flattering portraits as quickly as you can find a subject and get out the door.

For the best outdoor portraits on a sunny day, look for open shade. If your subject is squinting, that's a giveaway that something is not right. When you notice this squinting, or harsh shadows caused by direct light, reposition your subject so he or she is in open shade. Ideally, find a position and point of view where the background is darker or at least even toned, so it's not distracting.

Otherwise, shoot on a bright overcast day. Either way, your ideal is a soft, indirect light. Ideally you will have the sun at your back or slightly to the side, and behind something that will diffuse its harsh direct light.

Also, keep direct early morning or late evening light in mind. Not only is it great for photographing nature and landscapes, it can provide a beautiful, warm light for portraiture.

This photo on the left was captured in bright, direct sunlight and looks harsh and almost painful for the model. The second image, above, was created just a few feet away from the first, in the open shade under a large grove of trees. Note the soft, even skin tones and relaxed expression. Both photos © Jim Miotke

Keep the Sun at Your Back

Light can come from many different directions. When the light source (for example, the sun) is behind you, lighting the part of the subject you see, this is called *frontlighting*.

Frontlighting is the easiest light to work with because it provides few surprises. It's perfect for casting an even amount of illumination across your entire subject. With the sun at your back, you are less likely to experience problems such as lens flare and incorrect exposure. When you're taking a portrait, frontlighting can eliminate unwanted shadows on your subject's face and can add a nice sparkle, or catchlight, to the eyes. Just make sure the light is soft and not so bright that your subject can't help but squint and grimace.

You may want to get creative sometimes and use other types of lighting for special effects, such as a silhouette (see page 96). But more often than not, frontlighting will result in more keepers among your photographic attempts.

Sometimes shooting into the sun can lead to creative photos but generally it's safest to shoot with the sun behind you. Here is a clear examples of when keeping the sun at your back is ideal. The image works much better when I kept the sun behind me and captured the rose as it was being illuminated with frontlighting. Both photos © Jim Miotke

Find Great Indoor Light

If you want to make a photograph indoors, but want to avoid using a flash, here's the perfect solution! Place your subject just inside a door or window that leads to the outdoors, or just under an awning or porch. The indirect light can be wonderfully soft and flattering. Another benefit is that the colors may appear richer and more saturated than when shooting in direct light.

Here are some tips for shooting in indoor or window light:

- Make sure the light is indirect, rather than shining directly onto your subject. If direct beams of light are coming in through the window, diffuse them with a semi-opaque material such as thin, see-through curtains.
- Use a reflector to bounce light back into the shadows (see page 142 for more on using reflectors).
- If you are shooting from outside looking into a door or window, you can include the dark interior in the background. But if you're shooting inside, position yourself so the window or door is not in the background. Otherwise, it will appear ultra bright (blown out) or will trick your camera into underexposing the image and your subject will be too dark.

I took this photo of my son while he was standing just inside a doorway to the outdoors, where the light was indirect and diffused. Note how there is no direct light on him. Notice also the dark background of the interior, which keeps our focus on the subject. Finally, notice how his eyes are one third of the way down the composition. Placing the person's eyes in the upper third, rather than right in the middle, will make your portraits more compositionally pleasing. Photo © Jim Miotke

Prevent Red-Eye

If you do use a flash, you may find that people or pets stare back at you with glowing eyes, called *red-eye*. This problem usually happens when the lights are low and the pupils have dilated. The red-eye is, in actuality, light from the flash reflecting off the subject's retina and back into the camera.

If you can, flood the area with as much light as possible before taking your photos. This way, the eyes won't be dilated and the problem will be lessened. If this isn't an option, see if your camera has a Red-Eye reduction mode. Another solution is diffusing the light from your flash to make it less harsh, whether you use a piece of plastic or simply your own hand (see page 214). Or, better yet, if you have a portable flash that can be removed, move it farther away from the camera and point it at the ceiling, so the flash does not bounce straight back into the lens. Alternatively, remove the red-eye afterward on your computer (see page 194).

In this situation, using the Red-Eye Reduction feature on my camera actually increased the amount of red-eye, above. Sometimes it works and sometimes it doesn't work. Here I had to diffuse the light from my flash, softening it by placing a piece of plastic between my flash and the subject. As you can see in the top photo, the result looks far better. Both photos © Jim Miotke

Avoid Flash Shadows

Here is an example of what not to do when creating a portrait with the flash. My subject is much too close to the wall. When you are making portraits, remember to position your subject far enough from any solid background behind it to avoid producing the unwanted shadow seen above.
Photo © Jim Miotke

If you use a flash, you may get a heavy shadow behind your subject. To minimize this, simply move your subject farther away from the background. I would suggest keeping a minimum distance of five to six feet between a subject and the wall behind it. Another option you might consider is to soften the flash with a special diffuser (see page 214).

TIP

This is a very common problem in portraiture, and it's one reason why professional photographers like to work in large rooms with lots of space.

Avoid Flash Reflections

Another common problem with flash is reflections. Before you take a flash photo, make sure you are not facing any reflective surfaces, such as a window, mirror, or glass picture frame. These will bounce the light back into the camera and create a surprising and distracting burst of light. The easiest way to ensure that your photos don't suffer from this reflecting glare is to simply turn off the flash. Alternatively, you can work to find a different angle; simply reposition yourself so you are at an angle to the reflective surface rather than facing it head-on.

When I captured the first photo of these blue bottles at right, I forgot to turn off my flash. You can see a couple of star bursts of light reflected in the bottles. After I forced the flash off, I reshot and liked the results above better without those little unwanted highlights. Both photos © Jim Miotke

Catch the Decisive Moment

In photography we talk about capturing the "decisive moment"—in other words, catching the peak of the action, whether it's the moment a racehorse crosses the finish line, the moment your wife walks into her surprise birthday party, the moment your newborn lets out a tiny yawn, or the moment the sun bursts over the horizon. These are the shots we all want, though trying to capture them can be an exercise in frustration, especially if you are using a point-and-shoot with shutter lag. Here's an easy trick that will immediately increase your chances of catching that elusive perfect moment, no matter what camera you're using: Continuous Shooting mode.

Continuous Shooting mode is indicated on most cameras by a cascading series of frames. If you select this mode, the camera will take a series of rapid-fire images for as long as you press down on the shutter button. If you take, say, ten continuous frames, odds are one will be a winner, and you can simply delete the rest. This is a great strategy for photographing many situations: your child scoring a goal, a group photo, a baby's laugh, and so on.

This photographer, illuminated by the warm light of the sunrise, is captured here at just the right moment—when she is fully engaged in activity. In fact, she, too, is capturing just the right moment. I am capturing the decisive moment of her capturing the decisive moment of the sunrise. Photo © Jim Miotke

Overcome Shutter Lag

Don't miss the shot! When I pressed the shutter button to take the picture below of my son picking oranges in my parents' backyard, my camera delayed and did not take the picture right away. By the time the camera fired, he was already turning away. I asked him to pose again, left, and this time, I was ready! Both photos © Jim Miotke

Many point-and-shoot digital cameras do not take the picture immediately when you press the shutter button. The delay between the moment you press the button and the moment the camera actually takes the picture—called *shutter lag*—can cause you to miss the shot you want, and get frustrated in the process as well. Here are four tips to overcoming shutter lag.

- Try to anticipate the moment and then train yourself to take pictures *before* they actually happen. If your child or pet is about to run by you, for example, press the shutter button a second or two before the subject reaches optimal position.
- Prefocus your camera so the focus is set at a distance equal to what it will need to be when your subject passes. I usually focus on the ground where I anticipate the subject will be.
- Use the Continuous Shooting mode (also called the Motor Drive mode) and take lots of pictures as your subject passes. At least one of

them is likely to catch your subject at just the right moment.

- If you experience this problem persistently, the best solution is to upgrade your camera. Usually the more expensive point-and-shoot cameras, as well as any DSLR camera, do not suffer from shutter lag.

Grab a Safety Shot

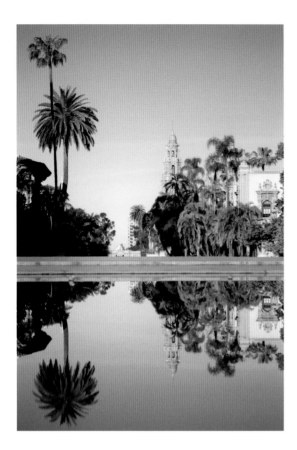

This fountain pool at left was serene and still in the early morning light at Balboa Park in San Diego. I worked quickly and made the first safety shot before I had much time to think. Just as I was about to shoot another photo, the fountains sprang to life. The calmness of the water and the reflections were gone for the rest of the day. It pays to take at least one shot before considering your creative options.
Both photos © Jim Miotke

We've already discussed the importance of taking a long look at your scene and removing clutter for a clean, simple composition. Sometimes, though, taking that extra minute can mean missing the photo altogether. If you are trying to record a particular moment, having no photo is worse than having a poorly composed one.

A good trick to avoid this is to take a quick picture before figuring out exactly how to best shoot the scene. By taking a "safety shot," you'll at least have something if things change dramatically. Especially if your subject might move at a moment's notice, don't wait until you're absolutely certain all the knobs and buttons are in their correct position. Practice getting quicker and quicker to the draw. By being quick with this first photo, you'll relieve any worries, allowing yourself to make the next shots as perfect and interesting as you can.

Trivia question:

What's missing from the safety photo? Look carefully. If you can find it, go to www.BetterPhoto.com/basics/ to enter your answer. If you're right, you'll win a cool prize.

Take Your Time

After getting one quick "safety shot" (see page 77), continue shooting as slow as molasses. Take your time and carefully construct a number of images. After you think you have taken all the pictures you need, wait around for a while. Conditions change, people walk by, and clouds blow off, letting the light hit your subject just right. You never know what the next few minutes will bring and it pays to be patient. By enjoying the view for a few moments longer, you open yourself up to a whole new realm of photographic opportunities.

TIP

When I spend time with my family in Carmel, California, we are often treated to some of the most beautiful sunsets I've ever seen. And we're not the only ones; numerous people come long distances to enjoy the sunset here. However, once they've captured a few shots, far too many people pack up and leave right after the sun dips below the horizon. If this sounds familiar and you're realizing that you too leave right away, I recommend that you wait around instead for 15-30 minutes, and you might be rewarded with a spectacular "encore" performance. You'll either get the most pleasing periwinkle twilight sky or maybe even watch an amazing afterglow paint the sky in brilliant colors. Just lingering around a bit often pays off.

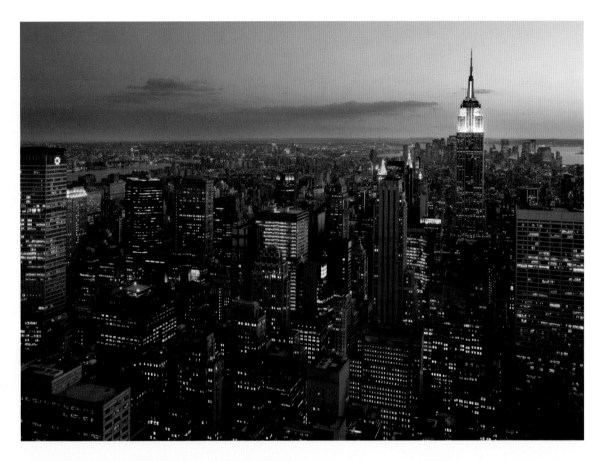

The sun had just set and I wanted an image of Manhattan with the colorful sky in the background. Unfortunately, my image opposite had an overly dark foreground, but after waiting around and shooting more, I was treated to a much more enchanting view of the city, above. The lights started to twinkle and the city came to life with a warm glow. Had I not waited, I would have missed the best shot of the night. Both photos © Jim Miotke

Work the Subject

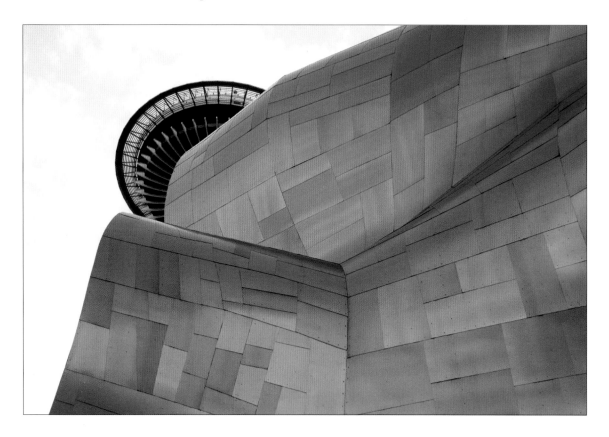

Getting as many pictures as you can doesn't mean taking lots of pictures that look exactly the same. Instead, make the most of each moment while it is happening, using a variety of techniques, angles, and positions. This is called *working the subject*.

The key is to make many different images while you are at the scene. Don't worry about the time it takes to get the variety of photos you need. The law of numbers demands that you take as many pictures as you can. If you get eight or ten good shots out of every hundred, congratulate yourself! Even the pros have to shoot numerous images to get satisfying photos. You'll never have another chance to shoot this exact subject at this exact moment, so why not make the most of it?

You've probably seen many pictures of Seattle's Space Needle, all with the same standard view; I wanted to try something different. This photograph shows the Experience Music Project with the Needle just peeking out from behind it. Photo © Jim Miotke

Photograph in Any Weather

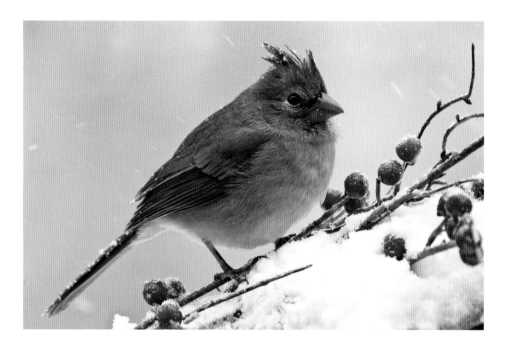

The trick to photographing in bad weather is to accept that there is no such thing as bad weather! Instead of allowing weather to prevent you from taking great pictures, work with it. It's all about flexibility and timing, getting yourself into position so you can click the shutter at exactly the right moment and use the challenging conditions to your advantage.

Pros never let slight changes in the weather stop them from taking great photos. In fact, many of the best photographers actively seek out dramatic weather conditions to add extra excitement to their photographs. The rewards can include surprises like dramatic light breaking through the clouds, a colorful rainbow, or a mood-enhancing fog. Rain can make reflections everywhere you look. Fog can transform typical scenes into enchanted, mystical moments. And an ice storm or heavy snow can cover everyday clutter in a winter wonderland of whiteness.

Larry Holder took this photo from inside his patio on a winter day, with heavy snow falling and an overcast sky providing soft, diffused lighting. Larry scattered birdseed and sat patiently with the door cracked open, waiting for the right shot.
Photo © Larry W. Holder

TIP

Your batteries will drain more quickly when they are used in very cold conditions. Bring extra batteries when it's cold and keep them in an inner pocket, close to your body.

Photograph in Fog

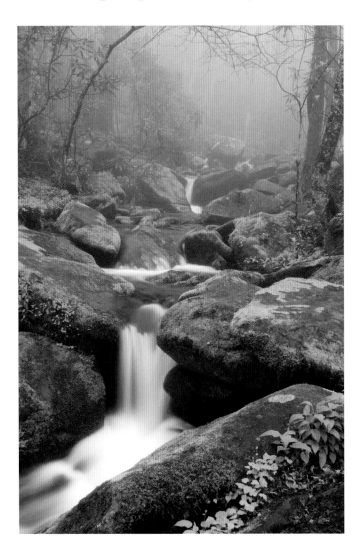

In the Great Smoky Mountains National Park, the atmosphere created by the foggy conditions added so much to the mystical appeal of this forest stream. To create this shot on my DSLR, I used a polarizing filter (for more on filters see page 180) and a 4-second exposure to create the silky, "cotton candy" effect in the flowing water. Minutes after I made this exposure, a sudden rain beat that fog into oblivion. It was a good thing I quickly captured this "safety shot" before the fog disappeared. Photo © Jim Miotke

Photographing in fog is a very low-contrast situation, so you will not need to worry about exposure or extreme tonal ranges (see page 180). Colors will appear more subdued (so don't go out looking for bright, bold colors). Instead, make the most of fog by working to capture what it's best known for: mood and atmosphere. Look for a great variety in the distances of various objects to your camera. When you find such a scene, get close to an especially interesting foreground element, making sure it's close enough to be clearly discerned through the fog. In a scene with this kind of depth, this close object will stand out and the other objects will seem to disappear into the distance. This can create a wonderful effect when photographing patterns, lines, and perspective. Truth be told, you almost can't go wrong in fog. The soft, mystical background can complement many subjects and create a unique, magical look that is rarely seen in photography.

Photograph in Rain

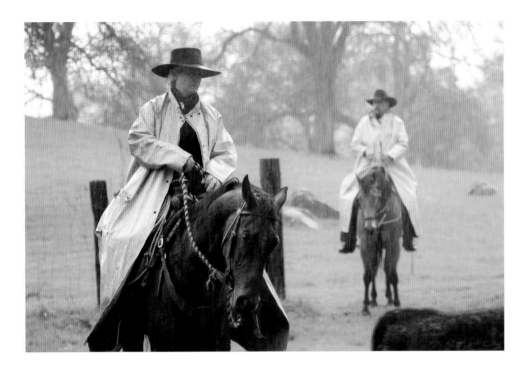

Keeping your camera from getting wet is generally a good idea. When shooting in misty conditions, wrap your camera in rain gear of some kind (I use a shower cap). When you are ready to take a picture, remove the plastic protection, shoot the photo, and put the cover back on. Caveat from my lawyers: by getting your camera wet, you risk ruining your equipment. Forego activity that will likely result in wet equipment if you are concerned about damaging your camera.

If you don't want to put your camera in danger to get great all-weather photos, here are a few more options:

- Buy a waterproof camera;
- Keep yourself in a protected place while shooting such scenes; or
- Get a protective case designed especially for your camera.

One day when I was photographing ranchers, the weather turned and a torrential rain pounded down. With a plastic bag as protective gear for me and my camera, I continued to shoot, knowing the wet weather would tell a side of the rancher's story that is rarely documented, giving the viewer a sense of the harsh elements experienced by those who choose this way of life. Photo © Jim Miotke

Shoot a Lot!

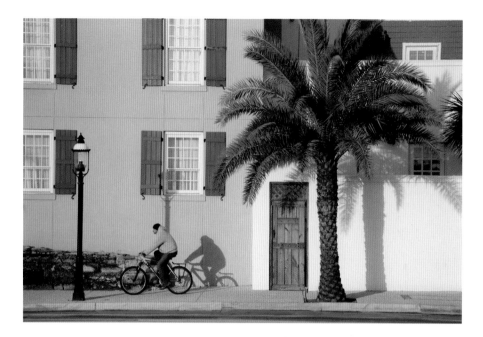

Every moment is an opportunity. If your daughter is getting her ears pierced, take the camera. Taking the dog for a walk down to the park? Bring your camera! You never can tell what scenes will present themselves until they unfold before your eyes. Don't let anything—inconvenience, embarrassment, plain old forgetfulness—stop you from bringing your camera everywhere you go.

Equally important, don't stop with just one shot—take as many as you can! Digital photography has freed us to shoot as many pictures as our memory card can hold and delete unwanted ones after the fact, for zero extra cost. As much as you might think pro photographers take only a few shots, they take many. They are simply selective when editing their work and show only their best photos. The more photos you take, the more likely you will be to get a few flat-out fabulous ones.

I was drawn to this beautiful scene in Saint Augustine, Florida, so I spent a half hour or so shooting it in different orientations and compositions, above. When this man rode by, top, I liked the human element, as well as the interesting shadow he cast on the wall. I would not have captured this second photo at all if I had just taken one quick shot and moved on. Both photos © Jim Miotke

Edit Your Images

Professional photographers don't just walk up to a scene, take one picture, and walk away. We shoot a large variety of "interpretations" to make sure we end up with at least one winning photo. The downside is that we have to weed through the resulting photos to select only the best. In the photo below, the main subject is blurry; both his hand and, more important, his eyes are unacceptably soft. This would be a photo I would discard. Luckily I had a follow-up shot that succeeded quite well. Both photos © Jim Miotke

It is true that to get great photos you have to take a ton of pictures. But if you take a plethora of pictures and leave it at that, you will be looking at many, many rejects and only a few winners. That's why the second stage, selecting the best of your photos, is so important.

After you've finished taking photos for the day, go through your shots and delete the bad ones—the totally blurry ones, the too-dark photos, and the really, really boring ones. Next, go through the remaining photos and pull out any mediocre ones. Try to be as objective as you can. If you find yourself thinking, "I almost had it with this shot," that means it's not quite good enough. Put these aside in a folder labeled "Mediocre" (or whatever). Finally, go through the remaining photos a third time, this time setting aside any that are only personally interesting to you. Put these into a folder named "Personal." Finally, after deleting the bad ones and setting aside the mediocre and personal ones, you should be left with only the real winners, the crème de la crème.

As difficult as this process is, it will do more for your image as a photographer than any other. As cute as your bouncing baby boy may be, most people do not need (or want) to see all of your photos—one or two great shots will do the trick. When you show only your best photos, your viewers will think you're a genius!

STEP 3:
Twenty Popular Photo Assignments

Now that you've learned the basics as well as a few tricks of the trade, it's time to treat yourself to a fun photo outing or two! Photography is a practical art. Even if we discussed it for days and days, you would not improve as much as you would by simply getting out there and taking pictures yourself.

By itself, though, "trial and error" learning can be frustrating and expensive. So we will focus our efforts on shooting a set of popular and practical assignments. These projects can be done with almost any camera, whether simple or sophisticated. Each project starts with an overview of the settings for use with either a point-and-shoot (P&S) or Digital SLR (DSLR) and a list of items you will need in addition to your camera.

Many point-and-shoot cameras allow you to control advanced creative settings, and many DSLRs allow you to shoot in an automatic "point-and-shoot" mode. So use the suggested settings as approximate guidelines and choose the shooting category that is most appropriate to your current skill level and camera.

So without further ado, let's get out there and start taking great pictures!

BetterPhoto instructor Lewis Kemper did not need to spend weeks tracking these beautiful animals in Alaska or the Sierra-Nevada Mountains. He was able to get these and many equally beautiful photos by engaging the services of a game farm designed especially to serve the needs of photographers. Using their services, Lewis was able to capture wildlife portraits in a natural, believable setting, without spending his entire winter out in the wild and without impacting the animals' home environment. Photo © Lewis Kemper

Photograph a Flower Close-up

For this image, I arranged some store-bought flowers in a vase and placed them in the open shade in a parking lot. Using a macro lens or mode, you will be able to get close enough to flowers and other small objects to entirely fill the frame with your subject.
Photo © Jim Miotke

TIP

To increase your odds of getting sharp flower photos, use a good tripod. I recommend using a tripod that lets you get very close to the ground. If you have one, you may need to remove the central column of your tripod in order to get extra low.

WHAT YOU'LL NEED

- Flower

SETTINGS

P&S: Macro mode 🌷, turn flash off

DSLR: Macro lens or extension tubes, Aperture Priority with small aperture (large *f*-stop number), turn flash off, low ISO

Making photos of beautiful flowers can be an inspiring exercise and result in gorgeous images to hang around the house, upload to an online photo-sharing site, or give to friends and family.

1. Search for the perfect flower.

2. Set up your flower in open shade or some place like a front porch or open garage.

3. Set your camera into the Macro mode or use a macro lens. Then experiment to find out how close your camera allows you to get to your subject before it loses the ability to focus clearly. If the camera cannot focus and will not shoot, you may be too close.

4. Stand above the flower and take a few pictures at various angles. Then get as low as you can to the ground—crouch down, or better yet, lie down and look up at the flower. Move around and look through your viewfinder from various positions. Watch how each change affects the look of your flower and whatever is in the background. Compose your picture so there is an even, nondistracting background. Each time you find an interesting composition, take a picture.

5. Be sure to focus on the flower, locking your auto-focus and then recomposing if you want to place the subject off-center.

6. Afterward, study the photos. Which shows off your subject best? Which makes it look most impressive? Which one pops off the page? You may find that the photos shot from extremely low angles have the most impact.

NATURE IDEAS

Capture a Scenic Landscape

Fran Saunders discovered this abandoned house a few miles from her home in Worcester County, Maryland, and photographed it over a long period of time, in a variety of seasons and from all viewpoints. She has hundreds of photos from this location but this particular one has always been her favorite. Photo © Fran Saunders

TIP

Take a few pictures of a view that is partially in the sun and partially in the shade. Then take a few more with the entire scene in shade. Finally, shoot again, including only things in direct sunlight. When you compare the results, you will see how extremes in contrast translate poorly. Either the shady area will be too dark or the highlights too bright. See page 143 for more on avoiding extremes in tone.

WHAT YOU'LL NEED

- Tripod or firm surface to steady your camera

SETTINGS

P&S: Landscape mode 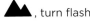 , turn flash off, low ISO

DSLR: Aperture Priority mode with small aperture (large *f*-stop number), turn flash off, low ISO

Let's head out now into nature, to the coast, or to a nearby city to capture a prize-winning landscape photograph.

1. Pick a location that you would like to photograph. If you live near a national park (lucky you!), then head in that direction. Large cities make good material for urban dwellers. Photographers who can get to the coast might prefer to focus on the sea. Don't worry if you don't live anywhere near a park, city, or sea—you can make great landscapes almost anywhere. Look for mountains, valleys, lakes, streams, forests, barns, bridges, cityscapes, seascapes, and so on.

2. Study the light. If you can get to your chosen place in the early morning before sunrise, do so. The best times to shoot are generally from a half hour before sunrise to a few hours after sunrise, and again in the late afternoon around the time the sun sets.

3. If your camera allows you to change it, select a low ISO, such as 100.

4. Attach your camera to a tripod or set it on something firm.

5. Compose your scene, paying attention to graphic elements such as lines, shapes, and forms. Look for interesting shadows and reflections. Try to make all elements lead the eye in a satisfying way through the image. If you are drawn to a particular tree or barn on the horizon, for example, position yourself so a road or other line leads to that subject.

Be Inspired by Nature Around You

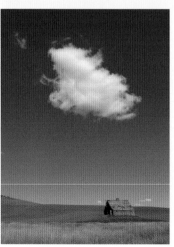

Wonderful nature pictures can be found just outside your door, in your own neighborhood. This photo, left, of the barn was captured in some farmlands near my home. For the image above, I turned on the self-timer, placed my camera in a field of grass, and backed away before the camera fired. I had to make several exposures to get one winner but, as you can see, you can get fun nature photos almost anywhere. You just have to look with an open heart and a willingness to sometimes work hard. Both photos © Jim Miotke

WHAT YOU'LL NEED

- A comfortable pair of shoes
- A notepad and a pen or pencil

SETTINGS

P&S: Landscape mode ▲▲ , turn flash off, low ISO

DSLR: Aperture Priority mode generally with small aperture (large *f*-stop number– but when everything is far off in the distance, it's okay to use a smaller *f*-stop number), turn flash off, low ISO

Finding subjects to photograph is not as hard as you think. Inertia and apathy might tempt you to stay at home, twiddling your thumbs and thinking, "There just isn't anything interesting to shoot." But as soon as you get out the door, you will be rewarded with wonderful pictures that you could not possibly have planned while sitting at home.

1. Grab your camera and head outside for a walk in a nearby wilderness, park, or rural area.

2. If using automatic settings, choose the Landscape mode. If using a more advanced camera that allows you to control things like aperture, choose a large *f*-stop number. As this will likely result in a slower shutter speed, be sure to securely mount your camera on a tripod.

3. Look for interesting trees, mountains, plants, wildflowers, wildlife, and so on. Each time you see a potential shot, take a picture. Don't think; just shoot.

4. If you get stumped, take a picture that documents your walk. Tell a story about your adventure through pictures. Try to capture every interesting detail.

5. If you encounter animals or people on your walk, be sure to include them in your photographic collection.

6. After each shot, jot down important points you would like to remember. By taking notes and reviewing them with your photos later, you will remember important details about the things you shoot. Write down things like:
 - Your intentions. You'd be surprised how often you forget what you were trying to achieve, unless you write it down.
 - Names of places, people, plants, animals, or any other subjects. Writing down these details on the spot is easier than looking them up later. Tip: if you see signs with these details, snap a picture of the sign for future reference.
 - From time to time, make a note of the photo number you are on, to use as a point of reference later.

NATURE IDEAS

Capture Reflections

Marilyn Cornwell captured this waterlily at Longwood Gardens in Pennsylvania, composing her photo to include the gorgeous wavy reflection. Photo © Marilyn Cornwell

TIP

When photographing colorful reflections, the trick is to find a subject bathed in direct sunlight that is being reflected into shady water. If the water is calm, that's even better. But don't pass up a colorful reflection just because the water is agitated. Ripples that bend and distort the color can add to the abstract beauty of your image.

WHAT YOU'LL NEED

- A colorful subject reflected in a body of water

SETTINGS

P&S: Landscape mode ⛰ , turn flash off, low ISO

DSLR: Aperture Priority mode with medium aperture (medium *f*-stop number), turn flash off, low ISO

I love photographing reflections because they offer abundant opportunity for creating fascinating, beautiful, and sometimes surprising abstract images. For strong, abstract reflections of color, the formula is simple.

1. Shoot in the early morning hours to increase your chances of getting mirror-like calm waters for your reflection.

2. Look for a colorful subject near water that is *front-lit*, with the sun illuminating it directly, though the reflection in the water should ideally be in the shade. For example, if you were photographing fall foliage, look for a place where the trees and leaves are receiving direct light, but the water they're reflected in is in the shade. A situation like this increases the intensity of color in the reflection and provides excellent opportunities for abstract photos.

3. Include the source of the reflection—the literal object and its mirror image, as in the water lily photo opposite—or tighten your composition to include nothing but the reflection.

4. Playfully experiment and review the resulting images, both while you're shooting and long after the fact.

Capture a Spectacular Sunset

I was delighted with my first image of the sunset, shown at left, and could have packed it in and gone home. But as I lingered, I noticed this amazing cypress tree, above. I created a silhouette with the beautiful tree in the foreground, adding depth as well as framing. Both photos © Jim Miotke

Have you ever photographed a beautiful sunset, only to be frustrated with photos that don't come close to capturing its beauty? Don't worry . . . we all have. Here's a trick the pros use to make their sunset photos stand out: include an interesting foreground object as a silhouette. This can result in a truly stunning sunset photo. Plus, once you learn how to do silhouettes, you can make them in all kinds of settings! Here's what to do:

1. Choose a pretty location and wait for sunset. While you're waiting, set your camera securely on your tripod.

2. Find an interesting shape in the foreground. Choose a simple shape that adds meaning to the scene, such as a shapely tree, a statue, a boat in the harbor, a cactus, or another recognizable shape. If you're using a point-and-shoot, set it into the Landscape mode.

3. Temporarily fill the viewfinder with the sky (being careful to avoid both the brightest part—the sun—and the darkest part) and press your shutter button down halfway to "lock" the exposure. If you have an advanced camera, set the exposure compensation feature to a –2 setting. Your camera may have a dedicated "exposure lock" button that you can also use, or you can note the settings, go into the "M" manual mode, and dial in the numbers.

4. Recompose with your foreground object in the composition, and press down the rest of the way to take the shot. This will result in a nice silhouette where the foreground object is rendered a rich, deep black.

5. Don't leave when the sun goes down. Wait for the "post-sunset show"—if conditions are just right, you'll be treated to a beautiful alpine glow in the sky and/or a gorgeous periwinkle twilight.

NATURE IDEAS

Celebrate the Seasons

Beverly Burke was shooting images at a lake near her home when she noticed the autumn tree colors reflected in the water. Her image captures the beautiful colors in an abstract, unusual way. Photo © Beverly Burke

WHAT YOU'LL NEED

- Time
- A natural location

SETTINGS

P&S: Landscape mode ⛰ , turn flash off, low ISO

DSLR: Aperture Priority mode with small aperture (large *f*-stop number), turn flash off, low ISO

Your goal here is a sequence of images showing the changing of the seasons. This is a challenging assignment that requires great organizational skills. Upload the sequence to BetterPhoto.com and e-mail me when you're done . . . I would love to see your results.

1. Select a place close to home that will change with the seasons, such as a local park, a special tree in your neighborhood, a field, mountains, and so on.

2. Walk around your subject, looking at it from several different angles until you find the composition you like most. In this situation, you will probably want a serene, peaceful composition. Think horizontal, with soft curving lines and no diagonals.

3. Set your camera securely on a tripod. Make a note of your exact location—you'll want to be able to find the exact same viewpoint months later. Take measures to make it as easy as you can to find the same spot again.

4. Use the Landscape mode or, if you can set aperture, choose a large *f*-stop number.

5. Make several photos of your scene. When you review the results from your first shoot, select your favorite composition. Carefully note your location, point of view, and other technical details of how you got the shot. Come back at least once every season, returning to the same place again and again. Aim to replicate the composition of your original favorite photo, referring to your technical notes and/or the original photo.

Take a Portrait Outdoors

TIP

To minimize blinking eyes, ask your subjects to close their eyes while you get ready. Once you're ready, have them open their eyes just before you take the picture.

Stacey Bates captured this charming family portrait on the beach in Perdido Key, Florida. She was trying to pose her sons in a more formal arrangement, but captured this moment right after the youngest jumped on the other two, which got them laughing and giggling.
Photo © Stacey A. Bates

WHAT YOU'LL NEED

- One or more willing subjects

SETTINGS

P&S: Portrait mode 🙂, turn flash off (or on—see below)

DSLR: Aperture Priority mode with medium aperture (medium *f*-stop number), turn flash off, low ISO

You will be amazed at how easy it is to make beautiful portraits of your friends and family outside. Here's what to do.

1. Plan your portrait session to occur late in the day. An hour or so before sunset, the light can get golden and very complementary for portraiture. A good alternative is midday in bright overcast conditions.

2. Set up your location before getting any of your models involved. Look for a simple, non-distracting background in even, indirect light, such as open shade. Be sure to avoid dappled and direct sunlight.

3. Turn off your flash. There is one exception: if you want to add a tiny bit of light in the eyes (a catchlight), you may want to use your flash in combination with natural light.

4. If you're using a point-and-shoot, select the Portrait mode. If you're using a DSLR, use Aperture Priority mode and select a small *f*-stop number such as *f*/8.

5. Once you're ready, invite your models to come and arrange themselves. If you're photographing a group, make sure everyone is close to each other and nobody is getting blocked. Arranging the taller people in the back will help. Consider positioning your subject(s) off-center for a nice environmental portrait.

6. Help your subject(s) feel comfortable. If humor comes naturally to you, use it to make people feel more at home. Telling them they look great can be more effective than endlessly shuffling them for a perfect composition.

7. Scan the scene for any distracting details. Are there any stray hairs in your subjects' faces? Check to make sure everyone is looking at the camera.

8. Make absolutely sure you're focusing on the eyes. Once you have your focus sharp, you can turn off your autofocus (if your camera lets you). This will keep the camera from trying to get the focus sharp as you shoot. Just remember to turn your focus back on when you're done or if the distance changes between you and your subject.

9. Put your finger on the shutter button, talking casually and genuinely while you wait for the perfect moment, when your subject looks relaxed and natural.

10. Shoot as many pictures as there are people in the photo—up to 7 to 10 photos. (You might consider using continuous shooting mode here to maximize your chances of capturing the perfect shot.) This is the best way to overcome the fact that you won't be able to predict when people blink, yawn, make a strange face, or look off in the wrong direction.

11. And just when you think you are done, shoot one more.

PORTRAIT IDEAS

Take a Portrait Indoors

WHAT YOU'LL NEED

- A willing subject
- A bright area near a window or door, or a household lamp
- White or black paper or fabric

SETTINGS

P&S: Portrait mode, turn flash off

DSLR: Aperture Priority with large aperture (small *f*-stop number), turn flash off or use external flash and direct it toward the ceiling, low ISO

TIP

If your subject wears eyeglasses, tilt the glasses so they are at a slight angle. This prevents them from reflecting light directly back to your lens and should reduce or eliminate glare. Alternatively, arrange your lights so they are not reflecting.

This portrait of Endre Balogh's ninety-three year-old father captures his personality and expression in a natural, beautiful way. Endre positioned his dad near a door in his living room that opened to the outside but was not getting direct light. He hung a piece of black fabric for a background, and placed a floor lamp with 60-watt bulbs to his right. Using nothing more than indirect natural light, a black background, and a small secondary light to fill in the shadows, Endre created a charming portrait of a happy and proud father. Photo © Endre Balogh

Here's the trick to getting wonderful, natural portraits when shooting indoors: use window light.

1. In midday or afternoon, find an area inside a door or window that is relatively bright. Avoid shooting where direct light is streaming through; find an opening that is letting only indirect light bounce into the room. Shooting just inside a garage (with the door open) might also work well.

2. Tape up a large piece of black or white paper or fabric to create a backdrop, making sure there are at least two feet between the backdrop and where your subject will stand.

3. Set up a source of secondary light to fill in the shadows on the side of the face opposite the window or door. You don't need to get fancy; a simple house lamp will do. Or, try using a reflector (see page 142).

4. Select Portrait mode on a point-and-shoot, or Aperture Priority and a small *f*-stop number on a DSLR. For both, turn your flash off.

5. Position your subject.

6. Experiment with different looks by changing the light. Dramatic directional light intensifies a subject's weathered features. Soft, even light allows warm skin tones to come through, hides wrinkles, and gives your subject a bit of glow. Light is your primary instrument; think of how you will photograph your subject only after you figure out the best light.

Take a Picture of Your Pet

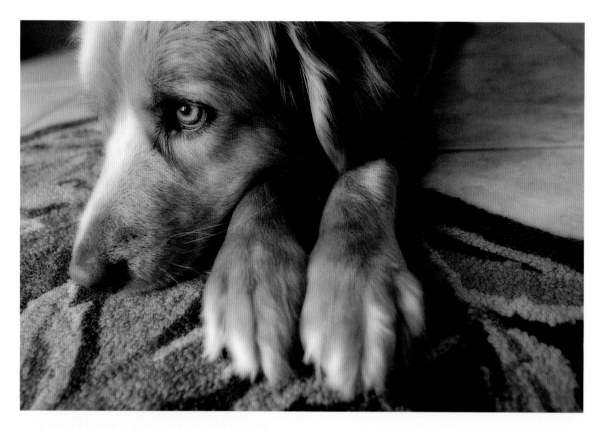

Susan Patton's dog, Henna, loves to lie on the floor looking out the front door. For this shot, Susan lay on her stomach with the camera supported on her left arm, centered the frame on Henna's eye, locked the autofocus, and recomposed, leaving the eye the sharpest part of the photo. Photo © Susan Patton

WHAT YOU'LL NEED

- Friend
- Pocketful of pet treats
- Tripod (optional)
- Oh yeah . . . and a pet

SETTINGS

P&S: If you have a very active pet, use the Sports mode 🏃 , or Kids and Pets mode 👧 . If not, use the Portrait mode 👤 , turn flash on (for a bit of catchlight in the eyes)

DSLR: If your pet is active, use Shutter Speed Priority with a fast shutter speed. If not, use Aperture Priority with a large aperture (small *f*-stop number)

Taking a picture of your pet is a fun, albeit challenging, project—especially if your pet doesn't want its photo taken. Unless Fido is a tortoise, he will tend to be very active, and you'll need an infinite amount of patience, the ability to juggle many things at once, and the ability to grab—and hold—your pet's attention. Here's how to maximize your chances for success.

1. Put a supply of pet treats in your friend's (aka, your assistant's) pocket. Put some in our own pocket, too (for the pet . . . not for you, silly).

2. Set up a makeshift portrait studio. This can be a picnic table at the park, a bench in your backyard, or a spot near a window.

3. Make sure the background is simple and does not distract from your pet. If it's too busy, place the pet (or reposition yourself) so the background is least distracting.

4. Set up your camera on a tripod, or rest it on something firm.

5. If you're using a point-and-shoot, select the Sports or Portrait mode, depending upon just how hyper Heidi is. On a DSLR, choose Aperture Priority and a small *f*-stop number to selectively focus on the pet. As long as conditions are fairly bright and you are a good distance away from your subject, turn your flash on. If done right, the resulting catchlight in the eyes will add a nice touch of life to your portrait.

6. Place your pet in position and ask your friend to pet it and divert its attention while you finalize setting up the shot.

7. When you are ready, do whatever works to direct your pet's attention back at the camera. This is a balancing act—getting the pet to look at you briefly without coming over for a visit. Work in tandem with your friend to keep juggling the pet's attention between the camera and your friend.

PORTRAIT IDEAS

Shoot Candid Photos

Janice Lococq invited a friend and his children to her pool one day, and captured this candid moment of love-at-first-sight between one of the girls and Janice's pet Airedale, Scout. Photo © Janice M. Lococq

WHAT YOU'LL NEED

- A quiet camera with zoom or tele-photo focal length possibilities

SETTINGS

P&S: Sports or Kids mode, turn flash off, higher ISO, continuous mode

DSLR: Aperture Priority mode with large aperture (small *f*-stop number), turn flash off, low ISO

A great candid requires more than simply snapping a shot of the subject when they are not looking. Such photos often look like nothing more than a "miss"—a time when the moment passed before you could capture it. To get successful candids, you still need to capture the person's expression and balance all elements so the image tells a story and charms the viewer.

Candid photos look less formal and staged than your usual portraits. If you have kids, try it out on them and their friends. However, almost any public place will offer a number of subjects. All it takes is the nerve to photograph them.

1. To help increase your chances of getting sharp photos, set your camera to a relatively fast ISO—400 or 800 might be ideal if you're using a compact point-and-shoot camera. If you're using a DSLR, you may be able to go higher (such as ISO 1600) without your image suffering from too much noise. Higher ISOs will allow your camera to use faster shutter speeds.

2. Select Sports mode on a point-and-shoot if you are photographing moving subjects or Portrait mode if they are still. On a DSLR, use Aperture Priority and a small *f*-stop number. For both, use continuous mode to increase your chances of getting a good shot.

3. Decide on a subject. Two or more people interacting can provide fascinating character studies. Individuals may also give you good material to shoot.

4. If you will be stuck in a stationary place for some time, such as in a restaurant, pretend to be fiddling around with your camera, trying to figure out how it works. Resist the urge to hold it up to your eye. Instead, hold it on the table or at waist level and do your best to aim it at your target.

5. If you can move around, take only a few shots of any one subject. Then move along before attracting too much attention.

6. If you think you may have gotten a great shot of a stranger, approach and ask him or her for permission. Take the person's picture again in a more formal pose, get his or her name and address, and offer to send your subject a copy. Remember to do unto others as you would have them do unto you. Respect individual privacy and be especially considerate of cultural attitudes toward having one's picture taken.

PORTRAIT IDEAS

Capture Pictures of Animals at the Zoo

Although taken at the Lincoln Park Zoo in Chicago, there is nothing in this photo that hints it was taken at a zoo. John Forrant captured a tight profile while leaving a bit of additional space to the left of the lioness's face. Photo © John Forrant

Aquariums and zoos are great places to go when you are in need of a subject. Everywhere you look you will find an inspiring scene, subject, or object to photograph.

1. Get thee to a zoo or aquarium. Animals are usually more active in early morning and late evening, often sleeping during midday hours. An active, alert animal is much more interesting than one that is napping. Keep this in mind, and try to time your visit accordingly.

2. If you're using a point-and-shoot and the animals are active, select the Sports mode. If you're using a DSLR, select Shutter Speed Priority and use a fast shutter speed of 1/250th or faster. If you can only control aperture, choose a small f-stop number and consider increasing the ISO number. These steps will result in a faster shutter speed and help you get sharp photos. If the animal is still, use Portrait mode on your point-and-shoot, or use Aperture Priority with a large aperture (small f-stop) on your DSLR.

3. Be careful to exclude anything that does not contribute to the overall picture. This doesn't mean you are limited to only shooting tight headshots; often the surrounding environment plays an important supporting role. For instance, including the bamboo forest behind the panda may give it additional meaning and a sense of place. When the environment adds to the overall value of the photo, be sure to include it. If it doesn't, move in tight on your subject and fill the frame with it.

4. Always keep your camera ready. You never know when a moment will happen between a cub and her mom, for example.

5. When photographing through glass at an aquarium, turn off your flash and keep your lens parallel to the surface of the glass. You may find that placing your lens very close to the glass, or using an accessory called a rubber lens hood, will help minimize glare.

ANIMAL AND WILDLIFE IDEAS

Go Hunting, the Humane Way

Laurie Shupp was looking for reflections in the water that harmonized with the beautiful colors of the duck's beak and feathers. Early in the morning, water yields wonderful colors and the patterns are soft and flowing. Once the sun starts rising higher in the sky, colors become more muted and dull. With wildlife, birds, and countless other subjects, it really does pay to shoot in the early morning hours.
Photo © Laurie Shupp

WHAT YOU'LL NEED

- A camera with zoom or telephoto focal length possibilities
- Ducks, squirrels, chipmunks, or other similar animals

SETTINGS

P&S: As telephoto as you can go, without using digital zoom, Sports mode 🏃, turn flash off (unless the animal is about 7 to 10 feet away)

DSLR: Aperture Priority mode with large aperture (small *f*-stop number), turn flash off, low ISO, telephoto lens

This project provides a fun and friendly way to enjoy the thrill of the hunt. Best of all, because the subjects are somewhat tame, the level of difficulty is not as high as for truly wild wildlife.

1. Get a camera with as much of a telephoto as you can get. If this is not an option, be prepared to face the challenge of quietly approaching subjects and getting as close as possible before being noticed.

2. Find a spot where squirrels, chipmunks, and similar beasts congregate. Parks and backyards are often a good bet.

3. Camouflage yourself as much as you can, hiding behind foliage or something else for some time before getting an opportunity to shoot.

4. If you do not have a tripod, stabilize your camera by resting your elbows on the ground or on another solid surface. You have to be especially careful about camera shake when your zoom/focal length is extended to an extreme telephoto setting.

5. When you finally do get an animal in your sights, shoot both horizontal and vertical images, moving in closer as you shoot.

6. Try to capture the most interesting moments, such as when the animal is at full alert or eating. You might also enjoy shooting the animals in their native environment or interacting with one another.

Get Close to Bugs

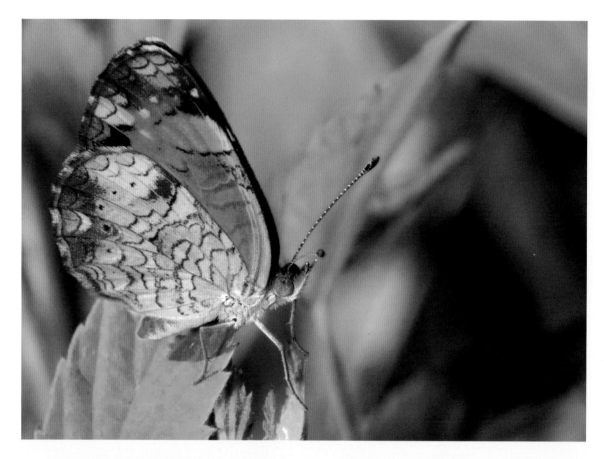

Emily Cook placed this butterfly off-center for a pleasing composition, but kept the most important part of the photo (its head and eyes) in sharp focus. Photo © Emily R. Cook

Just look at how this spider, photographed by Better-Photo instructor Rob Sheppard, jumps out at you. You can't help but have some kind of emotional reaction! Notice how Rob got in close and filled the frame with his subject. Photo © Rob Sheppard

WHAT YOU'LL NEED

- A camera with Macro mode or a macro lens

SETTINGS

P&S: Macro mode 🌷, turn flash off

DSLR: Aperture Priority mode with small aperture (large *f*-stop number), turn flash off, low ISO (unless the bug is moving . . . then you may need to use a smaller *f*-stop number, increase your ISO, or both), macro lens or extension tubes

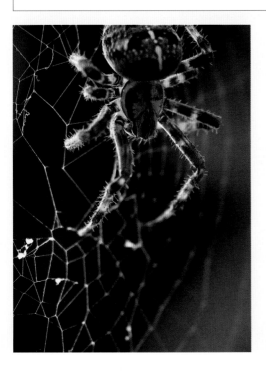

Creepy crawlers can be great fun to photograph. Let's explore nearby fields, grasses, bushes, and woods to find and photograph these tiny critters.

1. Go out on a bug hunt. If you don't like butterflies, beetles, or bees, choose any small object you like, such as flowers, stamps, coins, or even jewelry.

2. If you are using a point-and-shoot, select Macro mode. On a DSLR, use a macro lens or extension tubes so you can get especially close to your little subjects.

3. Make sure you are not getting closer to your subject than your focusing mechanism will allow. Some cameras will show a blurry view through the viewfinder or LCD when this problem occurs. Others will warn you with a blinking "focus ready" light.

4. Point-and-shoot users: Use the LCD screen instead of the optical viewfinder to accurately aim and capture your subject. If you get close to your subject while using the optical viewfinder, you may miss the subject and capture a slightly different scene, even when you feel like you're aiming right at it. If you see lines near the top and left or your viewfinder, you may need to realign your composition to those marks. You need not worry about this problem if you're using a DSLR.

5. Once you are relatively confident that you are within the focus range and are getting the correct view of the scene, take a picture. Shoot several, especially if the breeze is strong. Wind can cause your bug or flower to blur. Take a number of photos to maximize the likelihood of getting a winner.

ANIMAL AND WILDLIFE IDEAS

Photograph Birds and Other Small Animals

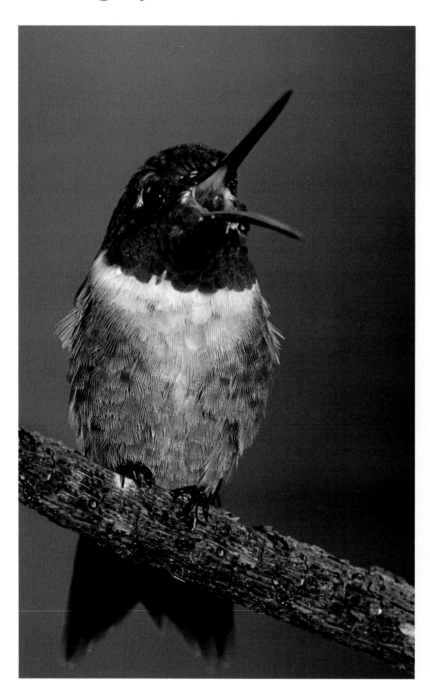

Robert Clark exercised a great deal of patience to get this image of a ruby-throated hummingbird.
Photo © Robert L. Clark

- A camera with a powerful zoom or telephoto focal length capabilities

SETTINGS

P&S: As telephoto as your lens can go, Sports 🏃 mode, turn flash on (unless the bird is further than 10 feet away)

DSLR: Aperture Priority mode with large aperture (small *f*-stop number), turn flash on, low ISO, super-telephoto lens

Photographing birds combines a variety of challenges and corresponding thrills. This form of bird watching can be exhilarating and result in many fun photos.

1. Choose the appropriate lens or focal length. If using a point-and-shoot camera, you'll find your job much easier with a 10X zoom—something that gets you into the focal length of 300mm or more. If using a DSLR camera, I often use a 400mm lens and sometimes use a 2X tele-extender to double the focal length. Less light gets through to the sensor when I use such a tele-extender but it helps me get closer to these small subjects.

2. Especially if you do not have such a strong telephoto, set up a bird feeder, a bird bath, or a bird house just outside an office or living room window, to attract the subjects closer to you. Place your camera and tripod near the window and conceal yourself to minimize the possibility of frightening your subjects away.

3. Whether you use a super-telephoto lens to get close to them, an attraction to let them get close to you, or a combination of the two, photographing birds and other small animals requires a great deal of patience. Hang in there and persevere until you get the opportunity to shoot. It will be worth the wait.

ANIMAL AND WILDLIFE IDEAS

Use Details to Tell the Story

- A camera with a telephoto focal length, or a Macro mode or macro lens

SETTINGS

P&S: As telephoto as you can go, Portrait mode 🖤 , turn flash off

DSLR: Aperture Priority mode with large aperture (small *f*-stop number) if you can, turn flash off, high ISO

Ernest Pile was taking random car photos at an outdoor auto club show at the end of a very long, hot summer day. Nothing seemed particularly interesting until, in a far corner of the parking lot, he noticed a deep red car with twin hood flaps, one of which was open to show the engine, and an unusual hood ornament and grill crest—all glowing in the late-afternoon light. He got in close, filled the frame, and looked for interesting angles, letting his eyes follow the lines. With this one detail, he successfully conveyed the beauty many people find in old automobiles. Photo © Ernest S. Pile

The project has less to do with close-up photography and more to do with learning how one small aspect of an overall scene can pack more emotional punch than a picture of the entire scene. This is especially true when you are traveling; the results will play a big part in your memories of the trip.

1. When viewing a scene, select one interesting detail that captures the essence of your scene. For example, a fire hose or ladder might be all that you need to successfully suggest an entire fire truck.

2. If you can, adjust your aperture to a small *f*-stop number to isolate focus on your subject. Otherwise, select Portrait mode as you will likely want just your detail to be in focus, with the rest of the foreground and background softly out of focus. Turn your flash off.

3. Focus on your detail and capturing it in an unusual way. Move in close and fill your frame with the detail.

4. Try orienting your photo as a vertical portrait as well as a horizontal landscape.

5. Push yourself to continue moving in closer and trying to see new views of the subject. Get so close that the detail itself is only partially captured in your view.

6. If you feel equally attracted to other details in your overall scene, repeat these steps with each one.

STORYTELLING IDEAS

Document Your Travels

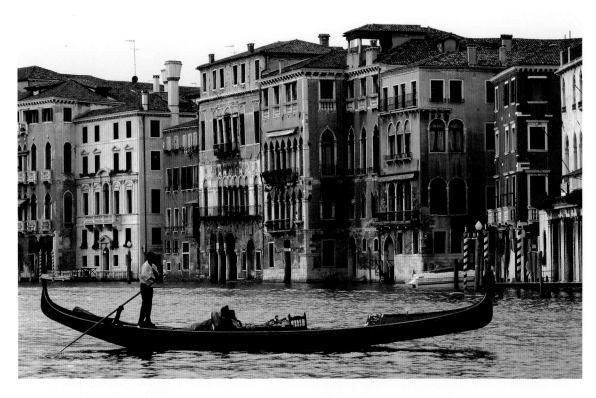

Kevin Lings wanted to take a picture that would convey the romance of Venice, Italy, so he waited an hour to get the corner table at a restaurant on the edge of the Grand Canal, where he would have an unobstructed view. Steadying his camera against a nearby wall, he waited for a gondola with a romantic couple on board to move into position. His planning and patience paid off! Photo © Kevin Lings

TIP

An album full of pictures of buildings can be more boring than you might imagine. Spice up your travel photos with images of people. Photograph candids (approaching your subjects later to ask if you can take their picture). If they are vendors, buying one of their products and showing an interest in what they do can be an effective ice-breaker. Also, have others take pictures of you from time to time. Having pictures of people—and yourself—will add balance and variety to your photos, and add to the memories of your adventures.

- Willingness and means to travel

P&S: Landscape mode ▲▲ (or Portrait, 🙂 as the subject dictates)

DSLR: Aperture Priority mode with large or small *f*-stop number, depending upon your subject

Trips and vacations are fun on many levels: while planning your adventures, during the experience, and afterward when you get to review your travels. Use these tips to make sure the review stage is as enjoyable as it can possibly be.

1. If you recently purchased a camera, practice with it before you travel. It's best to get to know how to use it long before you are on location.

2. Do some research. Look at pictures of the area you will be visiting. Study postcards, travel brochures, and look online for good pictures. Review the photos, questioning what you like about each, and make a list of your favorite photo ideas. This way, you will know what to look for when on the road.

3. Start shooting even before you arrive. Many cool shots can be made on the way to the airplane, for example. Carry your camera everywhere you go.

4. Use the Landscape mode (or set the camera into Aperture Priority and use a large *f*-stop number) when shooting landscapes, architecture, and other sweeping vistas. When photographing people, turn to the Portrait mode or choose a small *f*-stop number.

5. Shoot castles, cathedrals, villages, and so on, but also be sure to photograph people. Even if you do not speak the language, ask friendly looking people if you can take their pictures. People will know what you mean when you point to the camera and ask "Photo?" Politely sprinkle in a "please" and "thank you," and most won't be able to resist. Be bold, and you will have both photographic successes and fun experiences.

6. Aim to shoot at least 100 to 200 pictures in the morning and 100 to 200 pictures in the evening. At least. Take the middle of the day off and use that time to visit museums or recharge your batteries.

7. With each shot, ask yourself whether there is something more unique, more interesting that you can do. Try to get a new point of view on the subject. Think about what it is that you are after and imagine the creative expressions of any scene.

8. At the rate you are shooting, you'll be piling up a lot of images, so at the end of each day, remember to go back and edit your photos (see page 83 for more on editing images).

STORYTELLING IDEAS

Make Great Black-and-White Photos

David Gilmore took this image in Hong Kong while waiting for the light to change at a crosswalk. It was afternoon, and the bold sunlight and shadows were starting to emphasize the geometric shapes. David eliminated all distracting elements in an otherwise busy thoroughfare, creating a graphic, simple composition. When you want to make images like this, which emphasize line and form, lack of color can be a benefit.
Photo © D.S. Gilmore

- Camera with black-and-white shooting mode or, ideally, image-editing software such as Photoshop

SETTINGS

P&S: Your default Color mode (rather than the Black-and-White mode), unless you cannot convert to black and white in software later. Use Landscape ▲▲ or Portrait mode 🗣, depending on your subject

DSLR: Aperture Priority mode with large or small *f*-stop number, as your particular subject dictates

Black-and-white photography has a classic, elegant quality. Its simplicity also helps you focus on important elements of the photo, rather than get distracted by color. You can learn a lot about the graphic part of photography by making black-and-white images.

In this digital age, you do not need anything special to experiment with black-and-white photography. Although some cameras come with a special black-and-white shooting mode, I recommend you shoot in color and convert the images to black and white in a program like Photoshop. This way, you can have both color and black-and-

white versions of your favorite photos. If you shoot in black-and-white mode, you will not be able to put the color back into the photo.

1. As you head out with camera in hand, shoot a few photos of people. Portraits without color can be extremely attractive and pleasing.

2. Look for an especially busy scene, with lots of clashing colors. If you have a friend with you, ask him or her to pose in front of the scene while you take a few pictures.

3. Look for graphic elements such as line, pattern, shape, and form.

4. If shooting in an Automatic mode, choose either Landscape mode (if your scene has depth and you want everything to be sharp) or Portrait mode (if you want to isolate the focus on one object like a person).

5. If you are controlling your exposure settings, expose your image with an eye toward retaining detail in both the highlights and the shadows. If there are both dark areas and extremely bright areas in your scene, and you want to keep the detail, be sure to "expose for the highlights." More on this in the next chapter. For now, if you see bright areas, consider setting the exposure compensation feature on your camera to a negative number like –1 in order to keep those highlights from being blown out.

6. When you get back home, open your pictures in a program like Adobe Photoshop and convert them to black and white (more on this on page 199). Usually there are many simple ways to do this. I like to go into a function that controls color saturation and I simply remove all saturation. This turns your image into a grayscale image.

7. Perform a "Save As" function and name your new image something unique, like "[Image-Name]_bw."

ARTISTIC IDEAS

Shoot Graphic Shadows

WHAT YOU'LL NEED

- A sunny day or other direct light

SETTINGS

P&S: Portrait mode ![portrait icon], turn flash off

DSLR: Aperture Priority mode with medium aperture (medium *f*-stop number), turn flash off, low ISO

The low-angled sunlight of early morning or late afternoon provides the opportunity to catch dynamic interplays of light and shadow. When you photograph shadows, you are emphasizing form over detail, and the stark contrast between bright and dark areas has a quick and powerful impact.

1. Go out shooting when the sun is low in the sky and not blocked by heavy cloud cover.

2. Keep an eye out for well-defined shadows. The best shadow shots involve simple, graphic shadows that are recognizable and serve as a key focal point (or a strong graphic design element) in the picture.

3. When you notice clearly defined shadows, change your point of view until the lines, shapes, or patterns feel organized. For example, vertical shadows from tall thin trees could be captured in alignment with the edges of the photo, or as diagonals. If multiple shadows are present, see if you can position yourself in a way that causes these shadows to come together in a pattern of three or more elements.

4. Include sufficient space around your shadow to keep it from merging with other shadows and becoming unrecognizable.

For both of these photos, Kerry Drager photographed fellow BetterPhoto instructor Ibarionex Perello holding a camera. Working in the late afternoon, Kerry first captured Ibarionex's profile, right, then captured his equally identifiable shadow under the graphic pattern of the stairs, opposite. Notice that the photos differ in orientation as well as light. It's always good to mix it up and try a variety of orientations and compositions. You might just end up liking both versions! Both photos © Kerry Drager

Try Abstract Photography

Elsa Gary created this abstract image out of the colored lights that adorn the façade of the Santa Monica Civic Center in California. Arriving at twilight, she walked around the building and chose a spot to wait for the sky to darken. After several traditional shots, she decided to experiment by moving the camera on purpose while taking the photo, to blur the color. This one is her favorite.
Photo © Elsa Gary

TIP

Some photographers find it helpful when shooting abstracts to intensively study color. Alternatively, using black and white is another way to abstract an image from reality, by removing any reference to color at all.

WHAT YOU'LL NEED

- A willingness to let your hair down and get creative!

SETTINGS

P&S: Telephoto focal length, Landscape ▲▲ or Macro 🌷 mode, turn flash off

DSLR: Aperture Priority mode generally with small aperture (large *f*-stop number), turn flash off, low ISO

Photography may seem like the most realistic kind of art. But because it redefines our three-dimensional world into two dimensions, *every* photo is essentially abstract. Try your hand at making abstract photographs. These are images that are hard to define and understand, to the point of becoming barely recognizable.

1. Select a subject. Some of the best subjects for abstract art are extreme close-ups, color studies, and objects with very graphic elements. Scenes in the natural world will often include soft, curving lines and shapes, while those in urban areas provide more hard lines and angles.

2. When you find a subject, begin experimenting. Try positioning yourself or your scene so it becomes less identifiable. Take several pictures to make abstract, artistic statements.

3. Try including blur on purpose. If your camera permits, select a slow shutter speed, or use the Aperture Priority mode and select the highest *f*-stop number. On a point-and-shoot, this number will often be *f*/8. On a DSLR, this will usually be *f*/22 or higher. Make sure your ISO is as low as possible. Then, move your camera on purpose while you take the photo, or photograph a moving subject.

4. Shoot a lot, experimenting and creatively playing. Don't worry about reviewing each photo carefully now. Just shoot, and shoot, and shoot some more . . . You will be able to select your favorite results later, when reviewing your photos on your computer.

5. If you get stumped, try moving in closer. Often a detail can be photographed in a way that makes it less recognizable.

Copy Your Favorite Masterpiece

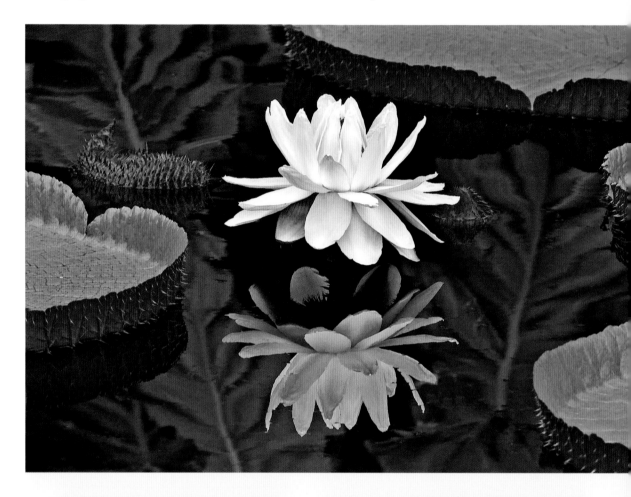

WHAT YOU'LL NEED

- A painting or photograph that inspires you

SETTINGS

P&S: Usually Landscape mode ▲▲ but, if your subject requires otherwise, use the mode that is appropriate

DSLR: Aperture Priority mode, large or small *f*-stop number, as your particular subject dictates

This is one of my favorite projects. Unlike what you might expect from a "copying" exercise, it can actually inspire you to produce some of your most original and beautiful photographs.

1. Find a painting or photo you especially enjoy. It can be something you see in a magazine or on a postcard, or a painting or other work of art. If you like one of my images, I happily give you permission to use it for this exercise.

2. Study the image and try to figure out what you like about it. Break it apart into its most basic elements: color, form, texture, composition, concept, and so on. Do your best to determine what first attracted you to the image.

3. Once you have a pretty good idea what the image is all about, try to copy it. That's what I said: copy it. Don't worry about plagiarizing in this case. The fact is, it is incredibly difficult to come anywhere near making a perfect copy. If your intentions are open, honest, and artistic (and you don't just use a photocopier or scanner!), you will likely end up with something very different and new, and in the process, you will learn a lot about technique. You will come to appreciate the masterpiece even more and end up with your own knowledge of how such an image is made.

4. The particular mode or settings you use will be determined by the subject you choose to shoot. Consider this your "test" for the chapter; if you have tried even a few of the previous assignments, you will be able to tackle this "coming of age" photo assignment with ease and confidence.

For this image, which is reminiscent of Claude Monet's impressionist paintings of water lilies, Richard Waas toured Fairchild Tropical Gardens in Coral Gables, Florida, looking for reflections in their many ponds. He cropped the final image to a panoramic view to accent the flower and reflection. Photo © Richard M. Waas

TIP

Try using inspiration from a non-visual form of expression, too. For example, if you love a certain novel or musical composition, try to imagine a way of representing the work with a photographic image. This can give you a ton of photographic ideas and projects.

ARTISTIC IDEAS

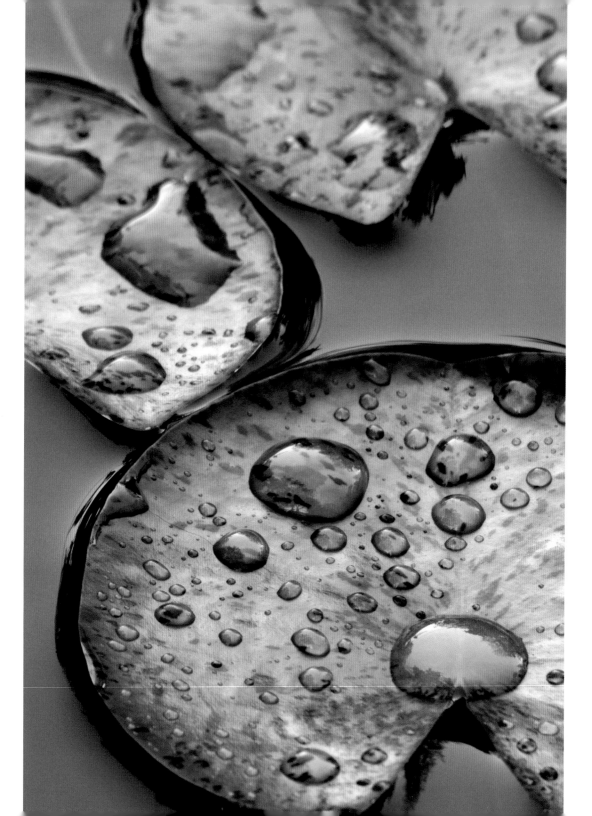

STEP 4:
Master the Light to Take Your Photos Further

Now that you have the basics under your belt, why not stretch your wings and soar to new photographic heights? This chapter is all about the one thing professional photographers appreciate and love—light! An understanding of light will be beneficial to photographers at every level.

One of the first and most important tips is that pros learn to see light in a new way, often rising before dawn to make the most of early-morning light. They learn to consider the direction of light, when to shoot from the best low-light conditions, and how to handle extremes in tonal range. Get ready for a whole new chapter on your photographic adventure. More than you can imagine, these techniques will help you make stunning, awe-inspiring images.

Sibylle Basel took this photo at her pond in early evening, when light conditions are ideal. Photo © Sibylle Basel

Pay Attention to the Light

Every great photographer understands and pays attention to light. Light has an infinite variety of characteristics and subtleties, and can change from bright cool blue to warm pink in a matter of minutes.

When you survey a scene, don't just focus on subjects but also notice the *quality of light*. Look for its color, angle, and intensity. Which way are the shadows falling? Is the light a particular tone (bluish and cold, or reddish and warm)? How is the light affecting your subject? Is your subject squinting?

Unless you want a silhouette, it's generally best to shoot with the sun behind you. This works especially well if you are in love with the bold colors in your subject. Side lighting, on the other hand, can add drama but can also cause extreme contrasts. You can also use indirect, overcast light to make your subject glow soft and pretty.

Let the light lead you to your subject—but balance this with the need to make the most of whatever light you are blessed with. Watch the dance of light and, regardless of the light you are given, make the most of it.

BetterPhoto instructor Ibarionex Perello—photographed here by fellow instructor Paul Gero—says that instead of focusing on finding the ideal subject, he lets the light *lead* him to his subject. The light is his first concern. Here, light from a laptop computer led Paul to the beautiful glow on Ibarionex. Photo © Paul F. Gero

Appreciate Soft Light

Soft light is indirect and diffused. This is as opposed to *hard* light, which is direct and strong. Soft light is good. Soft light is your friend. Whether you're shooting portraits or photographing fall colors in New England, soft light allows you to capture photos that do justice to the inherent beauty of your subjects.

Hard, direct light, such as when the sun is high in the sky and shining on your subject without interruption or diffusion, is often too harsh. It can obliterate pleasing details in a scene and produce unflattering or uninteresting shadows. Objects in this light can appear flat and lifeless.

This doesn't mean you should stop shooting if the light is strong and directly illuminating your scene. You can make the most of hard light by selecting particular subjects (such as details or graphic elements with bold colors). You can also soften hard light by using a reflector or diffuser (see page 142 for more on reflectors, and page 214 for diffusers). The main thing is to learn to see the quality and character of the light; that one simple step will greatly help you take your photography to the next level.

While Carla Saunders was visiting her daughter's family in England, she persuaded her grandchildren to play on an outdoor trampoline. When her tired-out granddaughter laid down on the trampoline, Carla shot this close-up in the soft, natural light at the end of the day. Photo © Carla Trefethen Saunders

Choose the Best White Balance

Light comes in many hues. Candlelight, daylight, incandescent light—each has a particular color, and that color has a profound effect on your photo. When you start noticing the color of light and take steps to balance it, your pictures will immediately improve.

The way to do this is with a setting on your camera called the *white balance*, often noted by **WB**. When you take your camera off "Auto white balance" and instead take control of this setting, selecting whichever option best suits the type of light you're in, the color in your photos will improve dramatically.

The white balance options on most cameras include the following:

• **AWB** **Auto white balance** lets the camera decide what to use. Avoid this option, as it may strip the color inadvertently in an attempt to "balance it out"—perhaps eliminating, for example, the warm, pink sunrise light you woke up so early to capture!

• ☀ **Daylight** is my go-to standard. I find that Daylight does the best job accurately capturing tints and tones in most outdoor and nature photography situations.

One early morning, I came across this interesting terracotta mask when photographing Old Town in San Diego, California. Shooting in open shade, the blue color in the sky cast a distinctly cool tone over the scene, so I adjusted the white balance to the Shade setting to warm up the image. Learn to look for color casts; once you begin to see how often light has a cast, and know how to correct it, you won't be able to accept anything but the most appropriate color of light in your photos. Both photos © Jim Miotke

- 🏠 **Shade** adds warmth to an image. Open shade is notorious for its blue cast; this setting brings your image back to a more daylight look.
- ⚡ **Fluorescent** is handy if you shoot in stores and other commercial locations where this kind of light is used. If your images look greenish or you notice a lot of neon-type bulbs around, try the Fluorescent setting.
- ☁ **Cloudy** adds warmth to an image. Some photographers shoot with this setting all the time, to give every photo an extra bit of warmth. I prefer relying on Daylight and only using Cloudy when the day looks very cool, blue, or gray.
- 💡 **Tungsten** takes care of the yellow/orange casts that often happen when shooting indoors without a flash. This is good when the scene is illuminated by tungsten, incandescent, or halogen lights (the kinds of bulbs found in most household lamps).
- ⚡ **Flash** warms up your subject, effectively eliminating the bluish cast that very often occurs when you use flash indoors. One exception for this setting is when you are shooting outdoors and using fill flash to brighten up shadows. In such situations, use the Daylight setting instead.
- 📷 **Custom** may be useful for professional product, portrait, and other studio work.

The most important options are **Daylight**, **Shade**, **Cloudy**, and **Tungsten**. These will get you by most of the time. Start with Daylight, then adjust the white balance when you're in special lighting conditions, such as shade, on a cloudy day, or using a flash.

One last tip: shoot in Camera Raw, so you can fix the white balance on the computer later. This applies to users of both point-and-shoots and DSLRs; if your camera allows you to capture Raw files, I highly recommend it.

Daylight

Shade

Fluorescent

Cloudy

Tungsten

Flash

If you want to learn white balance, photograph something white in a variety of settings and compare the results, as I have done here with my friend's white shirt. The photos were all shot in shade on a sunny day. Notice how the Daylight and final Flash version are similar; in this situation, either of these settings would be fine. You would certainly want to avoid the Tungsten and Fluorescent settings, however, unless you were purposely trying to make a creative, artistic, blue-toned effect. I feel the Flash version in this series is the best. All photos © Jim Miotke

Increase Your ISO

To photograph this chef in low light, I increased my ISO to a much faster speed. Photo © Jim Miotke

If you have been seeing more blurry results in your pictures than you would like, or are shooting a photo in a low-light situation, consider using a faster ISO.

ISO measures the sensitivity of a camera's light sensor, which serves the same purpose in a digital camera as film does in a film camera. A "fast" ISO, or one with a higher number, means the light sensor is working harder and needs less light to record an image. A "slow" ISO, or one with a lower number, needs more light.

Using a faster ISO, such as 400, is both a great way to avoid camera shake and also to freeze a moving target. When you use a faster ISO, your camera needs less time to make the picture, which makes camera shake and moving-target problems less likely to occur.

The downside is that using a high ISO can cause an effect called *noise*, where the image looks a little grainy. Noise may also cause the overall colors to look drab. Sometimes this grainy effect can add to a photo, giving it a more creative look, but too much noise can be distracting. The trick is to find the right balance between a faster ISO and not too much noise. With a point-and-shoot, try not to go over ISO 400; most point-and-shoots show worse noise than DSLR cameras when the ISO is 1600 or higher.

TIP

Unless your subject is moving or light is very low and you don't have a tripod, ISO 100 is still the best.

Shoot with Sidelighting

This photo above was created in strong, afternoon sidelighting. Notice the sense of form and depth this adds to the portrait. However, the highlights on the left are too bright and the shadows are too dark. Using a reflector, below, I bounced some warm light onto the shadowy side of the girl's face for a more even, balanced effect, left. The sidelighting is still visible, but is now subdued and complimentary. Photo © Jim Miotke

Photo © Denise Miotke

When the light source is off to one side, rather than behind or in front of you, it is called *sidelighting*. Sidelighting can add texture, form, and drama to your images.

Since sidelighting illuminates one side of your subject more than the other, however, you will often find that it creates too much contrast, and your photo will suffer from highlights that are too bright and/or shadows that are too dark. Happily, you can easily minimize this problem, while still retaining the texture and form caused by sidelighting, by bouncing or reflecting light onto the shaded side of your subject using a reflector. See page 142 for more on using reflectors.

Shoot with Backlighting

When the sun is in front of you and behind your subject, this is called *backlighting*. Backlighting is a bit trickier to shoot than frontlighting and side-lighting, but, oh, it makes for creative pictures! With backlighting, you can capture the warm glow of sunlight making its way through leaves or flowers. When photographing people, backlight-ing can add a rim of brightness to your subject.

One tricky part about shooting backlighting is that the front of your subject can be in shadow and too dark. If you want to fix this, use a *fill flash* or *reflector* to even things out (see opposite page and page 142). Or, you can go to the other extreme and create an interesting silhouette (see page 96).

Another possible problem is *lens flare*, which can happen when you're shooting into the light and it reflects on various elements in your lens, causing spots to appear. To minimize flare, shade your lens with your hand, a hat, a lens hood, or something similar. Alternatively, compose your photo in a way that blocks the sun behind some object in your scene. Either way, watch out for lens flare and do what you can to avoid it.

Suzanne McGarity took this photo around 5:30 p.m. one October evening—about an hour before sunset—in an attempt to capture the beautiful backlighting on these fronds. I'd say she succeeded! Photo © Suzanne McGarity

Use Fill Flash

Have you ever photographed someone in bright daylight, but ended up with his or her face in dark shadow? This is especially common when shooting with sidelighting or backlighting (see page 135 and opposite page), when the sun is next to or behind your subject. To fix this, force your flash to fire, even in bright daylight. The extra light—called *fill flash*—helps create a consistent, even light across the entire subject. And by brightening the shadows so they are almost as bright as the parts in the sun, the camera can more easily render detail in the entire scene. Fill flash is a great way to eliminate dark shadows in a person's eye sockets, slightly illuminate subjects lit from behind, and give your scene added crispness and color. Another benefit is that it will produce a small *catchlight*, or sparkle, in the subject's eyes, adding a nice touch of vitality.

Being able to force the flash on or off is a feature offered in most cameras. The function is usually represented with a little lightning bolt symbol on the LED display or on the camera body (⚡). Check your manual to see how to use the flash and how to turn the flash function on and off.

Bob Cournoyer captured this wildlife portrait at Northwest Trek Wildlife Park in Washington, where very tall trees cast the birds in shadow most of the time. Bob waited until the sun shone briefly through the trees and then, focusing on the eagle's eye, used his flash to fill in the shadows and add a tiny catchlight to the eye. Photo © Bob Cournoyer

Shoot During the Golden Hours

One easy trick to take better pictures is to simply shoot at certain hours. All you have to do is get up early or stay out late, when the light is most interesting, and you'll get more than just sunrises and sunsets; using that light, you'll be able to photograph a wide variety of subjects.

To get more stunning pictures, go out in the morning. Many professionals turn their cameras off around 10 a.m.—relaxing, eating lunch, reading a book, or taking a nap during the midday hours—and don't start shooting again until 3 p.m. or later. The soft, warm light of the morning and evening often casts such a flattering glow on the subject, midday pales in comparison.

The edges of the day are often the most exciting to photograph. Shadows caused by the lower sun add depth and drama to scenes. Streets are often free of crowds. Animals are likely to be feeding rather than sleeping. Consider skipping your morning meal to go out shooting. Whatever you do, schedule your mornings and late afternoons exclusively for picture-taking.

Mark Orlowski captured this photo at sunset on the way to Cape Royal on the North Rim of the Grand Canyon. Photo © Mark Orlowski

Turn Around . . . at Sunrise and Sunset

Sunsets and sunrises are extremely popular subjects to photograph. It is very difficult, however, to capture one in all of its natural beauty. So here's a trick: turn around.

When the sun is close to the horizon, turn around and look at what the sun is illuminating. These can be great times to photograph people—both "your people" (friends and family) and people you meet while photographing. The low light casts a magical glow and makes your portraits warm and inviting.

But don't limit yourself to photographing people. Use the warm, glowing light to illuminate any subject you choose. Photographing a tree, building, animal, or any other subject washed in this light can result in a truly delightful picture.

These two images show what you can get when you turn around after photographing a sunrise or sunset. Take advantage of the special quality and warm glow of the low light as it illuminates your subjects. Both photos © Jim Miotke

Make the Most of Midday Sun

Although mornings and evenings are generally best for picture taking, there are great ways to use midday light as well. So if midday (from 10 a.m. to 2 p.m.) is the only time you can shoot, try these simple techniques.

- Move in closer and focus on the details.
- Take advantage of a passing cloud to shoot in its shadow, or work in the shade. Place your subject just inside the edge of direct light, where the shade is still relatively bright. Ideal locations include just within the shade of a tree, inside a door or window, or just under a porch or other overhang. (Note: When shooting in shade, choose the Shade white balance setting to warm up the image and remove the slight blue cast.)
- Force your flash to fire so it will even out extremes in contrast.
- Look for subjects, that might be back-lit by the bright sun (such as leaves in a tree.)
- Take advantage of the light for photographing scenes in deep canyons.
- If you have a waterproof camera or cover, bright midday light can be the best light for underwater photography.
- Focus on bold colors that will pop even more when lit by bright, direct sunlight.

For this nature landscape photographed at Yellowstone National Park, the occasional cloud helped Judy Ann Rector provide depth and detail, even though she was photographing during the midday hours. Photo © Judy Ann Rector

Shoot at Twilight for the Best Night Photography

Probably the most overlooked but often most rewarding time of the day is just after the sun goes down. In the twenty minutes of twilight that follow sunset, you can balance twinkling city lights with amazing periwinkle and purple colors in the sky.

Especially in a big city, color comes alive in the evening, transforming streets and buildings. One of my favorite times to photograph the city at night is just after a rain when neon lights reflected on wet city streets offer abstract and colorful subject matter.

To take a photo like this, it's important to take the picture without touching the camera, as the slightest movement can cause blur. Whether you're using a point-and-shoot or DSLR, use a tripod and a remote shutter release. Alternatively, place your camera on a table or other firm surface, compose your shot, and then set your self-timer so the camera fires without your touch. If your camera has an on-camera flash, turn it off. And if the camera has a hard time focusing in low light, see if you can switch to manual focus.

Don't worry about the lack of light. In fact, because whatever light there is will be soft and glowing, it can be even better than the harsh light of day. What's more, you will almost certainly get unique images, as fewer people shoot at night.

Graham Sher made this twilight photo at about 5:30 p.m. on a gorgeous spring evening, standing on the Brooklyn side of the East River under the Manhattan Bridge.
Photo © Graham Sher

Instead of Flash, Use a Reflector to Fill in the Shadows

Notice the dark shadows in my daughter's face, especially in the eye sockets. Photo © Jim Miotke

Here, my wife held a reflector to the left of my daughter, just outside my field of view. Moving and tilting the reflector up and down, left and right, we were able to find the perfect position. Because this particular reflector had a slight gold tint, the bounced light not only filled in the shadows but also added a soft, warm glow. The light is even and beautiful, and most of the dark shadows have been eliminated. Photo © Jim Miotke

When shooting an outdoor portrait in direct sun, you may find that your subject's eyes are lost in dark, shadowy eye sockets. To avoid this, one option is to use a fill flash (see page 137). Another is to move the subject under an awning, a tree, or another form of open shade, and use a reflector instead. A reflector is a simple, inexpensive, but amazingly effective accessory that can be used to bounce light back into the shadows. To see one in action, turn to page 135.

Using a reflector may sound cumbersome, but it's actually very easy. All you need is some reflective, rigid material, and a helper (or stand) to hold it. Professional reflectors can be purchased at most camera stores and can be folded to fit in your camera bag. You can also buy white foamcore at craft stores and office supply stores. This is very inexpensive but, since it's inflexible, can be cumbersome to carry around.

Avoid Extreme Contrasts in Tone

Camera sensors do not see the world the same way we do. While our eyes can make out subtle details in shadows, a camera may only see black. Our eyes recognize a much wider range of tones and our brains compensate for differences in brightness within each scene.

Added to this is the problem that a camera does not know which are the important parts of a scene. When we focus on our spouse standing in front of a monument, the camera has to guess whether we are more interested in the person or the monument. Because your camera doesn't know what it should expose for, it settles for an average brightness of the whole picture. In certain situations, such as an outdoor scene in bright snow, or an interior with a bright window in the background, this can lead to an incorrect exposure. If you notice a large area of bright white as well as an area of dark shadow, either:

- The dark areas will turn out much darker than you see them;
- The bright areas will turn out much brighter than you see them; or
- Both.

This is where you come in. The quickest way to help your camera is to simply avoid including extremely dark and extremely light areas in the same scene. Analyze each scene before you take a picture and reposition yourself if necessary to eliminate any extremes and find a more even-toned scene.

Randall Jackson's aim was to convey the softness and warmth of sunset, and the gentle sway of grass being blown gently by a breeze. He also succeeded in providing a great example of an even-toned image. Photo © Randall Jackson

Watch Out for the "Blinkies"

This first image seemed a bit too bright when I reviewed it on the LCD, so I checked the histogram. Photo © Jim Miotke

"*Blinkies*" is the term for parts of an image that flash (or "blink") on your LCD. This is your camera's way of telling you that areas of your image received too much light and are *overexposed* or *blown out*, i.e, when the highlights are completely washed–out. (You may have to turn this feature on as it's not always active by default.) When this happens, those parts of the image will blend into a white, misty sea of nothingness. Sometimes blinkies are okay, such as when an object is naturally very bright, or when you don't care because that area is unimportant anyway and the pure white won't be distracting. But in general, you'll probably want to make some adjustments and try the shot again.

Here are a few ways that you can compensate for the blinkies:

1. Move or change your point of view to eliminate tricky bright light sources from the composition.

2. Reduce the amount of light entering your camera. Many point-and-shoots have an *exposure compensation* feature, which allows you to slightly adjust the amount of light getting to the camera's sensor. Set your exposure compensation to –1 and try the shot again. If you're using a DSLR, either reduce the size of your aperture or increase your shutter speed.

3. As a last resort, adjust the brightness of your image later in a program like Photoshop.

Another way to see if areas of your image are too bright is a *histogram*. A histogram looks like a graph and is displayed in your LCD screen just after you take a photo. Look for a spike on the far right wall of your histogram—this shows that some part of the picture was overexposed. Set your exposure compensation to –1 to shift the histogram to the left and get that little line away from the right wall.

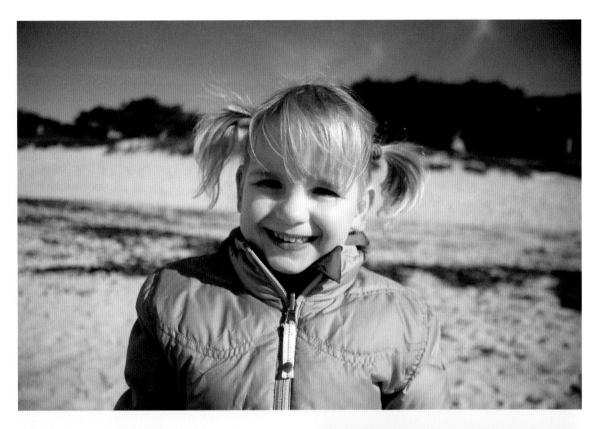

As you can see, the "reshoot" was success-
ful, and I ended up with a correctly exposed
image. Photo © Jim Miotke

The histogram for the first image. The
spike on the right confirms that parts
of the image were overexposed.

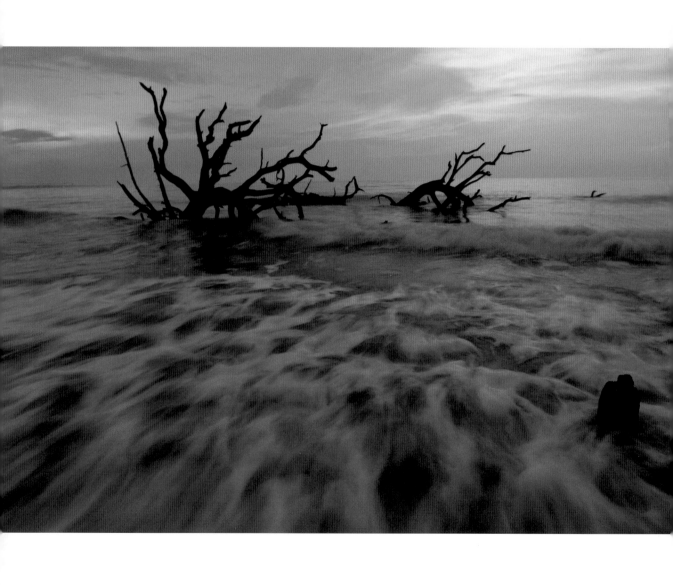

STEP 5: Aperture, Shutter Speed, and Focal Length

This chapter introduces the rather heady concepts of aperture and shutter speed. For the upcoming techniques and projects, you will need to know:

- Whether or not your camera allows you to control these things, and
- Exactly how to adjust aperture and shutter speed on your camera.

While we are under the hood, we will also define focal length, so you can easily translate those millimeter numbers to something you can actually use when trying to set up and compose a shot. Once you learn what these technical terms mean you'll be able to quickly and easily use them for lots of creative purposes!

On the fourth consecutive morning of photographing this beach at dawn during a photo workshop, photographer Cindy Hamilton set up her tripod in the water. Bored with the repetition of shooting the same location numerous times, she pushed herself to try something new. With this point of view, she chose a slow shutter speed and created this stunning landscape. Photo © Cindy Hamilton

Learn Your Camera Controls

Before we start, you'll need to know where to control each of these elements on your camera. Here is a birds-eye view of a DSLR camera, with lines pointing to the shutter speed, *f*-stop number (aperture), ISO, and the focal length of the lens.

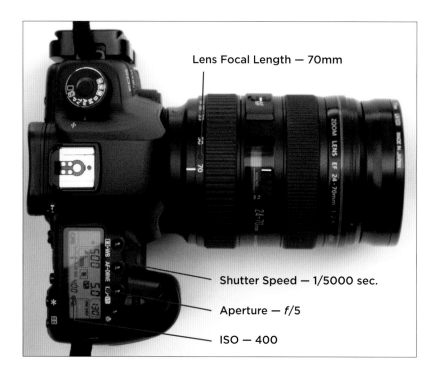

Lens Focal Length — 70mm

Shutter Speed — 1/5000 sec.

Aperture — *f*/5

ISO — 400

Understand Aperture

Aperture represents the size of the camera's lens opening when you take a photo, which then determines how much light gets in to *expose* the digital sensor.

Let's use a house as an example. Imagine the house is dark and has only one window. If the window is very small, it will let less light into the house. If it is larger, more light will come in. It's exactly the same with a camera. A small aperture (or lens opening) lets less light in, while a large aperture lets more light in.

The trick is to let in exactly the right amount of light. If our window (or aperture) is too small, then not enough light will get in and our photo will be too dark, or *underexposed*. If our window (or aperture) is too large, too much light will get in and our photo will be too bright and washed-out, or *overexposed*.

Aperture also affects something called *depth of field*, or how much of your photo is in focus. For more on depth of field, see page 152.

Aperture is measured by something called *f-stops*. Confusingly, a large *f*-stop number (such as *f*/22) means a small aperture, while a small *f*-stop number (such as *f*/4) means a large aperture. So I prefer to keep things easy and remember only one simple formula, which I will reveal to you on page 152.

Photographer Adam Caron combined a small aperture (high f-stop number) with a wide-angle focal length to get both the gargoyle and the background in focus. Imagine how less interesting this photo would be without the gargoyle, and how distracting it would be if the gargoyle was blurry. Photo © Adam Caron

Understand Shutter Speed

Sometimes your subject will look blurry because it moved while you took the picture. When one moving part of the picture is blurry in this way, it means your shutter speed was too slow to freeze the action. Solutions include using a faster ISO (see page 134), shooting in brighter light, or finding a way to keep your subject still. Both photos © Jim Miotke

Shutter speed is another way of controlling how much light enters the camera. Instead of controlling the *size* of the lens opening, however, it represents how *long* the opening is left open. In other words, it determines how long it will take for the camera to make a picture.

Let's go back to our example of the dark house. We can control how much light gets in by controlling how long the window shutters are left open. If we open and close the shutters quickly, less light will get in. This is like using a fast shutter speed on your camera. If we leave the shutters open longer, more light will get in, similar to using a slow shutter speed.

As with aperture, the idea is to let just the right amount of light in. If we open and close the shutters too quickly (use too fast a shutter speed), our photo will be too dark (underexposed). If we leave the shutters open too long (use a shutter speed that's too slow), too much light will get in and our photo will too bright (overexposed).

More important, a slow shutter speed can cause your subject or your entire photo to be blurry. A camera has to remain still while it takes a photo, which is easy with a fast shutter speed because the camera takes the photo quickly. But with slower shutter speeds, it's more difficult to keep things still and your photo might end up blurry. Sometimes blur is used on purpose to make a photo more interesting and creative, but most of the time our goal is crisp sharpness, and this usually means a fast shutter speed.

Shutter speeds are measured in fractions of a second, such as 1/60th of a second. The smaller the fraction, the faster the shutter speed. For example, 1/125th of a second is faster than 1/2 of a second. Shutter speed, while directly relating to the camera shake problem, also plays an extremely important role in getting supercreative exposures. Use a long shutter speed to blur activity in your scene and a fast shutter speed to freeze any activity in its tracks.

Extend the Depth of Field

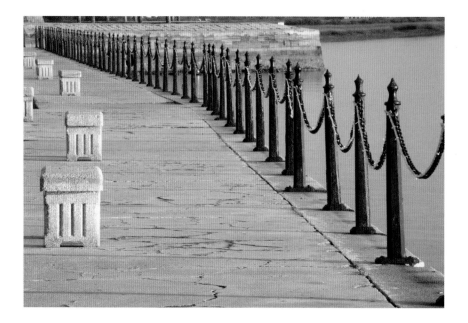

Notice how the fence and benches in the background are sharper in the version at left. That's all you need to know about depth of field! If you want objects at every distance to be sharp, choose a large *f*-stop number. This will give you the most extensive depth of field and is great for landscapes with a lot of depth in the scene. Both photos © Jim Miotke

The term *depth of field* refers to how much of your scene is in focus, from the closest foreground objects to the farthest background objects. A *shallow* depth of field means only a small range of focus is sharp; this can be useful when you want to keep the viewer's eye on one thing, such as a person's eyes and face in a portrait.

A *deep* depth of field causes everything to be sharp, from the foreground to the background. Any time you have both near and far subject elements, and want to render both in sharp focus, you want a deep depth of field. When this is what you want, you need to use a large *f*-stop number to get maximum depth of field, and keep the camera steady while taking the picture. Maximum depth of field comes in handy when doing landscape photography, as well as macro, nature, and travel photography, among others.

Here is an easy way to remember how to get depth of field:

- Use a small *f*-stop number, such as *f*/4, for a small (or shallow) depth of field.
- Use a large *f*-stop number, such as *f*/22, for a large (deep) depth of field.

Isolate Your Subject

Often you will want a select area in your image to be sharp while the rest is intentionally soft, creating a shallow depth of field. This can be a powerful creative technique that allows you to direct the viewer's eye directly to one part of your overall scene. In such a case, it's important to understand how and where to set your focal point in the shot.

The choice about where to focus is easy when you know what you want people to look at. Then all you have to do is use a small *f*-stop number (*f*/1.8, *f*/2.8, or *f*/4, for example) and set the point of focus on the right object. In this way, you can keep your subject sharp and let the rest of the scene blur into a soft, complementary background.

Isolating focus, in addition to changing your point of view, is also a great way to remove clutter in the background.

For this photo, I got down on my belly to include some of the grass in the foreground. I isolated the focus on this tiger cub by using a smaller *f*-stop number. I also used a telephoto lens to get in as close as possible to the cub. The use of telephoto had the nice side-effect of compressing foreground and background, which further accentuated this isolated focus. Photo © Jim Miotke

Use Your Depth of Field Preview Button

The image at left illustrates how the scene looked through my viewfinder. The below photo shows what you get with a larger *f*-stop number. Note how clear the background has become. If you wanted to isolate focus but forgot to use a small *f*-stop number (and forgot to use your "depth of field preview" button), you might be surprised in the end by the distractingly clear background. Both photos © Jim Miotke

When DSLR users open their images on the computer, they are sometimes surprised to see objects in the background rendered in sharp clarity when they were certain they would appear soft and blurry. This is a common accident and happens because DSLR cameras, by default, keep the aperture wide open (set to the smallest *f*-stop number) before the moment of exposure. This wide aperture lets in more light and makes the image you see in the viewfinder much brighter, helping you while you are composing through the viewfinder. At the moment of exposure, however, the aperture is decreased to whatever *f*-stop number is selected. If you have *f*/22 or *f*/32 set, the background may look nice and soft when you are shooting but render in perfect (and distracting) clarity in the resulting photo.

Many DSLR cameras have a built-in solution for this, called the *depth of field preview button*. Pressing down this button while viewing your scene will give you an approximation of the effect

your *f*-stop number will have on the final depth of field. It will also reduce the amount of light coming into the camera, so the image will get darker and this may make it difficult to get a good view of the change in depth of field. All the same, this simple step helps ensure that what you see is what you'll get.

Decide What's Most Important: Depth of Field or Stopping the Action

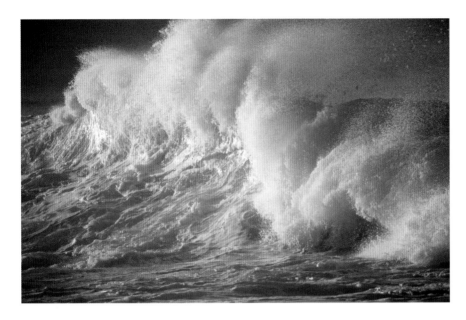

While photographing Carmel River Beach in California, my main goal was to stop the action of the waves. I wanted to see every water droplet as it was being blown by the wind. So my primary concern was to use a fast shutter speed to freeze this activity. I did not care too much about depth of field, so shooting with a small *f*-stop number was acceptable, especially since it allowed me to get the fastest shutter speed I could get while keeping my ISO set to 100. Photo © Jim Miotke

When you consider your scene, ask yourself whether you are more interested in freezing the action with a fast shutter speed or isolating depth of field with a small *f*-stop number. If you want to make one small part of your scene pop out from the other elements, or if you want to intentionally soften an object in the background to lessen its visual dominance, your main concern would be depth of field. In such a case, use a small *f*-stop number such as *f*/4 or *f*/2.8 to capture the subject with the least amount of depth of field.

Or perhaps your main interest is to extend depth of field with a large *f*-stop number, such as when photographing an expansive scene with objects both near and far. Think Ansel Adams in this case; he often used a very large *f*-stop number because he was most interested in achieving maximum depth of field. To get everything in your scene in clear focus, use a large *f*-stop number such as *f*/22.

Terry Ellis took this shot in the gardens at Mission San Juan Capistrano in California. She wanted a shallow depth of field so the flowers would be in sharp focus and the cross in the background soft, and to frame the cross and building with the flowers. Photo © Terry Ellis

If your subject is in motion and you want a sharp photo, your top priority isn't depth of field at all, but freezing the activity of the subject, which requires a fast shutter speed. Your top priority, in other words, would be to do whatever it takes to get this fast shutter speed.

Use Aperture Priority

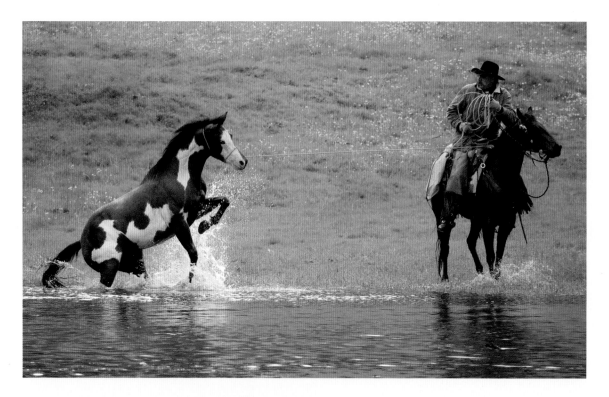

This image is more concerned with shutter speed and freezing the action than depth of field. I needed a fast shutter speed to capture the action of the horse in crisp sharpness, and knew I could do this in the Aperture Priority mode. While in Aperture Priority mode, I selected the lowest f-stop number available, *f*/5.6, knowing this would result in the fastest possible shutter speed. Because the light was dim, however, I also had to raise my ISO from 100 to 400. Photo © Jim Miotke

Here is the quick answer about controlling exposure modes: Use Aperture Priority.

My students love this tip because it makes one less thing for them to think about when they are out photographing. The "P" Program and automatic modes are fine places to start. They're good for beginners, while you're learning basic composition, because the camera does the exposure setting for you. However, once you feel confident, you may find it gives you too little control. Aperture Priority (or "A") lets you change everything you need to control for creative exposures.

In Aperture Priority mode, you control *only* the aperture (*f*-stop number). In response, the camera automatically selects a shutter speed that lets the correct amount of light into the camera. If you select a large aperture (smaller *f*-stop number), the camera sets a fast shutter speed. If you select a small aperture (large *f*-stop number), the camera slows the shutter speed.

Knowing this, you can use Aperture Priority to select shutter speed as well. Want a fast shutter speed to freeze action? Just choose a large aperture and the camera will automatically set a fast shutter speed. Want a slow shutter speed to blur movement? Choose a small aperture and let the camera do the rest. Either way, the only thing you're adjusting is aperture.

All you have to consider, then, is which of the following effects a scene calls for:

- deep depth of field—use a small aperture (large *f*-stop number)
- shallow depth of field—use a large aperture (small *f*-stop number)
- freezing action—get a fast shutter speed by choosing a large aperture
- blurring action—get a slow shutter speed by choosing a small aperture

My brain is wired in a way that makes it easier for me to stay in one exposure mode and choose the appropriate aperture/*f*-stop number. You may find it easier to use the Shutter Priority mode. Try both methods and select the method that works best for you.

For more on depth of field, see page 152; for more about stopping action, see page 155. If you would like to dig in and learn more of the "why" behind exposure, check out my book, *The BetterPhoto Guide to Digital Photography*. In it, I go more in depth when it comes to topics like depth of field and exposure. All you need to know for now though is contained in the four bullet points at left.

TIP

Keep your camera as easy to use as possible. Find the simplest settings and stick with them until you master them. Then, move on and try adjusting different settings. In this way, you'll more efficiently learn the creative effect each setting has on your final image. Finding the simplest way to make your camera work for you is key to getting consistently great results. Working in an exposure mode like Aperture Priority most of the time will cut down on the overwhelming number of decisions you have to make. In this way, you'll be able to control certain basics without letting the other basics control you, and thus keep that 250-page manual where it belongs—in your camera bag.

Understand Focal Length

I liked the shapes and colors in this scene, but there was just too much going on in the first shot. I exchanged my 28–135mm lens for a 70–300mm telephoto focal length and, as I moved in closer to the blue jet skis from the opposite images left to right to the final above, an interesting pattern began to emerge. All photos © Jim Miotke

Focal length measures the magnifying power of a camera's lens—in other words, how closely you can zoom in, or how expansively you can pull back. Different lenses have different capabilities.

Focal lengths fall into three main categories: wide angle, normal, and telephoto.

- **Wide-angle** focal lengths (17–35mm) offer the most expansive power. They are great for shooting big panoramic vistas or tight interiors, such as inside museums or homes. The smaller the number, the wider (more expansive) the focal length. Point-and-shoots normally only go down to 28mm, while DSLR lenses can get down to 14mm or less.
- **Normal** focal lengths (50–60mm) shoot scenes that look about the same as they do to the naked eye.
- **Telephoto** focal lengths (80mm and above) offer the maximum magnification, meaning the best ability to get in close to a subject. Point-and-shoots usually only go up to 160mm while DSLR lenses can reach 300mm or higher.

Zoom lenses offer a range of focal lengths in one lens. They allow you to quickly magnify or shrink your subject, going from wide angle to telephoto with a simple movement of your fingers. *Fixed lenses*, on the other hand, are fixed at only one focal length, such as 50mm. Most point-and-shoots have zoom lenses, while DSLRs can use either fixed or zoom lenses.

If you want to get even closer than telephoto, *Macro* modes and macro lenses let you take super close-up photos of things, such as of insects, stamps, and other small objects.

Here is a cheat sheet of the best focal lengths and lenses for various types of photography:

- Nature: wide angle and telephoto
- Travel: a high-quality general-range zoom lens (28–135mm, for example)
- People/portraits: a fast, fixed lens around 100mm
- Macro/flowers: Macro mode or, if using a DSLR, a macro lens or extension tubes

Compress the Background (with Telephoto)

Note how I kept the archer roughly the same size in all three of these images. The only thing that is changing is the size of the bull's-eye in the background. I created this compression effect by moving farther from my subject as I increased the focal length of my lens. All photos © Jim Miotke

The most common use of a zoom lens is to simply increase or decrease magnification. However, there are other important side effects to consider when using different focal lengths: *perspective* and *distortion*. Wide-angle lenses tend to bend lines, while telephoto lenses make the background look bigger and closer to the foreground.

To understand what I mean, try the following experiment:

1. Ask a friend or family member to serve as your model.

2. Align yourself so something of interest appears in the background, behind your model.

3. Shoot your first picture from afar using a telephoto lens.

4. Gradually begin walking closer to your model, keeping the same background in the picture, while going wider and wider with your focal length. Do your best to keep your model roughly the same size in each shot.

Afterward, compare the different images. Especially if you shot portraits of your model, you should see how telephoto focal lengths (especially in the 100–110mm range) capture a more flattering, natural look. Images shot from a closer range with a wide-angle focal length often distort the subject.

Also, in the telephoto pictures taken from a greater distance, notice how objects in the background get bigger, even though your model remains the same size. A telephoto lens captures less background area, and the distance between foreground and background appears compressed.

As you choose lenses, keep in mind the side effects that different lens lengths have on perspective and distortion.

Watch Your Corners
When Using Wide Angle

When using circular filters with a wide-angle lens, you may see the four corners become black. This is called *vignetting*. It's usually undesirable (although sometimes you may like the effect as an extra creative touch).

Pay close attention and check every part of the view before pressing the shutter button. If you notice this vignetting problem, you can solve it by zooming in a little bit before shooting, or removing the filter from your lens.

When you see vignetting in your photos as in the one above, the solution is easy. Simply zoom in a bit or remove the filters. Both photos © Jim Miotke

Get a "Fast" Lens

Lee Saunders made this photo at the Monterey Aquarium, with the only light coming from the tank itself. He chose to shoot with his Canon 50mm fixed lens because it was a "fast" lens with a wide aperture. This allowed him, even in the low-light conditions and without using a high ISO, to get a shutter speed fast enough to stop the movement of the jellyfish. He held the lens up against the glass to be as perpendicular as possible to avoid distortion caused by the glass. Photo © Leland N. Saunders

With a "*fast lens*", you can shoot in lower light without increasing ISO; usually the *fastest* lenses are the ones known as *fixed* lenses.

A *fixed* lens does not allow you to change the level of magnification on the fly like a zoom lens. A zoom allows you to either zoom in, getting closer to faraway objects, or zoom out, getting farther from faraway objects and thus squeezing in more of the scene. Fixed focal length telephoto lenses often have a smaller "maximum aperture" number such as $f/2.8$ or $f/1.2$. These lenses are called *fast*. With such a lens, you can isolate the focus more than a lens with a higher maximum aperture number such as $f/5.6$. This means that using a fast lens allows you to get a faster shutter speed in low-light conditions.

Another way to avoid blur.

Now that you have a firm grasp on shutter speed and focal length, let me share an additional trick for minimizing the likelihood of blurry pictures. As long as you can control shutter speed or aperture, and you're photographing stationary subjects while hand-holding the camera (rather than using a tripod), keep your shutter speed at **1/the focal length of your lens.** Generally, a shutter speed of 1/60 is a good starting point. But if you're shooting telephoto, such as a 100mm focal length, shoot at 1/100 or faster. If using 200mm, make sure your shutter speed doesn't go below 1/200. If your subject is moving or there is increased likelihood of vibration (such as when shooting on a windy day or from an unstable platform such as a bridge or boat), you may need to select an even faster shutter speed, such as 1/500 or faster.

STEP 6:
Thirteen Advanced Creative Techniques

In this chapter, you'll get some creative techniques to add to your repertoire. Some are specific to a particular subject, such as photographing lightning and fireworks, while others can be applied to a wide variety of subjects, such as shooting silhouettes. All of them will result in exciting images that will wow your friends and family. I wish I had this chapter when I was first starting out, but I'm grateful to be able to share these techniques with you now!

NOTE: This chapter is only for folks who have cameras that allow you to control aperture/shutter speed. You don't necessarily need a DSLR; as long as your compact camera allows you to use a slow shutter speed (15 seconds will do) and allows you to set the *f*-stop number, you should be fine. If your camera does not feature this creative control, you can skip this chapter and go directly to the next chapter for quick tips on fixing photos in Photoshop.

During a recent visit to New York City, one of my photographic goals was to create a compelling image of Times Square at twilight. I wanted to convey the bustling activity of the people there with a blurred look, set against a nice periwinkle blue sky in the background. I set my camera securely on a tripod and used a slower 1-1/3 second shutter speed and a super wide angle lens to achieve both of these creative effects. © Jim Miotke

Get a Flowing Effect
with Waterfalls and Rivers

To get a slow shutter speed effect such as that "cotton candy" look of blurry, smooth water, it's best to shoot in low-light conditions (such as early morning, late evening, or in deep shade) and to use a low ISO number. Low-light conditions help because they force your shutter to remain open for a longer period of time, in an effort to get a proper exposure. Set your camera in Aperture Priority and choose an *f*/22 aperture.

If you are using a low ISO in relatively low-light conditions and you still cannot slow down your shutter speed enough, you can use a dark filter, such as a polarizer or a neutral density filter, to block out more light. This will help you slow down the shutter speed, even in brighter conditions. This open shutter allows more of your moving subject to pass by while the camera is taking the picture, resulting in a soft, flowing effect.

It might go without saying, but I'm going to say it anyway: to do long exposure effects such as streaming rivers and waterfalls, you'll need a sturdy tripod.

TIP

When photographing flowing water in nature, work on overcast days or in shade. This keeps the water from being illuminated by direct light, which often causes the white water to overexpose and become one amorphous blob.

Note the different effects in these two photos of this raging waterfall. The image at left was captured with a fast shutter speed while, for the image above, I used a slower shutter speed to intentionally blur the water. Also note the warm sunset light illuminating the cliff-top hotel at the end of the day. Both photos © Jim Miotke

Shoot Fireworks

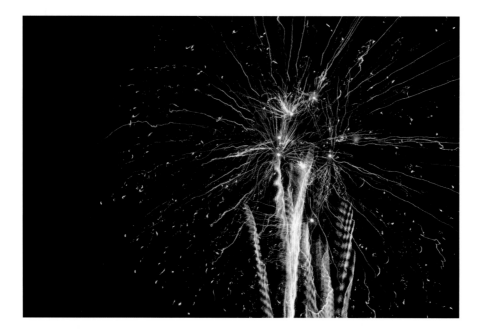

Like shooting "cotton-candy" waterfalls and streams, photographing fireworks is fairly easy as long as you have a tripod, a camera that allows you to take long exposures, and a remote shutter release. In fact, this is one of the most exciting uses of a tripod.

1. First, check your user manual to see if your camera features a "bulb" or "B" exposure mode. This will allow you to keep the camera shutter open for as long as you please. If your camera doesn't have this "B" mode, find out the camera's maximum exposure time. If you can set the shutter speed to a long exposure such as 15 seconds, you should be able to capture fireworks photos with success.

2. Use a low ISO such as 100 and set your camera securely on a tripod.

3. Use a wide-angle focal length if you are unsure where the bursts will occur or if you would like to include some foreground elements, such as a famous monument or landmark. Zoom in and use a telephoto setting if you know where the explosions will occur and want greater impact.

4. Use a remote shutter release to fire the shutter. In this way, you will be able to see the missiles launching and time your shutter release to start just before the burst begins. Every time a missile goes up, either use the "B" bulb mode and open the shutter until the bursts stop, or take a 15-second exposure. If you don't have a remote release, use the self-timer to avoid camera shake. Review your LCD often, experimenting with various exposure times. And remember to enjoy the fireworks as you shoot!

Using a remote shutter release will allow you to both keep your hands from moving the camera and watch the fireworks. As things progress, watch out for clouds created by the blasts, which tend to muddy up the composition. You'll want to work hard to get your firework photos during the beginning of the show. Photo © Jim Miotke

Photograph Lightning

This amazing lightning photo was captured by Jim Zuckerman outside of Phoenix. Jim set his shutter speed for a long, 60-second exposure and fired just when the first bolt began. The long exposure both allowed him to capture many bright bolts and caused the foreground cactus to become a beautiful silhouette. Photo © Jim Zuckerman

According to BetterPhoto instructor Jim Zuckerman, who's driven far and wide to photograph lightning, the best locations in the United States are in the Phoenix/Tucson area; around Tampa, Florida; and on the east side of the Rockies (Denver, Colorado Springs, and so on). In general, the Midwest is better than either coast. In terms of season, July and August are the best months.

1. The first challenge is to find an appropriate location. The ambient light in or near a big city will make things more difficult, so shoot outside the city, where the sky is darker.

2. Set up your camera on a tripod in order to keep it steady.

3. If you are using a point-and-shoot, select Fireworks mode. If you're using a DSLR, select manual ("M") and set an aperture of $f/8$, an ISO of 100, and, if your camera allows it, a 15- or 30-second shutter speed.

4. Choose whether to keep your lens pulled back to a wide angle, which will increase your chances of catching a bolt, or to zoom in/use a telephoto lens, which will give the photo more drama.

5. Point your camera in the general direction of the bolts and trigger the remote release or set the self-timer. Avoid pressing the shutter button or you'll likely get camera shake.

6. If no bolts happen during your shot, keep repeating step 5 until you catch one.

TIP

Turn off Image Stabilization and/or Vibration Reduction, since you are using a tripod anyway, and either setting can cause slight blur.

Make Car Lights Stream off into the Distance

With a tripod, a remote release, and the ability to use slow shutter speeds, you can easily get these cool, long-exposure special effects when photographing traffic.

The best time to photograph traffic is just after sunset, after the lights come on but before the night sky gets so dark it will look black in your photo. To get the streaming traffic effect, use the same technique discussed on page 166 for shooting waterfalls and rivers. The only difference is that, because you are shooting at twilight or night, you should have no problem getting a slow shutter speed.

The best place to photograph traffic is often on an overpass, but any location with a clear view will do. Find a location that gives you a nice, softly curving section of the road or freeway. If your camera allows such long shutter speeds, 15- or 30-second shutter speeds will give you the longest streaks. Anything longer than a few seconds, though, can be used to produce interesting trails of light. Experiment to see which shutter speed produces the most satisfying result.

What a difference an hour makes! I was attracted to this view of Seattle because of the moody clouds in the background and great view of the city. However, I could not create a compelling photo . . . until later. Note the purple sky in the second photo, opposite. This is the reward you sometimes get when photographing at twilight. The streaking lights were possible at this later time because I was able to slow my shutter speed down to 20 seconds. Both photos © Jim Miotke

Save an Evening Portrait with Creative Use of Flash

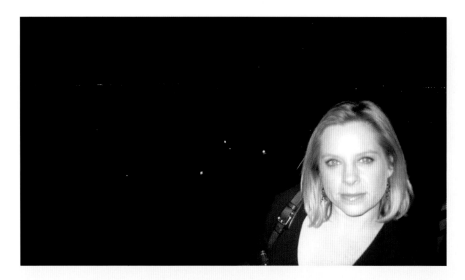

Evening portraits can be very challenging. Sure, you could simply blast a flash of light onto your foreground subject but one problem with this (in addition to the flash providing such harsh light) is that the background will often go black. While you may enjoy the warm colors of a sunset or the twinkling lights of a city or monument, your camera will underexpose the background, causing those background details to be lost.

To solve this, here is what the pros do:

1. Make sure your flash is off.

2. Go into the Aperture Priority mode and get a meter reading off the entire picture by pressing down the shutter button halfway and then noting the numbers.

3. Turn your flash back on. Attach a diffuser if you have one.

4. Go to the "M" manual exposure mode and dial in the *f*-stop number and shutter speed you got in step 2. You can also use a slower shutter speed, to give the camera even more time to soak in the background details.

5. Take a test shot and make adjustments to your settings as necessary.

For an even more pleasing evening portrait, tilt your flash up to the ceiling or diffuse its light through some kind of diffusive material.

This first photo, opposite, resulted when I tried to photograph my subject in front of the beautiful city lights. Because the camera relied on the light from the flash, it did not expose for lights in the background, which appears nearly black. I attached an external flash to my camera and used a Gary Fong diffuser. But before I turned the flash on, I took a meter reading. Then I went to manual exposure mode, dialed in the f-stop and shutter speed numbers, and created this more balanced photo above. Both photos © Jim Miotke

Shoot More Colorful, Dramatic Flower Photos

One big challenge of flower photography is that we often need to use a large *f*-stop number in order to maximize the depth of field, keeping most of our subject satisfyingly sharp. This can cause two problems:

- With a foreground and background entirely in focus, they may distract the viewer from appreciating your beautiful floral subject;
- A large *f*-stop number means a slow shutter speed (if you keep ISO constant), which can increase the likelihood of unwanted blur.

To solve these problems, I recommend the following technique:

1. Before you photograph your main subject, create an out-of-focus backdrop. Set your camera to manual focus and shoot a colorful subject such as foliage or a flowerbed as a soft blur of color.

2. Make a print of this blurry image and mount it on foamcore.

3. Buy cut flowers and place them in a vase. Set up to shoot indoors in indirect light near a bright north-facing window if it's breezy outside. This can be much easier than doing macro flower photography out in the field, where you can be blessed with great natural light but the wind can often stop you in your tracks.

4. Place the blurry background you created behind your subject.

5. Select an *f*-stop number that is just large enough to put your entire subject in focus.

6. If you want to get an even dreamier effect with the foreground soft and colorful, try shooting "through" another flower. Focus on your subject and then turn your autofocus off and place another colorful flower so close to your lens that it is almost touching it.

In this way, you can intentionally blur everything but your subject into a soft, abstract foreground and background where only one tiny part of your subject is in sharp focus.

To create this image, I set flowers in two vases—a yellow sunflower nearer to me, and a purple iris farther away. I then placed a print of out-of-focus foliage in the background behind the iris to eliminate distractions. To shoot the image, I brought my camera so close to the sunflower that the petals were practically touching the lens. Photo © Jim Miotke

Shoot Infrared Photos

Isn't this magical? Although I know this image was shot in Hawaii, it looks like a winter wonderland, with snow hanging from the trees. This is exactly the kind of otherworldly imagery you can capture with infrared photography. Photo © Kathleen T. Carr

If you are interested in a cool otherworldly effect, try making infrared images. Foliage, plants, and trees will appear glowing white, and blue skies will turn jet black. Infrared photography takes bit of planning and a few preliminary steps. Thanks to some help from BetterPhoto instructor Kathleen T. Carr, here's how infrared photos are created.

The infrared band of light can be captured in three ways:

- Use a digital camera converted to infrared;
- Use a digital camera with an opaque infrared filter; or
- Convert an image you have already shot to infrared on the computer.

The advantage of the first method—converting a regular digital camera to shoot infrared—is that you can hand-hold the camera in most lighting situations without having to deal with a tripod or infrared filter. There are several companies that specialize in such conversions. (Note: Once a camera is converted, there's no going back.) If you want to have your camera converted, first test it to see if the sensor can pick up the infrared spectrum. Aim your TV remote control at the lens of your digital camera from a few inches away, then push a button on your remote and take a picture while holding down the button. If you see a white flash of light coming from the TV remote on your camera's LCD screen, your camera is infrared-sensitive and can be converted.

A second method is to use your existing camera with an infrared filter, such as the Hoya 72IR, and a tripod. You will likely find it easier to use a point-and-shoot camera with a digital viewfinder for this, as you'll be able to see the image in the viewfinder as it will look in infrared.

A third way is to convert normal color or black-and-white images to mimic an infrared effect after the fact, in Photoshop. There are several plug-ins you can buy that will do this quite well, including Nik's Color Efex Pro, *F/X*, and Fred Miranda.

Photograph Water Droplets with Reflections

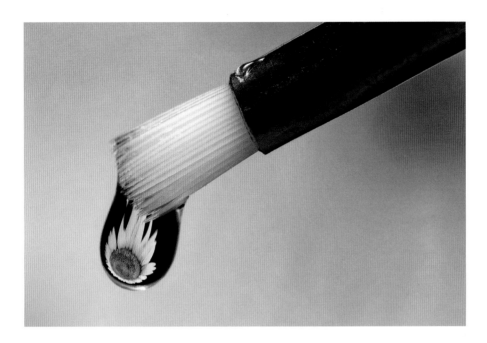

According to photographer Connie Bagot, here is how your can have fun making cool photos of water droplets:

1. Print out a photo of a colorful subject. For this example, Connie printed out a photo of a sunflower.

2. Find a rectangular mid-size cardboard box that is longer than it is wide, such as a shoebox.

3. Cut one end and the top out of this box.

4. Line both sides and the bottom of the inside of the box with black construction paper.

5. Attach your printed photo (from Step 1) to the back inside of the box.

6. Select an object to hold the droplet (Connie used a paintbrush).

7. Poke this object about a third of the way into one side of the box, near the top.

8. Point a light into the box through the top (Connie used Novatron Strobes, but, really, almost anything will do). Set up your camera at the box's open end.

9. Apply liquid to your paintbrush (or whatever you're using) and photograph the droplet being formed on the end.

10. Set your camera into Macro mode or use a macro lens on a DSLR. Shoot a lot!

11. That's all there is to it. Take these steps and experiment, always watching the results on your LCD screen.

To create this fun photo, Connie Bagot used a box, a picture of a sunflower, and a paintbrush. By taking a lot of photos, she determined the best distance between the sunflower picture, the water droplet, and the camera. She shot about 100 photos to get ten or twelve keepers. Photo © Connie J. Bagot

Channel Claude Monet

It's time to throw what you've learned about blurry photos and camera movement out the door. For this fun technique, you will intentionally use a slow shutter speed . . . without a tripod! Yes, that's right! You're going to purposely move the camera around while you take a picture.

Here are some recommendations:

1. Find a colorful subject. Blooming flowers and neon lights are particularly suitable.

2. Select Aperture Priority mode and set your camera to f/22, for a slow shutter speed.

3. Move the camera as you take the photo. The only rule is to exclude the sky as you sweep your camera around. Other than that, it's up to you. You can pan your camera in a straight line. You can move it up and down. You can make little circles or arcs. The only key is to experiment like crazy. Try one thing and then another. View your work on your LCD screen as you shoot to see if you need to try a different movement, or change your subject.

4. Have fun breaking the rules!

Alvaro Colindres noticed these red-colored grasses on a walk and liked how they were back-lit from the sun and swaying in the wind. It was too windy to obtain a sharp focus, so instead he panned the camera in the direction the wind was blowing. The back-lit grasses turned into streaks of red, green, and white light. Photo © Alvaro Colindres

Blur Your Entire Photo Except for One "Sweet Spot"

For this technique, you need either a DSLR (so you can switch your current lens with a Lensbaby lens) or you will need to get an inexpensive software program to replicate the effect.

Remember how we learned in the last chapter how to isolate focus on one point? By selecting a small f-stop number, you could make it so only objects within one slender focal plane would render as sharp, with the rest of the image—the foreground and background—looking soft and blurry.

But what if you want to go even further then that? What if you want to isolate focus on one spot without having other objects at the same distance appear sharp?

Enter the Lensbaby. This is an accessory lens that allows you to precisely control which one spot in your photo is sharp. The rest of the photo renders as a nice, soft blur. Used creatively and with care, you can produce beautiful (and unique!) images, like Brenda's photo on this page.

If you cannot remove your current lens—even some DSLRs don't allow you to do that—you can still create this isolated focus effect. The look of a Lensbaby can be replicated using various inexpensive software programs. A great place to start is onOne FocalPoint.

BetterPhoto instructor Brenda Tharp photographed this poppy from an extremely low point of view, attaching a Lensbaby to her DSLR camera to blur the areas around her main subject. Photo © Brenda Tharp

Use Filters to Even Out Extremes in Tonal Range

These two photos by BetterPhoto instructor Tony Sweet show the benefit of using a graduated neutral density filter. Notice how in the second image, opposite, the filter makes the sky darker and the foreground brighter. It also brings out detail in both the highlights and the shadows, and intensifies the colors and tones. Both photos © Tony Sweet

Filters are special pieces of glass that you can attach to your camera lens. There are three filters I would like to introduce you to: the graduated neutral *density* (also called the *grad ND*), the *UV*, and the *polarizer*.

The grad ND is half dark, half clear, with either a soft or hard edge. It's used to allow less light into the lens on especially bright areas in your scene. The filter is popular with professional landscape photographers since landscape scenes often have an extreme range of tones from superbright skies to dark foregrounds. But the filter can be used in any scene where there is a great range in tonal values and a relatively straight line separating the two.

The UV filter is used by most photographers simply to protect their lens. Needless to say, a filter is a lot less expensive to replace than a lens.

Lastly, the polarizer will enable you to:

- make deep blue skies and pure white clouds;
- reduce glare and eliminate reflections;
- make colors pop on wet days.

The polarizer only works when you're perpendicular to the direction of sunlight, so don't leave it on your lens all the time. Only one filter should be left on your lens at all times: the UV filter. All other filters should be used only when it makes the most sense.

Filters come in two formats, circular and rectangular. For grad ND filters, you'll want the rectangular format. (Cokin and Singh-Ray are two popular choices. The former is entry-level; the latter is expensive . . . but oh, so sweet!) For the UV and polarizing filters, use the circular variety and screw them onto your lens.

TIP

You may also be able to even out a high-contrast scene by using a reflector or your flash. When your scene has an extreme range in tones, experiment to fill in the shadows.

TIP

If you use a DSLR with several lenses and are shopping for filters, first figure out which lens has the largest diameter. Then purchase step-up rings from a pro camera shop for each of your other lenses. This way, you can buy one large size filter that works for all of your lenses instead of several filters (which can get unnecessarily expensive). A side benefit is that all of your lens caps will be the same size so you will be able to mix and match lens caps.

Make a HDR (High Dynamic Range) Photo

This creative technique requires that you both shoot in a particular way and then process your photos with a particular functionality.

1. Find a scene with both bright highlights and dark shadows. Ideally the areas in each extreme will both have some interesting details in them. Also, it's best if there are no moving elements in your scene. If you can't find a scene without people or cars or plants that are blowing in the wind, that's okay. You can still shoot this scene; just understand that the resulting photo may have some blurry elements.

2. Set your camera securely on a tripod.

3. Set it to Aperture Priority and choose an f-stop number that serves your purpose. If you need extensive depth of field, use a high f-stop number. Otherwise use a mid-range aperture of f/8 or f/11.

4. Set the white balance to any setting other than Auto. I usually like to use the Daylight setting.

5. Take at least three to five pictures quickly, using your exposure compensation feature to adjust the exposure for each shot, without moving your camera, so you get at

least one image where the bright areas are not washed-out and one exposure where the dark areas are not too dark.

To process your HDR images, go to www.hdrsoft.com to download PhotoMatix Pro. You can try it out to see if you like it enough to buy it.

1. Open up PhotoMatix Pro and click the "generate HDR image" button.

2. Click "Browse" to find and select the photos you would like to blend together. Click "OK" when you see them listed.

3. Leave all the default settings and click the "generate HDR" button.

4. Click the "tone mapping" button.

5. Experiment with the Strength, Saturation, and Luminosity sliders. I generally prefer to turn down the Strength and Saturation, and slightly increase Luminosity. But you will need to experiment with these controls until you get an image that balances the exposure blending effect with a natural, believable look.

6. Tone Compressor: just click "OK."

7. Check to see if anything looks wrong, like moving subjects, noise, or fake looking tones. If it

doesn't appear satisfying at this point, consider using a different set of photos.

8. Click the "process" button when you like the look of your new image.

9. Click *File > Save* As and save your new file.

The first two images, opposite, show what I would have been limited to had I not turned to High Dynamic Range (HDR) software. Limited in the range of tones my camera could capture, I would have had to decide between a dark version, left (where the highlights look good but the shadows are too dark), or a bright version, right (where the highlights look washed-out but detail is pleasing in the shadows). With HDR software, I can create a high-range combination, above, that takes the best of both worlds. All photos © Jim Miotke

Give Yourself Wiggle Room:
Shoot Camera Raw

Note the underexposure, muddiness, and dullness of color in the first version of this photo at right, as compared to the second above. I was able to fix this photo because I saved a Raw file when shooting. Had I only captured a JPEG, it would have been extremely difficult, if not impossible, for me to resurrect it. Both photos © Jim Miotke

Most people think of JPEGs as a "beginner level" file format and Camera Raw as "advanced." This is mainly because Raw is a bit challenging to convert when you're first getting going. Also, Raw files take more storage space on your memory card and computer.

But saving large Raw files is far easier than shooting JPEGs. Because they contain so much more information, Raw files are more forgiving. If you make a mistake with exposure or white balance while shooting Raw files, you have many more options for correcting your mistake later. Truthfully, I'm not a good enough photographer to shoot JPEGs.

I recommend that you start shooting in Camera Raw as soon as you possibly can. If you do not have the time to take a class or read a book to master Camera Raw, don't sweat it. Just learn how to save and store the files for now. You may have the opportunity to learn how to convert Raw files in the future and, when you do, you'll be able to easily correct, salvage, and optimize many more photos. Take it from me, once you learn the powerful things you can do with a Raw file, you will be glad you saved all of your previous photos in Camera Raw.

If your camera allows, capture both a Raw and a JPEG file. This will help when you cannot convert your Raw files or need to quickly share a photo with a friend. It also helps you sort and browse photos before getting them into your favorite editing application, such as Photoshop, Lightroom, or Aperture.

> **NOTE:** Whether you are shooting on a point-and-shoot or DSLR, you use automatic shooting modes (such as Portrait, Landscape, Night, or Sunset) your camera will likely capture the image as a JPEG, even if your camera features Camera Raw. If you end up liking Camera Raw as much as I do, I recommend shooting in the Aperture Priority mode.

Ten Easy Fixes You Can Do on Your Computer

The world of image editing can be just as fun and creative as making the photos to being with. With a software program like Photoshop, you can make colors pop, remove distractions, crop to a better composition, sharpen, add text . . . you name it.

This chapter will give you the essentials—the top ten fixes you can do in software. The tips in this chapter use settings from Adobe Photoshop Elements, but you can also use any of a wide variety of software options, such as the full version of Photoshop, Lightroom, Aperture, Paint Shop Pro, Microsoft Office Picture Editor, or any other image-editing program. It's outside the scope of this book to provide comprehensive directions for every software program out there, but this will give you a good, strong start. If these techniques interest you, I recommend taking an introductory image-editing course at BetterPhoto.com or your local photography school. And if you're short on time (who isn't?), or frustrated with computers in general, then don't worry about "post-processing," as it's called. Just focus your creative energy on making photos and turn to others for their image-editing and printing services. The key is to follow your heart and do what excites you. You can shape your hobby to be exactly how you like it.

When I visited the First Church of Christ, Scientist in Boston, the sensor of my DSLR camera had a bit of dust on it. This resulted in many small black dots in the picture, most noticeably in the blue sky. The ideal is to keep your sensor clean, but in this case, my second best option was to go ahead and shoot this beautiful architecture, knowing that I could remove the dust spots later using Photoshop. The Healing Brush tool made cleaning up the image a snap. © Jim Miotke

Start with Good Photos

This photo with the international "No" symbol on it is simply too blurry. Such extreme blur is one of the things that cannot be fixed with software. No amount of Photoshop magic can save the photo. Fortunately, after taking this first photo, I set my camera securely on my tripod and got a good, sharp photo—something I can definitely work with in Photoshop. Both photos © Jim Miotke

As the saying goes, "Garbage in, garbage out." Nine times out of ten, starting with a bad photo will result in a bad end product. If your photo is just plain boring, the computer won't act as a magic wand to make it better. The photo may be personally satisfying to you, or you may be attached to the fun experience you had shooting it, but if it doesn't stand the test of whether an objective viewer likes it, no amount of fancy computer effects will bring it back from the dead. If you have limited time and want a sure thing, start with stellar originals. That way, you'll be much more likely to experience success with your image-editing endeavors.

TIP

Before you edit any photo on the computer, make a copy! That way, you'll still have your original if you don't like how the post-processed image turns out.

Choosing the Best Software

All of these techniques were written with Adobe Photoshop Elements in mind. Adobe has done a fantastic job over the years creating and continually improving their fantastic full version of the Photoshop software product. The only problem with it was that, at around $600, it was too expensive for most people. Then Adobe created Photoshop Elements, which features just about everything a photographer needs for under $100 or so. Also, Adobe makes Elements for both Windows and Mac operating systems. For these reasons, and because it's one of the most popular programs, I will use Elements to describe these techniques. I used Windows but these techniques will translate smoothly if you're using Elements on a Mac. Even if you use a completely different program, odds are high that your buttons and menus will look similar.

Crop for Impact

Cropping is as easy as it gets. You simply select the Crop tool and drag a box around the area you want to keep, thus getting rid of the rest. Here's how to do it:

1. Open your image in Photoshop Elements.

2. Select the Crop tool, which should look like two right angles overlapping each other.

3. Place your cursor where you want your Crop box to start and drag the box to include the area you want to remain. Don't worry about precision. Once you have dragged enough to create a rectangle, release your mouse button.

4. Adjust the crop box by grabbing and moving the corners.

5. Crop the image by hitting the Enter or Return key.

6. Go to *File > Save As* to save this new version with a different file name.

You can also achieve the same effect by drawing a rectangle with the Rectangular Marquee Tool and then selecting *Image > Crop* from the menus. As they say, "All roads lead to Rome," especially when it comes to Photoshop.

When Laurie Shupp captured this photo, she composed a wider view, showing the entire mother elephant standing over the baby elephant. But when she shared the image with a professional photographer, he suggested she crop it so the baby was framed by the body of the mother. This simple change turned an average photograph into something much more unique and emotional, and also demonstrates the power of "framing." Photo © Laurie Shupp

The top image was nice, but I wanted to get even closer to the bird, so I cropped out the left portion of sky, left. Both photos © Jim Miotke

Note that if you crop a big image down into a small image, you are by definition making the image smaller. Cropping means you're cutting away material, and you will be limited in how big you can print the image. You can get away with more cropping when displaying on the Web, but I recommend refraining from cropping too severely. It's better to get the composition as tight as you want it while you're photographing the image to begin with.

TIP

Avoid cropping your photos into odd shapes. Try to stick with traditional shapes, such as a standard rectangle, a perfect square, or a wide panorama.

Rotate Your Image

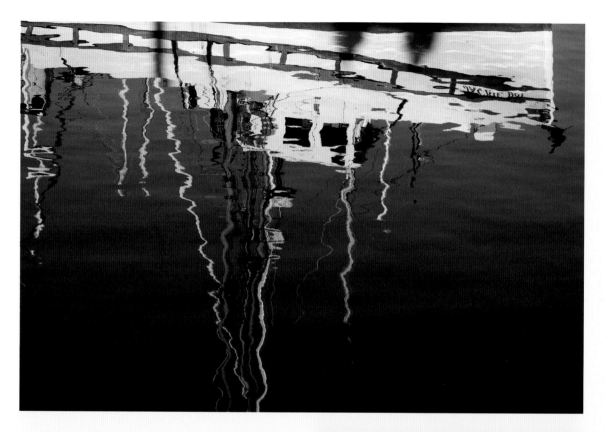

I was attracted to this reflection of a boat, right, in the Monterey harbor. Conditions were ideal because the light illuminating the boat was direct and bright, but the foreground water was calm and mostly in shade. Afterward, I rotated the composition 180 degrees, above, so the reflection was upside down and the photo had a more balanced, less unsettling feeling. Both photos © Jim Miotke

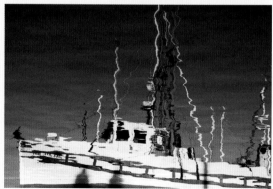

If you want to turn your image 90 degrees clockwise or counterclockwise, or completely flip it, you can use the easy Rotate function.

1. Open your image in Photoshop Elements.
2. Go to *Image > Rotate* and then select the kind of rotation you'd like to do. For the example on this page, I chose to rotate the original photo 180 degrees.
3. Go to *File > Save As* to save this new version.

If you want to rotate your image just a little, as when you need to level a slightly askew horizon, you can use the Crop tool, as on page 190. The only difference is that, this time, after you draw a rectangle with the Crop tool, look for curved double-arrows outside each of the four corners. And then:

1. Click on the curved double-arrow symbol and drag to rotate the Crop box.
2. When your rectangle aligns with the horizon, release the mouse button to stop rotating.
3. Click the red arrow (or hit the Enter key) to process your changes.
4. Go to *File > Save As* to save this new version.

TIP

You can hold down the Shift key if you want the image to "snap" to perfect rotation points.

TIP

If you cannot seem to do what you want to do, it may be that you are in a particular mode that restricts the user from selecting other functions. Try hitting the Escape key.

Eliminate Red-Eye

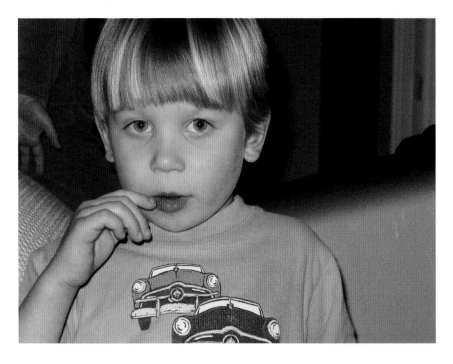

The "before" photo below is the same one displayed on page 71. Instead of diffusing the light from my flash when taking the photo, I used the Red-Eye Removal tool in Photoshop Elements after the fact, left. As you can see, there are numerous ways to defeat red-eye. Both photos © Jim Miotke

1. Open your image in Photoshop Elements.

2. Change your view magnification to 100% by double-clicking on the Zoom tool (which looks like a magnifying glass).

3. Select the Red-Eye Removal tool from the tools palette. (It looks like an eyeball.)

4. Using this tool, click on the red part of the eye you'd like to fix. Elements will do its best to eliminate the red-eye without giving you unnatural results.

5. If you like how your photo now looks, go to *File > Save As* to save this new version.

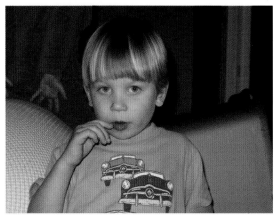

Darken or Brighten Your Image

Brightening a somewhat dark photo—or darkening a somewhat bright photo—can be easy. As long as your image is not too overexposed or underexposed, you can turn to a function called Levels in Photoshop or Photoshop Elements to easily darken or brighten an image.

1. Open your image in Photoshop Elements.

2. Go into the Levels function (*Enhance > Adjust Lighting > Levels*).

3. Under the big black mountain (the histogram), you will see a gray triangle in the middle. Push this gray triangle to the left to brighten the image or to the right to darken it.

4. Toggle the Preview checkbox on and off, so you can see if you like what you've done. If you don't like it, back off and try again.

5. When you're satisfied with the new brightness of your photo, click "OK."

6. Go to *File > Save As* to save this new version.

In the first image of this detailed ceiling interior in England, the exposure is too dark. By using Levels in Photoshop Elements, I was able to significantly brighten the image. If a favorite photo turns out too dark, don't throw it away! You might be able to save it with a quick adjustment in Levels. Both photos © Jim Miotke

Make Colors Pop

Sometimes the brightness of an image looks about right but the colors still don't "pop." The photo may look lackluster or simply dull, as if it has a milky shine on it. The good news is that you can usually increase contrast and make the colors in your photo jump out. However, there are better ways to increase contrast than to go to the Contrast function in Photoshop. The following technique utilizes the same Levels function used on page 195. In addition, we'll adjust saturation. This offers an excellent way to intensify color, remove sheen, and make your photos more vibrant.

1. Open your image in Photoshop Elements.

2. Go into the Levels function (*Enhance > Adjust Lighting > Levels*).

TIP

If the menu item you want to use is grayed out or otherwise inaccessible, it may be that you need to take another action first. For example, you will need to have an image open before you can select the *Enhance > Adjust Lighting > Levels* menu option.

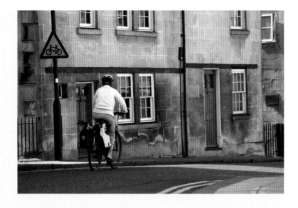

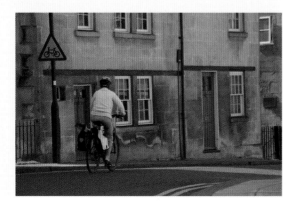

3. Under the big black mountain (the histogram), you will see a triangle on either end. Push the right (white) triangle to the right and the left (black) triangle to the left until they are close to the edges of the histogram. Just don't go too far, or your image will take on an overly contrasting, posterized look. Go slowly. It's better to make several small adjustments than one big adjustment.

4. After each baby step, see if you like the effect. Toggle the Preview checkbox off and on to review the result, so you can see if you like what you've done. If you don't like it, back off or undo and try again.

5. Click "OK."

6. Now move on to the Hue/Saturation function (*Enhance > Adjust Color > Adjust Hue/Saturation*).

7. Drag the slider under the Saturation line to the right, until the number for Saturation increases to about +14. This should give the image a light extra punch of color. Look at the resulting image and, if necessary, experiment with more or less until you find a nice balance between a dull color and an unrealistic, oversaturated look. Check the Preview checkbox off and on to see the effect your saturation adjustment is having.

8. Finally, when you're satisfied with the colors in the photo, go to *File > Save As* to save this new version.

In these two series, you can see how much color can be enhanced in Photoshop. For each, I adjusted the image's Levels (as shown in the upper right of the screencapture displayed in the middle image, left), and then tweaked the colors a bit more using the Hue/Saturation controls. See how the colors have been improved in the opposite right image and top image, left. All photos © Denise Miotke

Sharpen Your Already Sharp Photos

Here's the rule about blur: Blurry photos cannot be made sharp. This may not be what you want to hear. We all find it frustrating when we open an image only to find it blurry. Unfortunately, no computer sharpening option can bring such an image back from the dead. The only solution is to take corrective measures while shooting (see page 60). If, however, a photo is acceptably sharp, you can take it an extra step to make it supercrisp, with the kind of clarity that makes people stop and take notice. Appropriately and subtly applied, sharpening can give your photos an extra degree of crispness before you print it or upload it to a Web site.

1. Open the image in Photoshop Elements.

2. Change your view magnification to 100% by double-clicking on the Zoom tool (magnifying glass icon).

3. Now select the *Enhance > Adjust Sharpness* menu option.

4. Move the sliders until you have an Amount of about 50% and a Radius of 1.5. This is a good starting point. If you feel the image needs more sharpening, experiment with increasing the Amount and the Radius.

5. Don't go too far. If you notice a light halo effect along the edges on your subject, your image will look unnatural. This may be because you're trying to salvage a photo that is too blurry.

Anne Young made this portrait of an elder from a Northern Philippines village. He was sitting in a wooden hut in the midmorning sun, and she captured his profile with the bright sunlight blowing out the background. Anne added to the crisp nature of the image by using a sharpening filter in Photoshop. Photo © Anne Young

Convert a Color Photo to Black and White

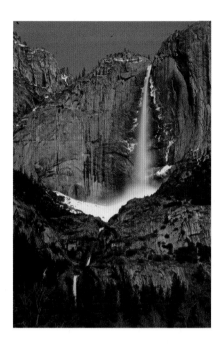

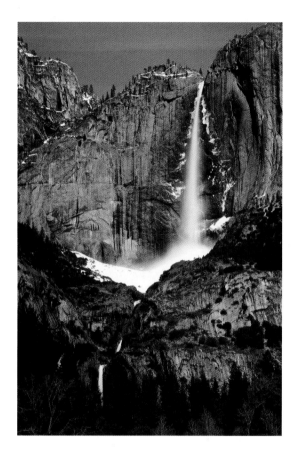

Removing the color from an image sometimes makes it a much better photograph. Especially when the color is a bit yucky, gaudy, or distracting, you may find a great black and white underneath a failing color photo. All you have to do is experiment with taking this element out of your visual statement.

As I said before, "All roads lead to Rome." In Photoshop, there are a number of ways you can convert a color photo into a black and white. Here's one simple method:

1. Select an image. Look for a photo with interesting shapes, contrast, or texture. Sometimes it works best to use an image that looks great in color but not always: sometimes color can be distracting and take away from a photo's potential impact.

2. Open your image in Photoshop Elements.

3. After opening your color image, go to *Enhance > Adjust Colors > Hue/Saturation.*

4. Click on the slider (the little triangle) for Saturation and drag it all the way to the left.

Alternatively, you can go to *Enhance > Convert to Black and White* and immediately have a black-and-white version of your image.

Either way, you will now have a desaturated image, with all the color removed. Way to go!

This image, above left, of Yosemite Falls was captured in mid-winter and the colors were not satisfying. Converting to black and white made for a more interesting and eye-catching photo, above. Both photos © Jim Miotke

Remove Dust Spots and Other Clutter

With a Photoshop tool called the Healing Brush, you can remove things from an image, such as dust spots or telephone wires. This is how digital artists give models flawless skin and remove man-made clutter from nature landscapes. The most common use is to remove black dots caused by dust on the camera's sensor. Here's how to remove them:

1. Open your image in Photoshop Elements.

2. Change your view magnification to 100% by double clicking on the Zoom tool (magnifying glass icon).

3. Select the Healing Brush tool, which looks like a Band-Aid.

4. When you bring your cursor back over the image, it will show a circle. This is the size of your "brush." If your brush is too big, go to the menu toolbar and use the Brush pull-down menu to adjust the brush diameter. Use the smallest brush size you can, while still covering the dust spot.

5. Click on the spot. Your offending element should go away.

6. If the area now looks worse, undo the last step by selecting *Edit > Undo*.

7. Select an area next to the dust spot and then click while pressing down the Option key or the Ctrl key.

8. Move your cursor directly over the dust spot and click. The spot should disappear, blended into the background.

9. Repeat these steps to get rid of any other dust spots.

10. Once you're done, go to *File > Save As* to save this new version.

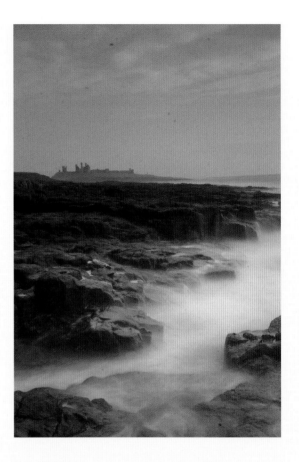

TIP

If you're using a DSLR, minimize dust by changing lenses in a dust-free environment. Also, don't use canned air to dislodge dust from your sensor. Follow the instructions that came with your camera and use a hand blower like the Giotto Rocket Blower.

The opposite photo was captured at a time when the sensor on my camera was very dusty. In the photo above left, the arrows point to several of the largest black spots caused by the dust. There were actually hundreds (or at least it felt that way as I cleaned them off, one by one, in Photoshop). To do this removal, I used the Spot Healing Brush. As you can see, the resulting image, above right, is a lot cleaner. All photos © Jim Miotke

Reduce the "Noise"

The photo shown in the detail at right is far too noisy. When I tried to reduce the noise using Photoshop Elements, the improvement was just not enough. Using Topaz DeNoise, I was able to reduce the noise to an acceptable level, above. Both photos © Denise Miotke

Noise is that often-unpleasant, grainy effect that occurs when you shoot using a high ISO (see page 134). If you're on a tripod all the time, photographing stationary subjects, you will rarely need to go higher than ISO 100 or 200. If, on the other hand, you might photograph your children or wildlife or other moving subjects in low light, you will get more keepers if you occasionally let yourself increase the ISO to 400 or 800. After all, it's better to have a sharp, noisy photo than a blurry, noiseless photo. If you do use a high ISO, and you don't like how noisy your resulting image looks, you may be able to minimize it using an image-editing program. For this, you can use Photoshop Elements or turn to noise reduction software programs by other companies.

1. In Photoshop Elements, open your noisy image and double click on the Zoom tool (magnifying glass) to change your view magnification to 100%.

2. Go to *Filters > Noise > Reduce Noise*.

3. Use the default settings and toggle the Preview checkbox off and on to see the result.

4. If you're not satisfied with the default settings, try increasing the Strength. Be careful not to overdo it and make the photo look too blurry. The trick is to balance the noise reduction and the inherent sharpness in the image. Sometimes it's easy and sometimes it's so difficult that you may decide, in the process, that you don't mind the noise so much after all.

5. If you like the new look, go to *File > Save As* to save this new version.

Of the alternative noise reduction software programs, I recommend a program called Topaz DeNoise. Their seven-minute video offers a good introduction and tutorial for beginners just starting out. Once you know your way around the program, you can accept the default settings or make a couple of minor changes. Once you like what you see, click "OK" and you will end up with a new version of your photo with far less noise.

Make a Panorama

To create a superwide, panoramic photo, you can:

- Simply crop your photo. This, however, will result in a much smaller file, one that you cannot print as big.
- Take several photos and use software to stitch them together. This is my favorite method.

Shooting for a Panorama

1. Place your camera securely on a tripod. It helps to use a pan/tilt head—rather than a ball head—or a special panorama head (these are the top parts of a tripod, sitting on the tripod legs). Both make it easier for you to align each section of the panorama and keep perspective from causing differences in distortion from piece to piece.

2. Do a dry-run sweep of the view you plan on shooting. Decide where you want your image to begin and end, and what you want to include in your composition.

3. Set up to shoot your first photo but, before you do, hold your hand in front of your lens and take a picture of your index finger. When you're done shooting all pieces, take another picture of your hand or fingers. This will help you know where your collection of panorama pieces begins and ends.

4. Set your focus and then, if your camera lets you, turn off the autofocus.

5. Set your camera into the Aperture Priority exposure mode, so the depth of field won't change. If the subject is distant, choose *f*/11; if you have important objects close in the foreground, select *f*/22.

6. I prefer to shoot two images per section, to ensure that I will have at least one sharp photo per piece. But this doubles my workload later, causing me to sift through twice as many images.

7. Overlap each photo by 1/3 or 1/2 frame. This will help the software line up each piece when stitching them together.

Stitching the Panorama

To stitch the photos together, I use the Photomerge feature in Adobe Photoshop Elements. Here's what to do:

1. Open your image in Photoshop Elements.

2. Select and open the photos you would like to stitch together.

3. Go to *File > New > Photomerge™ Panorama*.

4. Select the "auto layout radio" button.

5. Click the button that says "Add Open Files"

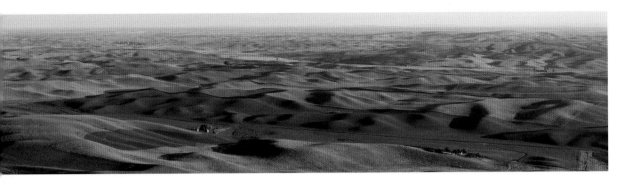

6. Click "OK." Photoshop Elements will then automatically stitch the files into a new panorama and align the layers to the best of its ability.

7. Crop off the rough edges and *voilà!* you have a finished panorama.

8. Go to *File > Save As* to save your new panorama. Print it, frame it, and hang it on your wall, or upload it to a site like BetterPhoto.com to share with other photography enthusiasts.

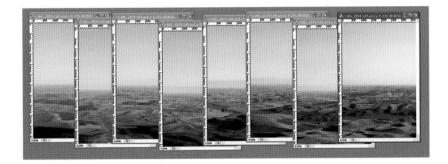

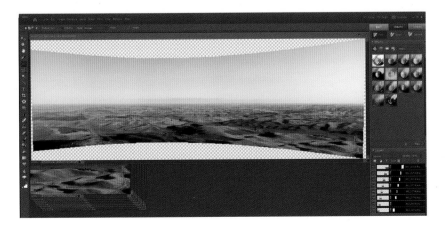

Creating panoramic photos is fun! For this wide panorama of the Palouse region in eastern Washington, I used the Photoshop's Photomerge function to combine eight photos. The two screen-captures at left provide a glimpse of the process. I first gather and combine the pieces and then, after Photomerge has done its thing, crop off the edges to make a wide panoramic image, top. All photos © Jim Miotke

ADDITIONAL REFERENCES

BRIEF BUYER'S GUIDE TO HELP YOU FIND THE BEST CAMERA

The number one question I get asked by beginning photographers is, "What kind of camera should I buy?" If you are heading to the camera store in a few minutes, here's the quick answer:

- If you are tight on cash, don't know how far this photography thing will go for you, and/or need a camera that fits in your pocket, get a compact digital point-and-shoot with a strong optical zoom lens and some creative control over aperture and/or shutter speed. This will cost more than a $200 point-and-shoot without these features, but the versatility is worth every extra penny.
- If you're exploring photography as a serious hobby, spend the extra money for a DSLR (digital single lens reflex) camera with a zoom lens that stretches from a wide angle (about 35mm) to a telephoto (around 105mm).

Most think of point-and-shoot cameras as "beginner" cameras. In reality, one can just as well start out with a DSLR. In fact, DSLR cameras make it easier to get great pictures. I'm not a good enough photographer to exclusively rely upon a point-and-shoot; my DSLR makes my job a million times easier.

For those of you who do have time, here's the longer answer. There is no one best camera for everyone. For some, a point-and-shoot may be the most fun and produce the best results. Others may be frustrated with anything less than a professional-level DSLR.

What makes the decision even more difficult is that until you have spent time taking pictures, you probably won't know what kind of camera you'd like. On the other hand, you can't take many pictures before you get a camera. The way out of this chicken-and-egg conundrum is to identify the issues that are most important for you before heading to a camera store. Let's start by taking a look at the two main groups of digital cameras: point-and-shoots and DSLRs.

Point-and-Shoots

More than nine out of every ten digital cameras sold are point-and-shoots. And it makes sense. They ask you to make only two decisions: which direction to point, and when to shoot. You can choose from an overwhelming number of cameras within this category.

Point-and-shoot cameras are compact, convenient, and give you decent pictures, especially when you are mainly interested in recording the events of life. If you want photos of family parties and snapshots from vacations—without having to lug around a big camera and a bag full of lenses—a point-and-shoot may be the way to go.

Because almost all of the photography decisions are made by the camera, point-and-shoots may not be ideal for those interested in more artistic, creative expression. They can be used to capture creative, artistically beautiful images but photography enthusiasts interested in a lifelong hobby will likely be more satisfied with a DSLR.

Many of today's higher-end point-and-shoots allow you to control things like aperture, shutter speed, focus, and lighting options. These are popular with photographers who shoot often, need high quality, and like the simplicity and compactness of a point-and-shoot. Just be aware that operating the creative controls of these cameras can be a pain in the neck! Sometimes you are required to follow a complicated set of instructions, press a bunch of tiny buttons, and drill down into multiple menu systems to change simple settings. More important, the sensor in compact cameras is usually much smaller than those found in DSLRs. This results in images with more noise and less quality. Both the point-and-shoot and the DSLR may capture 14 megapixels, but photos shot with a point-and-shoot—especially when using a high ISO such as 800—will still look worse.

Point-and-shoots are also notorious for a problem called "shutter lag," a delay between when you

© Jim Miotke

© Sarah Christian

press the shutter button and when your camera takes the picture. Some high-end point-and-shoots are free of this problem, as are all DSLRs.

If you find point-and-shoots frustratingly limited, or yearn for a little more control when taking pictures, you may want to look into buying a DSLR.

Digital SLRs

SLR stands for *single lens reflex*. With an SLR, you look through the lens itself as your viewfinder, which, by the way, is where the term *single lens* originated. Instead of looking through a separate lens (the viewfinder), an SLR uses a mirror to allow you to look through the same lens used to capture the photo. What you see in the viewfinder is a good representation of what you will get in the photo. Digital SLR cameras are also called DSLRs.

DSLRs are best for those who don't mind carrying a bulkier camera and lenses, and who see themselves growing as a photographer. Many students use DSLRs to learn how to control aperture and shutter speed. You can also shoot quickly with a DSLR, making it better for photographing children, wildlife, and other fast-moving subjects. Other advantages include:

- **An ability to switch lenses.** Unlike most point-and-shoots (which are complete camera/lens packages in themselves), DSLRs usually consist of two parts: a lens and a body. Most entry-level DSLR kits come with both a body and a lens, but often camera bodies and lenses are sold separately. I recommend buying a lens from the same company that made your camera. If you can afford it, get the body by itself and the best lens you can afford (rather than the kit lens packaged with the camera). This will ensure the sharpest, most satisfying results. This does cost more, though, and if you're on a budget you may be perfectly happy with third-party lenses or the kit lens that came with the camera. Do the best with what you can afford,

but know that, if you continue in the photographic hobby, buying the better lens now may be more cost-effective in the long run than buying a less expensive lens now, only to replace it in a year or two.

One plus of having separate parts is that you can change them to get different effects. For example, you can use a *telephoto lens* to photograph extremely distant subjects, a *wide-angle lens* to shoot expansive views or the interiors of small rooms, and a *macro lens* to get close-ups of tiny things like insects. By simply switching lenses, you can go from shooting an amazing little ladybug to capturing the joyous expression on your kid's face as she scores a goal. There are even specialized lenses such as fisheye (that can capture round, 180-degree views, like looking through a fish's eye), telescope and microscope adapters (that let you photograph the cosmos or microcosms), and much more.

- **Scalable simplicity.** Many DSLRs can be set on automatic Program mode, which is just like a point-and-shoot. But you also have the option of expanding the camera or progressing into a more manual mode when you feel ready. This means you can easily make wonderful pictures from the beginning and learn advanced features as you go. Most DSLRs are also designed with future expansion in mind.

TIP

If you haven't taken your camera out of the closet in a long time, ask yourself why. Are you frustrated with how the pictures turn out? If so, use the tips and techniques in this book, and consider upgrading to a better camera.

Different options are available with regard to lenses, filters, flash, macro, remote shutter releases, and studio lighting. . . the choices are endless. Even if it never occurred to you to try macro photography, portraiture, or filters, for example, your DSLR can grow with you as you grow as a photographer.

DSLR cameras also have two major downsides:

- **Higher cost.** You can buy a point-and-shoot for under $200, while entry-level DSLRs may cost around $700. It's important to keep in mind, though, that creative types will likely get frustrated with less expensive point-and-shoots. You may, for example, find yourself upgrading to a $500 or $600 compact camera simply because of shutter lag with the cheaper point-and-shoots. Spending the extra $200 for a DSLR may provide you with a much more satisfying hobby. Even if you have to save, it might be worth the wait.
- **Bigger size.** While you can often slip a point-and-shoot into your pocket, a DSLR is heavier and bulkier, and may require a separate carrying case or shoulder strap. If you do not see yourself carrying a big DSLR around, then by all means, get a point-and-shoot. There is no value in a camera if it's never used.

Take Your Camera Out for a Test Drive

Once you've reached this stage, you're ready to try out a camera or two. The best way to know which model you prefer is to hold them in your hands and see how each feels. Go to a camera store and pick up each camera to feel its weight. Does it seem too heavy or light? Too bulky? Do you like how it feels in your hands?

Fiddle with the camera's buttons and attachments. Are they easy to read and move? Are they too small for your fingers to work? Do the locations of the main buttons make sense to you? Or do you consistently fumble around, looking for a button on the wrong side of the camera? Is looking through the viewfinder intuitive? If you are getting a camera with a zoom, is it slow and noisy or fast and quiet?

Ask if you can try shooting a few pictures with your potential camera. Ask the salesperson if you can bring in your own memory card and use it with your top camera choices. Usually a good camera salesperson will be happy to let you test it in the store.

You may be able to find a camera shop that rents cameras, lenses, and other gear. The cost of a rental is a small price to pay for knowing firsthand how much you like or dislike using your top camera candidates. Far too many people run through the purchase process only to put the camera in a drawer after a few frustrating experiences. By trying the camera out before you buy it, you won't be surprised by features you don't like.

TIP

Try not to buy a camera right before heading off on vacation. It's better to shoot with it for a few days first, then transfer the photos to your computer and review the results. This way, you won't make needless mistakes on your trip because you have not practiced enough.

7 Questions to Ask Before Buying a Camera

In addition to considering the size of a camera, ask yourself the following questions before you head to the store.

1. **What cameras have you used in the past?** Think about the kinds of cameras you have previously owned. What did you think of them? If you have been happy with point-and-shoots, you may enjoy another compact camera. If you were unsatisfied, you might like to upgrade to a DSLR.

2. **What are you are going to photograph?** If you plan to primarily photograph your friends and family, and don't see yourself carrying a big DSLR for this, a point-and-shoot may be just the ticket. If you see yourself photographing nature, landscapes, animals, portraits, travel, architecture, sports, or concerts, you will likely appreciate the features in a DSLR.

3. **What do you want as your final results?** Do you see yourself e-mailing photos, sticking them in an album, or framing your favorites and hanging them on the wall? A point-and-shoot should be fine if you only plan on emailing your photos or uploading them to a Web site. If, however, you think you'll want to print your own photos, you may find a DSLR a better investment.

4. **Do you see yourself shooting in Camera Raw?** "Raw" is a term for digital images that are not processed into a file format (like JPEG) in the camera. Many point-and-shoot and DSLR cameras capture Raw files. Whichever way you lean, make sure the camera saves in the format you prefer. And if you want to make things even easier, get a camera that can be set to create one Raw and one JPEG for each photo.

5. **How close will you be to your subjects?** If you plan to shoot wildlife, you'll need a strong telephoto. Most point-and-shoot zooms have an upper limit of around 135–160mm, and probably won't do the job. You're likely to need at least a 400mm lens for birds and a 300mm for larger animals. Parents on the sidelines, unable to get close to their child playing sports, will also appreciate a strong zoom. If on the other hand, you are planning to visit lots of museums and other places where you will often find yourself in tight quarters, a wide angle (a zoom that goes down to 28mm or less) may come in handy. And lastly, if you see yourself getting superclose to small subjects, you will want a point-and-shoot with Macro mode or a DSLR with a macro lens.

6. **What is your price range?** This camera will be with you for some time, and an extra $100 can go a long way. The additional features and better quality lenses cost more, but generally lead to clearer, more satisfying results.

7. **How many megapixels do you need?** The simple answer is that you don't need to worry about it. You practically cannot buy a new camera nowadays that won't have enough megapixels. Contrary to what camera ads tell us, this "MP" number has nothing to do with image quality. More megapixels allow you to print larger pictures—that's all. If you get a camera with 5 megapixels, you can print enlargements up to 11 x 14 inches. For most people, that's pretty big . . . and it's hard to find a digital camera with less than 5 megapixels these days.

RESOURCES

Magazines

- *Outdoor Photographer* and *Digital Photo*
 www.outdoorphotographer.com
 www.dpmag.com
 For many years, *Outdoor Photographer* has been one of the best photography magazines for nature, landscape, and wildlife photographers. You'll enjoy the articles and columns by great photographers like Bill Neill and DeWitt Jones, among others. One year of this magazine can take you light years ahead in photographic understanding and enjoyment. Study each issue and take what you learn with you out into the field. *OP*'s sister publication, *Digital Photo,* is a great introduction into the world of digital imaging.

- *Photo Life*
 www.photolife.com
 For over thirty years, photography amateurs and professionals have turned to *Photo Life* as a partner in furthering their photographic skills. Covering all aspects of photography, including industry news, photographic techniques and tips, field tests, travel, digital, secrets of the trade, and much more, *Photo Life* has something for everyone, plus it's supplemented with images and articles by some of the best photographers, including Peter Burian.

- *Shutterbug* and *Petersen's Photographic Quarterly*
 www.shutterbug.com
 www.photographic.com
 Shutterbug offers excellent in-depth equipment reviews, interviews, how-to photography articles, and up-to-date announcements on new products. With an editor like George Schaub and a team of world-class photographers behind it, *Shutterbug* produces outstanding content each and every month. Petersen's, another notable photography resource, was cancelled for several years but recently resumed as a quarterly publication.

- *Popular Photography*
 www.popphoto.com
 Popular Photography provides extensive guidance on what to buy and how to take the best possible pictures and is one of the most widely read photography magazines available. This is a great magazine to turn to if you are wondering, "What kind of camera should I buy?"

Camera and Gear Manufacturers

- Canon
 consumer.usa.canon.com
 This is the brand of DSLR that I use. Visit Canon's website to learn everything you ever wanted to know about their EOS, Powershot, and Digital Elph camera lines.

- Nikon
 www.nikonusa.com
 Just like Canon, Nikon's website will tell you all you ever wanted to know about their excellent DSLRs and Coolpix cameras. (Note: If you love Nikon, also visit www.nikonians.org—a great resource for Nikon shooters.)

- Sony
 www.sony.com
 This mega-worldwide site is a portal to everything Sony. Once you get to the home page, choose *Electronics > Consumer > Digital Cameras > Learning Center* from the upper navigational menu for a slick introduction to their camera choices.

Camera and Gear Retailers

- Amazon.com Camera and Photo
 www.amazon.com
 Everybody knows about Amazon.com's bookstore, but fewer people know about its online camera store. Turn to this comprehensive site

for great deals on digital cameras, memory cards, and accessories. (Amazon is also a great source for photography books.)

- **B&H Photo**
 420 Ninth Avenue
 New York, NY 10001
 Ph: 800-606-6969
 www.bhphoto.com
 B&H Photo is the leader in online photographic equipment and camera sales. I love their great customer service and their prices can't be beat. Go to bhphoto.com, call their toll-free number, or visit their superstore in New York City. They continue to be the biggest and best for a reason—they're great.

- **MyDigitalDiscount**
 www.mydigitaldiscount.com
 This online reseller offers incredible deals on memory cards, adapters, and card readers. I go here when I need to add to my library of memory cards.

- **Regional Camera Stores**
 There is nothing like going into a pro camera store to get one-on-one service. In addition to the B&H Photo SuperStore in New York City, I recommend: Hunt's Photo and Video in Boston, Massachusetts, and surrounding areas; Glazer's Camera Supply in Seattle, Washington; Samy's in Pasadena, California; Keeble & Shuchat in Palo Alto, California; and Calumet in Chicago, Illinois; and other locations around the world.
 - www.huntsphotoandvideo.com
 - www.glazerscamera.com
 - www.samys.com
 - www.kspphoto.com
 - www.calumetphoto.com

Software and Miscellaneous

- **Adobe Photoshop and Photoshop Elements**
 www.adobe.com
 Photoshop and its little brother, Photoshop Elements, set the standard for image-editing software. Elements costs about one sixth the price for the full version and has everything the beginning digital photographer could ask for. I highly recommend it as a great place to start. Advanced photographers and computer geeks might like to invest in the full program—a few additional features come in handy when you want to do serious photo-enhancing.

- **Nik Software**
 www.niksoftware.com
 Established in 1995, Nik Software has become the recognized leader in digital photographic filters and are the producer of award-winning technology and software products including patented U Point® technology, Dfine®, Viveza™, Color Efex Pro™, Silver Efex Pro™, and Sharpener Pro™.

- **Photographer's Edge**
 www.photographersedge.com
 Photographer's Edge features a complete line of do-it-yourself photo-frame greeting cards that are perfect for photographers. Use these cards to showcase your photographic talents and share your special moments with family and friends. Their photo-frame greeting cards are guaranteed to hold your photo exactly in position without shifting. The result is a professional-appearing distinctive greeting card showcasing your photographs.

AT-A-GLANCE CHART OF CAMERA ICONS AND SYMBOLS

I don't like it when designers use icons without words, forcing us to learn a new "language" to understand simple controls and functionality. If you're like me, the following chart will help you understand the basic shooting modes that can be found on most point-and-shoot as well as beginning DSLR cameras. You will see the icon or symbol, a descriptive phrase, and the page number it is explained on. Once you learn how to interpret these symbols, you'll take an immediate step toward better photographic results, as well as a more satisfying experience! Please note that this is only a general guide; your camera's symbols may look slightly different.

CAMERA SYMBOL	WHAT IS IT?	EXPLAINED ON PAGE
Shooting Modes		
⚡ ⚡ ⚡A	Flash on/Flash off/Auto flash	39
👤	Portrait mode	28
⛰	Landscape/infinity mode	29
🌷	Macro mode	30
🏃	Sports mode	31
🐕	Kids and pets mode	31
🌃	Night mode/Night Portrait mode	32
🎉	Indoor mode	33
⛱	Beach mode	34
⛄	Snow mode	34
❄	Fireworks mode	35
▭	Continuous Shooting mode	75
⏱	Self-timer	62

CAMERA SYMBOL	WHAT IS IT?	EXPLAINED ON PAGE
White Balance		
AWB	Auto white balance	132
☀	Daylight	132
🏠	Shade light	133
☀	Tungsten light	133
☁	Cloudy light	133
🔆	Fluorescent light	133
⚡	Flash light	133
◻	Custom light	133
Other		
ISO	Set ISO	134
±	Set exposure compensation	144
🗑	Delete image	

GLOSSARY OF PHOTO TERMS

A. See *Aperture mode*.

AE. See *Autoexposure*.

AF. See *Autofocus*.

AF lock. *Autofocus lock*. A function that allows you to hold the focal point while you move the camera to recompose your photo. It also allows you to prefocus on a fast-moving subject, as a way to help you catch the right moment when shooting action shots.

Aperture. The size of the hole in the lens which, when combined with shutter speed, controls how much light gets into the camera.

Aperture mode. Also called *Aperture Priority*. On some cameras this represents the mode that automatically calculates shutter speed after you specify the aperture that you would like to use. Many point-and-shoot cameras do not offer this mode.

Autoexposure. When the camera automatically sets the aperture and/or shutter speed to what it considers best for your particular lighting situation.

Autofocus. When the camera automatically focuses for you, as opposed to the manual focus function.

B exposure mode. A setting that lets you keep the shutter open as long as you like. This comes in handy when shooting special effects such as fireworks, lightning, and streaking car lights at night.

Backlighting/back-lit. When the sun or light source is in front of you, lighting your subjects from behind.

Blinkies. You may be able to set up your camera so that you see overexposed highlights flash in the LCD monitor. This warning flashing is often referred to as *the blinkies*.

Blocked up. When shadow areas are underexposed, losing all detail and appearing to grow in size.

Blown out. When the highlights are completely white and washed-out.

Bounce. Some flash units allow you to change the direction of light. If you have such a flash, directing the light toward the ceiling or wall so that it bounces off of that surface before illuminating your subject will cause the subject to be lit more softly.

Camera shake. When the camera moves a little as you press down the button, causing the picture to come out blurry.

Candid. An unposed picture of a person or group of people. Candids are less formal and staged-looking than portraits.

Catchlights. Tiny reflections of light in the eyes of people or animals you are photographing.

Close focusing distance. The minimum distance you can get to a subject before the lens can no longer focus properly.

Close-ups. See *Macro*.

Composite. An image combining two or more photos.

Composition. Arrangement of everything in the photo. See Step 2, "Get Composed."

Contrast. The difference between the bright areas of a photo and the dark. High contrast photos have very dark and very light areas in the same image. Low contrast has a more even toned look.

Cropping. Cutting off the edges, either by moving in closer to your subject when you are taking the picture or by trimming off the edges of your finished photograph.

Depth of field. The range of components in a scene, from front to back, that remain sharp. Shallow depth of field makes objects sharp in the foreground only, while deep depth of field makes everything in the picture look sharp, from the closest to the farthest away.

Diffuser. A device that you can attach to your flash to soften the bright light. This may be a small box or little piece of semi-opaque plastic. You can also use your hand to block some of the light or, if your camera lets you, bounce it off the ceiling or a wall. Also, a diffuser may refer to a filter that softens focus.

Dioptic adjuster. A feature on some cameras that allows those who wear eyeglasses to change the magnification level of their viewfinder so they can look through the lens without eyeglasses.

DOF. See *Depth of field*.

DSLR. A digital single lens reflex camera.

Exposure. The amount of light that is allowed to hit the sensor. Balance is key here. Too much light results in overexposed, light images; too little light results in underexposed, dark images.

Exposure compensation. A function found on more expensive cameras that lets you slightly adjust exposure levels to compensate for circumstances that might trick the camera meter.

Exposure meter. See *Light meter*.

f-stop or *f*-number. In the photo world, *f*-stops are the numbers that represent aperture. This, combined with shutter speed, serves to expose each photo with the correct amount of light.

Fast. A fast lens generally has higher quality glass and can be set to a very low *f*-stop number to allow more light to pass through. Such a lens is also sometimes called *bright*. Fast lenses can come in handy when shooting sports, weddings, or other subjects where you need a fast shutter speed in low-light situations.

Fill. When you use a secondary light source (such as flash or light being bounced by a reflector) to fill in shadows.

Film speed. One way film photographers refer to ISO.

Filter. A circular piece of glass that filters out certain kinds of light when you place it in front of your lens. Filters can be used to wash an entire scene in a certain tone, correct bad lighting conditions, make skies brighter, and more. Also, in the world of digital imaging, filters are software functions that can be used to make an image look softer, sharper, as if it was shot through a particular photographic filter, and much more, all at the touch of a button.

Fixed lens. Also called *fixed focal length lens*. A lens that's permanently wide angle, telephoto, or something in between; it does not allow you to zoom in or out.

Flare. Stray beams of light shining into the lens and onto the picture.

Flash. A function or accessory that allows you to provide additional, artificial light to a scene.

Flash meter. A special kind of handheld light meter used to measure flash output in studio settings.

Flat light. When the light is dull, producing very little contrast or shadows, it can be said to be flat.

Focal plane. The point in your photo that is in focus, along with everything else at the same distance from your camera.

Focal length. A measurement of the magnifying power of a lens. A 50mm lens has a focal length of 50mm and sees things at roughly the same size as the unaided human eye sees them. A 400mm telephoto focal length is like looking through a pair of binoculars; things far away are greatly magnified. A 20mm wide-angle lens allows you to squeeze in an expansive vista.

Focus. The process where you make the image sharp.

Focus ready lamp, or focus ok lamp. A little light, usually in the viewfinder, that tells you when the camera thinks it has achieved sharp focus.

Form. A shape with three-dimensional depths.

Formal. Connotes a more traditional, staged portrait, in which the subject is usually dressed up a bit.

Format. Refers to file format. JPEG is most popular but capturing Raw files (photos before they are processed into a file format) gives one more flexibility and latitude when it comes to processing the photo later.

Frame. The view you see through your camera's viewfinder. Also, framing can refer to a compositional trick where you look through something, such as tree branches or a window, and include them along the edges of your picture. And, of course, a frame is also something into which you place your picture before hanging it on the wall.

Front lighting/front-lit. When the sun or light source is behind you and therefore lighting your subject from the front.

Glare. When light reflects off of a reflective surface, such as glass or a mirror and back into the lens.

Glass. Some photographers refer to lenses with this term, with statements such as "The quality of your glass is much more important than the quality of your camera body."

Glossy. The shiny, as opposed to matte, dull, finish on prints. A glossy finish seems to accentuate the nice, bright colors in your print and the prints are much easier to scan on a computer, but glossy prints also show fingerprints more than matte prints do.

Grain. Also known as *noise*, a textured visual effect caused by using a high ISO.

Highlights. The extremely bright points in a scene.

Hot lights. Studio lights that continuously illuminate a scene rather than burst the scene with a momentary flash of light, such as strobes do.

Hot shoe. The little square port where you slide an external flash into the camera. This is an important feature to look for, especially if you like to photograph people and despise red-eye.

In camera. Refers to doing a technique while shooting, to save yourself the time and hassle

of having to later fix the image in a program like Photoshop.

Infinity lock. A setting that allows you to lock your focus on what amounts to the farthest distance. This comes in handy when taking picture through a window.

ISO. Stands for "International Standards Organization" and refers to how sensitive a camera sensor is to light. A sensitive sensor reacts more quickly to light, and thus does not require as long of a shutter speed as a less sensitive sensor. A fast ISO, such as 1600, will capture images more quickly and generally results in nonblurry results when hand-holding the camera in dim conditions. An ISO of 50 or 100, on the other hand, is much slower, less sensitive, and works best in bright light or when combined with the use of a tripod. The lower the ISO, the better, because high ISOs cause a side effect called "noise."

K. Kelvins; a measure of light temperatures.

Landscape. A picture of an outdoor scene, usually done with a somewhat wide-angle lens. Nature inspires the bulk of landscape photos, although sometimes people shoot cityscapes and seascapes, too. This term is also used to refer to images shot in a horizontal orientation, as opposed to vertical portrait images.

LCD. Liquid crystal display. Refers to a monitor on a digital camera that allows you to review images immediately after shooting them.

LED. Light emitter diode. Refers to an electronic display that provides information, such as how many exposures you have left and whether your flash is on.

Light meter. A device that measure the brightness in a scene to help the camera get the proper exposure. Most of the time they are in your camera, but some photographers use special, handheld light meters.

Long lens. See "Telephoto lens."

Macro. Polo . . . No, really folks, macro actually means close-up photography. A Macro mode (on point-and-shoot cameras) or a macro lens (on digital SLR cameras) is great for taking pictures of flowers, bugs, stamps, and other tiny objects.

Manual focus. A setting on your camera for when you would like to dictate what to focus on in your scene, as opposed to letting the camera automatically do the focusing.

Matte. A softer, less shiny print surface than glossy prints.

mm. Millimeter. A unit of measure used when referring to either a lens (such as a 100–400mm zoom lens) or, less frequently, to film formats (such as 35mm film). Confusingly, though, millimeter is also used to specify filter sizes on some lenses. You may have a 50mm normal lens that accepts 52mm size filters. Common filter sizes include 48, 52, 62, and 72mm. Common lens focal lengths include 28, 35, 50, 80, 100, and up.

Noise. An effect of grainlike texture in a photo. The colors often appear duller and the grainlike texture can seem to reduce clarity. This is a common side effect of using high ISOs such as 3200 or 6400.

Normal. A normal lens sees things at about the same magnification level as the unaided human eye. Telephoto and wide-angle lenses, on the other hand, make things bigger or smaller than the human eye usually sees them.

Overexposure. When the sensor receives too much light and the picture looks too bright.

P. See "Program mode."

Panorama. A very long, thin picture. This format is often used to capture panoramic vistas, such as that of an expansive landscape. Some digital software programs allow you to stitch multiple pictures together to create one seamless panoramic image.

Parallax. A problem in which the camera is too close to the subject and the viewfinder no longer accurately represents the scene that will be photographed. This is only for compact, point-and-shoot cameras.

Pattern. A graphic element repeated in a logical and orderly way.

Perspective. The way lines converge as they stretch father away. Also, the way objects in your photo relate to one another in size.

Point-and-shoot. A basic, automatic camera. Point-and-shoots are usually simple, inexpensive, compact, and easy to operate.

Point of view. The place and position from which you shoot.

Polarizer. A filter you can attach to your lens to reduce glare, make skies deep blue, and make clouds ultra white, among other things.

Portrait. A picture of a person or group of people; also refers to pictures taken in a vertical

orientation, when you turn your camera on end before shooting the picture, as opposed to horizontal, or landscape, orientation, for which you leave the camera flat.

Preflash. When the camera's flash emits a burst of light before actually taking the picture; usually used as an attempt to reduce red-eye.

Prefocusing. See *AF lock*.

Program mode. On some cameras, this represents the mode that automatically calculates both aperture and shutter speed to you. Most point-and-shoots offer no other options than this mode.

Raw. A pre-processed image, larger but containing much more information than a JPEG file. See *Format*.

Red-eye. When a subject's eyes reflect a red glare and look slightly demonic in a photograph.

Rule of Thirds. A principle of composition used to add a sense of balance and uniqueness to photographs. See "Use the Rule of Thirds" in Step 2.

S. See *Shutter mode*.

Selective focusing. The art of limiting depth of field so that only your subject is in sharp focus.

Self-timer. A feature that delays the moment when the camera takes the picture. A self-timer allows you to get into the picture yourself or to shoot without actually moving the camera, thus avoiding the camera-shake problem.

Sensitive. When speaking about ISO, *sensitive* means that the sensor reacts more quickly to light than lower ISO settings. For example, ISO 1600 is much more sensitive than ISO 100.

Sepia. Brownish gold tone. A sepia print looks just like an extremely old photograph.

Short lens. See *Wide-angle lens*.

Shutter. A mechanism that controls how much light is allowed to get into the camera.

Shutter button. The button you press to take the picture.

Shutter mode. Also called *Shutter Priority*. On some cameras, this represents the mode that automatically calculates aperture after you specify the shutter speed that you would like to use. Most point-and-shoots do not offer this option.

Shutter speed. How long the shutter is left open, or how long the camera takes to make the picture.

Slow. Slow ISOs generally produce brighter, less grainy pictures but can be more difficult to shoot, especially in low-light situations. Examples include ISO 50 and ISO 100 speeds.

SLR. Although car fans might think of a Mercedes-Benz 300 Super Light Racer, in this case, they would be wrong. In the photography world, SLR stands for *single lens reflex*, a kind of camera that allows you to use interchangeable lenses. SLRs feature sophisticated focus, exposure, and flash systems. Also, users of the SLR look through the lens itself to see the scene rather than through a separate window known as the viewfinder.

Soft. Refers to photographs that are slightly blurry and out of focus. Can also refer to diffused, gentler kind of light like that of a bright, overcast day.

Still life. A traditional shot of an inanimate object that is usually set in a studio, against a plain background, and using controlled lighting. Common subjects for still-life photos include fruit, a bouquet of flowers in a vase, and products a company is advertising.

Strobe. A studio light that, much like the flash on your camera, momentarily floods the scene with light.

Subject. What you are taking a picture of.

Telephoto lens. A lens that magnifies your subject, enabling you to shoot subjects that are very far away, usually 80mm or more.

Thumbnail. A tiny version of a digital picture, which uses a fraction of the computer memory that a full-size image might use.

Tripod. Wise photographers often attach their camera to this three-legged stand to keep the camera steady while taking a picture.

Tv. Time value. Especially on SLR cameras, this if often used to indicate a Shutter Priority mode. See *Shutter mode*.

Underexposure. When the sensor does not receive enough light and the picture looks too dark.

UV. Ultra violet. A kind of filter that essentially does nothing to change the look of your picture. It does, however, keep your lens from getting scratched. It also makes your picture slightly clearer in hazy conditions.

Viewfinder. Fancy name for the little window in the camera you look through when you take a picture.

Viewpoint. See *Point of view*.

Wide-angle lens. A lens that gives you a wide, expansive view of your scene. Because more

scene is squeezed into the picture, things look smaller through such a lens than they do in real life.

Wide open. Shooting at a low *f*-stop number such as *f*/2.8

WYSIWYG (pronounced wizzy-wig). What You See Is What You Get. Beginners are often surprised that point-and-shoot cameras show only an approximation of the image being captured, often causing novice photographers to miss part of their subject. SLR cameras, on the other hand, let the photographer see almost exactly what the sensor will record, giving a much more accurate idea of how the final print will look. Thus, with SLR cameras, what you see is what you get.

Zoom. A zoom lens provides more flexibility by allowing you to easily change the amount of magnification just before you shoot. You can either zoom in to make faraway things appear closer, or zoom out to fit more into the picture. On point-and-shoot cameras, they are usually electronic and controlled by a toggle on the camera itself. On more expensive cameras, you move through the range of focal lengths by twisting the lens or pulling part of it away from the camera.

© Kitty Riley Kono

CAMERA SETTINGS USED FOR PHOTOS IN THIS BOOK

The images in this book were created by myself, my students in the BetterPhoto.com "Masterpiece of the Month" program, and a few of my pro instructors—with a combination of DSLRs and higher-end compact cameras that allowed them to control aperture. The exact settings used to take each image are listed below, by page number. Here's how to read each "recipe" of settings:

1/640 sec. at *f*/8, ISO 400, 28–135mm lens at 115mm

Shutter speed Aperture ISO Zoom Lens ranging from 28mm to 135mm, set at 115 mm for the photo

The most important things to note are shutter speed, aperture, and the lens used. For shutter speed, note whether it's slow (30 seconds) or fast (1/500 of a second). For aperture, note if the photo was made with a large *f*-stop number, such as *f*/22, or a small number, such as *f*/4. Be aware that *f*/8 on a compact camera is not equal to *f*/8 on a DSLR; it's more comparable to *f*/16 or *f*/22 on a DSLR. (Photos taken on a compact camera will be listed as such below.) The most important thing to note is whether you will need to go low or high with the *f*-stop number.

For lens, note if the focal length is superwide angle (14–20mm), wide angle (28–35mm), "normal" (50–70mm), telephoto (100–135mm), super-telephoto (300mm and up), or macro (for shooting extreme close-ups). Note: Point-and-shoot digital cameras often display smaller focal length numbers than what you would find on a DSLR lens. In such cases, I have translated the focal length to 35mm equivalent, for easier comparison.

p. 1

1/30 sec. at *f*/10, ISO 100, 28–135mm lens at 75mm

p. 2

1/1250 sec. at *f*/6.3, ISO 100, 18–55mm lens at 25mm

p. 5

1/800 sec. at *f*/10, ISO 250, 100–400mm lens at 400mm

p. 8

1/125 sec. at *f*/5.6, ISO 200, 100–400mm lens at 400mm

p. 9

1/500 sec. at *f*/9, ISO 100, 24–105mm lens at 75mm

p. 10

1/80 sec. at *f*/8, ISO 640, 24-70mm lens at 70mm

p. 12

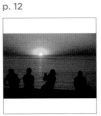

1/640 sec. at *f*/8, ISO 400, 28-135mm lens at 115mm

p. 12

1/640 sec. at *f*/7.1, ISO 100, 70-300mm lens at 185mm

p. 14

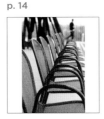

1/80 sec. at *f*/6.3 ISO 800, 70-300mm lens at 90mm

p. 16

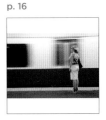

1/15 sec. at *f*/10, ISO 1600, 28-135mm lens at 53mm

p. 19

1/125 sec. at *f*/3.0, ISO 100, 28-85mm lens at 36mm

p. 19

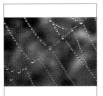

1/100 sec. at *f*/10, ISO 400, 24-105mm lens

p. 19

1/100 sec. at *f*/8, ISO 250, 18-200mm lens at 112mm

p. 20

1/100 sec. at *f*/2.8, ISO 100, 100mm macro lens

p. 20

1/1000 sec. at *f*/5, ISO 800, 18-200mm lens at 18mm

p. 20

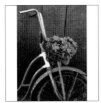

1/60 sec. at *f*/11, ISO 100, 400mm lens

p. 21

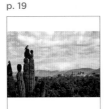

1/100 sec. at *f*/8, ISO 400, 18-55mm lens at 45mm

p. 26

1/2 sec. at *f*/32, ISO 100, 105mm lens

p. 28

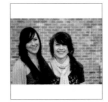

1/40 sec. at *f*/5, ISO 100, 28-135mm lens at 75mm

p. 29

1/800 sec. at *f*/8, ISO 200, 18-200mm lens at 40mm

p. 30

1/200 sec. at *f*/2, ISO 100, 50mm lens

p. 31

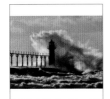

1/250 sec. at *f*/5.6, ISO 200, 18-55mm lens at 55mm

p. 31

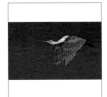

1/1600 sec., at *f*/5.6, ISO 200, 100–400mm lens at 300mm

p. 32

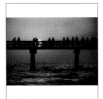

1/400 sec. at *f*/8, ISO 200, 18-200mm at 200mm

p. 33

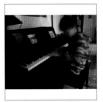

2/3 sec. at *f*/2.8 ISO 100, 35-210mm lens at 35mm

p. 33

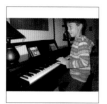

1/60 sec. at *f*/2.8 ISO 250, 35-210mm lens at 35mm

p. 34

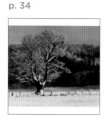

1/800 sec. at *f*/10, ISO 200, 28-135mm lens at 135mm

p. 35

1/8 sec. at *f*/16, ISO 100, 28-135mm lens at 100mm

p. 36

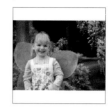

1/125 sec. at *f*/5.6, ISO 160, 28-135mm lens at 80 mm

p. 38

1/400 sec. at *f*/10, ISO 100, 70-200mm lens at 110mm

p. 39

1/125 sec. at *f*/7.1, ISO 320, 70-300mm lens at 160mm

p. 40

1/80 sec. at *f*/18, ISO 200, 12-24mm lens at 12mm

p. 42

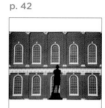

1/1600 sec. at *f*/4, ISO 100, 28-135mm lens at 41mm

p. 42

1/1250 sec. at *f*/5.6, ISO 100, 28-135mm lens at 135mm

p. 43

1/320 sec. at *f*/5.6, ISO 100, 28-135mm lens at 47mm

p. 43

1/160 sec. at *f*/5.6, ISO 100, 28-135mm lens at 47mm

p. 44

1/200 sec. at *f*/10, ISO 400, 24-70mm lens at 45mm

p. 45

1/200 sec. at *f*/4, ISO 400, 24-105mm lens at 24mm

p. 46

1/30 sec. at *f*/8, ISO 1600, 100mm macro lens

p. 46

1/60 sec. at *f*/2.8, ISO 1600, 100mm macro lens

p. 47

1/640 sec. at *f*/13, ISO 200, 135mm lens

p. 48

1/200 sec. at *f*/3.2, ISO 200, 100mm lens

p. 49

1/400 sec. at *f*/5.6, ISO 100, 28-135mm lens at 135mm

p. 50

1/320 sec. at *f*/5, ISO 400, 28-135mm lens at 65mm

p. 51

1/125 sec. at *f*/16, ISO 400, 70-200mm lens at 135mm

p. 52

1/250 sec. at f/5.6, ISO 800, 70–300mm lens at 300mm

p. 52

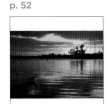

1/100 sec. at f/5.6, ISO 100, 70–300mm lens at 100mm

p. 52

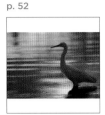

1/250 sec. at f/5.6, ISO 400, 70–300mm lens at 300mm

p. 53

1/60 sec. at f/4.5, ISO 100, 24–70mm lens at 60mm

p. 54

1/800 sec. at f/4.5 ISO 100, 24–70mm lens at 32mm

p. 55

1/250 sec. at f/8 ISO 100, 16–35mm lens at 16mm

p. 56

1/100 sec. at f/20, ISO 250, 28–135mm lens at 85mm

p. 56

1/125 sec. at f/20, ISO 400, 28–135mm lens at 135mm

p. 57

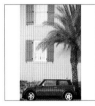

1/125 sec. at f/8, ISO 1600, 28–135mm lens at 28mm

p. 58

1/200 sec. at f/6.3, ISO 100, 70–300mm lens at 185mm

p. 59

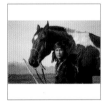

1/60 sec. at f/14, ISO 200, 24–70mm lens at 70mm

p. 60

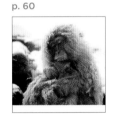

1/200 sec. at f/3.2, ISO 250, 16–35mm lens at 35mm

p. 61

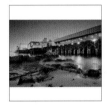

1/250 sec. at f/3.2, ISO 200, 105mm macro lens

p. 62

30 seconds at f/22, ISO 400, 16–35mm lens at 16mm

p. 63

1/2500 sec. at f/2.8, ISO 200, 70–200mm lens at 200mm

p. 64

1/1250 sec. at f/2.8, ISO 400, 24–70mm lens at 70mm

p. 65

1/1600 sec. at f/2.8, ISO 400, 24–70mm lens at 70mm

p. 66

1/160 sec. at f/4, ISO 160, 24–105mm lens at 75mm

p. 66

1/160 sec. at f/4, ISO 250, 24–105mm lens at 60mm

p. 67

1/20 sec. at f/3.5, ISO 400, 28–140mm lens at 50mm (compact camera)

p. 67

1/80 sec. at f/3.5, ISO 800, 28–140mm lens at 50mm, Macro mode (compact camera)

p. 68

1/60 sec. at f/5, ISO 400, 28–135mm lens at 80mm

p. 68

1/30 sec. at f/6.3, ISO 3200, 28–135mm lens at 95mm

p. 69

1/1000 sec. at f/8, ISO 800, 28–70mm lens at 70mm

p. 69

1/100 sec. at f/8, ISO 800, 28–70mm lens at 70mm

p. 70

1/800 sec. at f/4.5, ISO 200, 28–140mm lens at 140mm (compact camera)

p. 70

1/400 sec. at f/8, ISO 200, 28–140mm lens at 140mm (compact camera)

p. 71

1/80 sec. at f/14, ISO 3200, 28–135mm lens at 135mm

p. 72

1/60 sec. at f/3.5, ISO 100, 35–210mm lens at 80mm (compact camera)

p. 72

1/60 sec. at f/5, ISO 400, 70–300mm lens at 120mm, with external flash and diffuser

p. 73

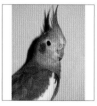

1/60 sec. at f/5, ISO 800, 28–140mm lens at 140mm (compact camera)

p. 74

1/60 sec. at f/7.1, ISO 1600, 28–140mm lens at 28mm (compact camera)

p. 74

1/320 sec. at f/2.8, ISO 1600, 28–140mm lens at 28mm (compact camera)

p. 75

1/30 sec. at f/5.6, ISO 100, 28–135mm lens at 135mm

p. 76

1/400 sec. at f/4, ISO 100, 28–135mm lens at 28mm

p. 76

1/320 sec. at f/4, ISO 100, 28–135mm lens at 28mm

p. 77

1/2500 sec. at f/2.8, ISO 100, 100mm macro lens

p. 77

1/15 sec. at f/29, ISO 100, 28–135mm lens at 100mm

p. 78

1/125 sec. at f/4.5, ISO 100, 16–35mm lens at 35mm

p. 78

5 seconds at f/11, ISO 100, 16–35mm lens at 35mm

p. 80

1/80 sec. at *f*/11, ISO 640, 28–135mm lens at 75mm

p. 81

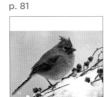

1/160 sec. at *f*/5.6, ISO 800, 70–300mm lens at 300mm

p. 82

4.0 sec. at *f*/22, ISO 100, 28–135mm lens at 44mm

p. 83

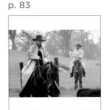

1/100 sec. at *f*/6.3, ISO 800, 100–400mm lens at 200mm

p. 84

1/320 sec. at *f*/6.3, ISO 100, 70–300mm lens at 115mm

p. 84

1/320 sec. at *f*/6.3, ISO 100, 70–300mm lens at 150mm

p. 85

1/30 sec. at *f*/5.6, ISO 200, 24–70mm lens at 40mm

p. 85

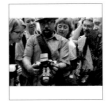

1/40 sec. at *f*/5.6, ISO 200, 24–70mm lens at 51mm

p. 86

1/250 sec. at *f*/8, ISO 100,400mm lens at 400mm

p. 88

1 second at *f*/22, ISO 100, 100mm macro lens

p. 90

1/90 sec. at *f*/22, ISO 200, 35mm lens

p. 92

1/20 sec. at *f*/18, ISO 100, 16–35mm lens at 16mm, using self-timer after camera was placed on the ground

p. 92

1/570 sec. at *f*/7.2, ISO 100, 28–112mm lens at 28mm (compact camera)

p. 94

1/2000 sec. at *f*/4, ISO 100, 85mm lens

p. 96

1/160 sec. at *f*/4, ISO 100, 28–135mm lens at 28mm

p. 96

1/40 sec. at *f*/4, ISO 100, 28–135mm lens at 33mm

p. 98

1/30 sec. at *f*/8, ISO 400, 70–200mm lens at 122mm

p. 100

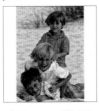

1/250 sec. at *f*/8, ISO 200, 70–200mm lens at 160mm

p. 102

2/3 sec. at *f*/2.8, ISO 100, 28–70mm lens at 70mm

p. 104

1/50 sec. at *f*/4.0, ISO 400, 12–24mm lens at 24mm

p. 106

1/400 sec. at *f*/4, ISO 200, 70–200mm lens at 200mm

p. 108

1/250 sec. at *f*/11, ISO 800, 70–300mm lens at 300mm

p. 110

1/400 sec. at *f*/4, ISO 100, 70–200mm lens with 1.4X teleconverter at 240mm

p. 112

1/60 sec. at *f*/16, ISO 200, 105mm lens at 157mm

p. 113

1/400 sec. at *f*/3.2, ISO 200, 34–102mm lens at 102mm

p. 114

1/125 sec. at *f*/4, ISO 100, 300mm lens with extension tubes

p. 116

1/80 sec. at *f*/14, ISO 400, 24–70mm lens at 70mm

p. 118

1/100 sec. at *f*/6.3, ISO 200, 28–135mm lens at 65mm

p. 120

1/250 sec. at *f*/8, ISO 200, 18–200mm lens at 90mm

p. 123

1/350 sec. at *f*/8, ISO 200, 105mm lens

p. 122

1/350 sec. at *f*/3, ISO 200, 105mm lens

p. 124

3 seconds at *f*/4.5, ISO 200, 24–105mm lens at 47mm

p. 126

1/160 sec. at *f*/8, ISO 640, 180mm macro lens

p. 128

3/4 sec. at *f*/25, ISO 200, 70–300mm macro lens at 300mm

p. 130

1/15 sec. at *f*/1.2, ISO 6400, 50mm lens

p. 131

1/125 sec. at *f*/5.6, ISO 200, 120mm lens

p. 132

1/60 sec. at *f*/5.6, ISO 200, 28–135mm lens at 109mm

p. 133

1/125 sec. at *f*/5.6, ISO 100, 24–70mm lens at 70mm

p. 134

1/320 sec. at *f*/4.5, ISO 6400, 28–135mm lens at 53mm

p. 135

1/400 sec. at *f*/8, ISO 800, 24–70mm lens at 70mm

p. 135

1/125 sec. at *f*/8, ISO 800, 24–70mm lens at 46mm

p. 136

1/640 sec. at *f*/10, ISO 100, 18–55mm lens at 18mm

p. 137

1/60 sec. at *f*/9.5, ISO 400, 70–200 lens 2X extender at 365mm

p. 138

1/40 sec. at *f*/2.8, ISO 100, 28–70mm lens

p. 139

1/125 sec. at *f*/5.6, ISO 100, 28–135mm lens at 135mm

p. 139

1/320 sec. at *f*/10, ISO 250, 70–300mm lens at 300mm

p. 140

1/500 sec. at *f*/10, ISO 100, 200mm lens at 149mm

p. 141

5 seconds at *f*/3.8, ISO 400, 18–50mm lens at 25mm

p. 142

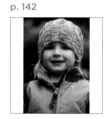

1/250 sec. at *f*/3.2, ISO 200, 100mm macro lens

p. 142

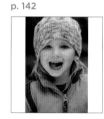

1/200 sec. at *f*/3.2, ISO 200, 100mm macro lens

p. 143

1/5 sec. at *f*/19, ISO 100, 17–55mm lens at 32mm

p. 144

1/100 sec. at *f*/4, ISO 100, Lensbaby composer lens

p. 145

1/1250 sec. at *f*/4, ISO 100, Lensbaby composer lens

p. 146

1/3 sec. at *f*/4, ISO 100, 17–35mm lens at 17mm

p. 149

1/30 sec. at *f*/11, ISO 200, 28–135mm lens at 30mm

p. 150

1/125 sec. at *f*/3.5, ISO 100, 100mm lens

p. 151

1/125 sec. at *f*/3.2, ISO 200, 100mm lens

p. 152

1/125 sec. at *f*/5.6, ISO 100, 70–300mm lens at 300mm

p. 152

1/3 sec. at *f*/40, ISO 100, 70–300mm lens at 300mm

p. 153

1/400 sec. at *f*/6.3, ISO 100, 70–300mm lens at 300mm

p. 154

1/320 sec. at f/5.6, ISO 500, 70–300mm lens at 300mm

p. 154

1/40 sec. at f/40, ISO 3200, 70–300mm lens at 300mm

p. 155

1/800 sec. at f/5.6, ISO 100, 70–300mm lens at 300mm

p. 155

1/500 sec. at f/5, ISO 100, 75–300mm lens at 120mm

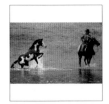

p. 156

1/500 sec. at f/5.6, ISO 400, 100–400mm lens at 400mm

p. 159

1/30 sec. at f/18, ISO 100, 28–135mm lens at 28mm

p. 159

1/125 sec. at f/18, ISO 250, 28–135mm lens at 135mm

p. 158

1/250 sec. at f/18, ISO 800, 70–300mm lens at 300mm

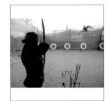

p. 160

1/30 sec. at f/18, ISO 250, 28–135mm lens at 28mm

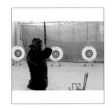

p. 160

1/80 sec. at f/18, ISO 800, 70–300mm lens at 70mm

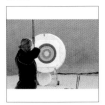

p. 161

1/320 sec. at f/18, ISO 3200, 70–300mm lens at 300mm

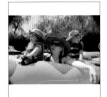

p. 162

1/200 sec. at f/9, ISO 100, 28–135mm lens at 30mm

p. 162

1/160 sec. at f/8, ISO 100, 28–135mm lens at 28mm

p. 163

1/100 sec. at f/1.4, ISO 400, 50mm lens

p. 164

1.3 seconds at f/5.6, ISO 100, 16–35mm lens at 16mm

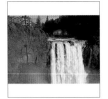

p. 166

5 seconds at f/29, ISO 100, 28–135mm lens at 47mm

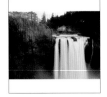

p. 167

1/320 sec. at f/8, ISO 100, 28–135mm lens at 53mm

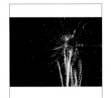

p. 168

6 seconds at f/16, ISO 100, 28–135mm lens at 95mm

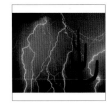

p. 169

60 seconds at f/8, 250mm lens

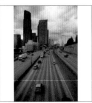

p. 170

1/125 sec. at f/4.5, ISO 100, 28–135mm lens at 28mm

p. 171

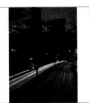

20 seconds at *f*/13, ISO 100, 28–135mm lens at 135mm

p. 172

1/30 sec. at *f*/2.8, ISO 100, 6.3mm lens

p. 173

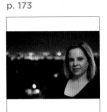

1/30 sec. at *f*/2.8, ISO 12800, 24–70mm lens at 70mm

p. 174

1/125 sec. at *f*/2.8, ISO 100, 100mm macro lens

p. 176

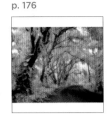

1/500 sec. at *f*/5, ISO 100, 70–300mm lens 170mm

p. 177

1/60 sec. at *f*/9.5, ISO 100, 180mm macro lens

p. 178

1/20 sec. at *f*/4, ISO 100, 70–200mm lens

p. 179

1/1000 sec. at *f*/8, ISO 100, Lensbaby lens

p. 180

1/20 sec. at *f*/22, ISO 200, 24mm lens

p. 181

3 seconds at *f*/22, ISO 200, 26mm lens

p. 182

1/25 sec. at *f*/22, ISO 100, 16–35mm lens at 35mm

p. 182

2 seconds at *f*/22, ISO 100, 16–35mm lens at 35mm

p. 184

6 seconds at *f*/29, ISO 100, 28–135mm lens at 60mm

p. 186

1/200 sec. at *f*/9, ISO 100, 28–135mm lens at 90mm

p. 188

8/10 sec. at *f*/7.1, ISO 200, 24–70mm lens at 27mm

p. 190

1/800 sec. at *f*/2.8, ISO 200, 70–200mm lens at 155mm

p. 191

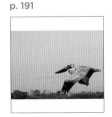

1/500 sec. at *f*/5, ISO 100, 70–300mm lens at 170mm

p. 191

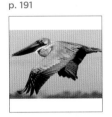

1/800 sec. at *f*/2.8, ISO 200, 70–200mm lens at 155mm (adjusted in Photoshop)

p. 192

1/500 sec. at *f*/5, ISO 100, 100mm lens (adjusted in Photoshop)

p. 194

1/60 sec. at *f*/3.5, ISO 100, 35–210mm lens at 80mm (compact camera) (adjusted in Photoshop)

p. 195

1/40 sec. at f/4.5, ISO 640, 70–300mm lens at 70mm (adjusted in Photoshop)

p. 196

1/250 sec. at f/8, ISO 800, 70–300mm lens at 90mm (adjusted in Photoshop)

p. 197

1/250 sec. at f/7.1, ISO 200, 70–300mm lens at 160mm (adjusted in Photoshop)

p. 198

1/250 sec. at f/3.2, ISO 400, 70–200mm lens at 78mm

p. 199

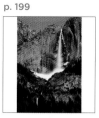

10 seconds at f/25, ISO 50, 28–135mm lens at 85mm

p. 201

1/13 sec. at f/22, ISO 100, 16–35mm lens at 30mm (adjusted in Photoshop)

p. 202

1/1000 sec. at f/16, ISO 6400, 70–300mm lens at 70mm (adjusted in Photoshop)

p. 204

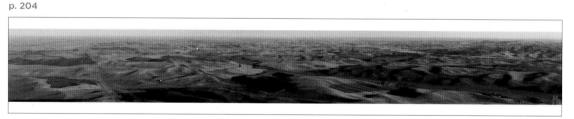

Series of images, with most pieces shot at 1/160 sec. at f/10, ISO 100, 24–70mm lens at 70mm

p. 206

1/2 sec. at f/10 ISO 100, 70–300mm lens at 70mm

p. 209

1/1000 sec. at f/2.8 ISO 200, 24–70mm lens at 43mm

p. 210

1/320 sec. at f/4.5, ISO 200, 100mm lens

p. 223

1/40 sec. at f/5, ISO 100, 50mm lens

p. 240

1/500 sec. at f/4, ISO 100, 28–135mm lens at 28mm

ACKNOWLEDGMENTS

Without the help of the following people, this book would never have made it to print. First and foremost, I would like to thank my wife, business partner, and best friend, Denise. When I first met Denise, it was love at first step and yet I never imagined just how amazing our life together would be. Denise and her sister Melody were my team in the trenches when it came to completing this project, and I thank both deeply. I am also very grateful to Brian and Marti Hauf for their prayerful and practical support. I feel equally indebted to many members of Team BetterPhoto—including Kerry Drager, Karen Orr, Jay and Amy Wadley, Celia Burkhart, Brian Lobdell, and Ricardo Chavez—we are indeed small but were also mighty!

A special thanks goes to the fantastic team at Amphoto—Victoria Craven, Julie Mazur, Vera Fong, Jess Morphew, Kim Small, and Abigail Wilentz. I want to thank Jim Zuckerman and Kathleen T. Carr for sharing their advice on lightning and infrared photos. I feel deeply honored to work with such great photographers as Brenda Tharp, Lewis Kemper, George Schaub, Rob Sheppard, Tony Sweet, Susan and Neil Silverman, Vik Orenstein, Peter Burian, Ibarionex Perello, William Neill, Paul Gero, Jennifer Wu, Sean Arbabi, Richard Lynch, Michael Frye, Newman Lowrance, Jim White, John Siskin, Charlotte Lowrie, Simon Stafford, Dave Pavol, Jenni Bidner, Doug Johnson, Kevin Moss . . . and all the amazing instructors at BetterPhoto. You rock, and I salute you!

For when they are old enough to read this (it's coming all too soon), I want to give a big thank you to Alina, Alex, and Julian for cheerfully modeling for me, and reminding me constantly of the joys of living in the present moment.

I would like to thank Art Wolfe, Jack Warren, Kevin La Rue, and Laurie Shupp at Nik Software; Gabriel Biderman and Tana Thomson at B&H Photo; Sam Perdue at Lensbaby; Neal and Chris at Photographer's Edge; Gary Farber at Hunt's Photo in Boston; Kathleen Davis at PopPhoto.com; Ben Willmore, Colin Smith, Joe and Casey at Really Right Stuff; the team at Singh-Ray Filters; Bob Krist, and the team behind the life-saving software: Adobe Lightroom.

On the following pages, there is a list of the many contributors from my Masterpiece of the Month program who shared their images. I would like to thank each of you and I want to say . . . Congratulations, masterpiece members! You did it!

I want to thank the 3,000+ BetterPhoto members who responded to my survey and helped me remember what it was like when I was first beginning to learn photography. With your help, I gained insight into your needs and the book is all the better for it.

And I give my thanks to the entire BetterPhoto community—the millions of photographers who make my business joyful, special, and new each day. I live for your constant stream of positive e-mails. Keep them coming!

Contributing Photographers

Many of the photos in this book were contributed by the following students in my Masterpiece Membership program, some were contributed by great instructors at BetterPhoto. com, and the rest were created by yours truly.

- Connie J. Bagot — www.betterphoto.com?cjbagot
- Endre Balogh — www.endresphotos.com
- Sibylle Basel — www.castingshadowphotography.com
- Stacey A. Bates — www.betterphoto.com?sabates
- Guy D. Biechele — www.betterphoto.com?guyb
- Kathy Blank — www.betterphoto.com?kathyb
- Beverly A. Burke — www.bevburkephotography.com
- Adam Caron — www.thislifephotography.com
- Kathleen T. Carr — www.betterphoto.com?kathleen
- Sarah A. Christian — www.schristian-photography.com
- Robert L. Clark — www.bclarkphotos.com
- Sue C. Cole — www.betterphoto.com?suenette
- Alvaro Colindres — www.alvarof8.com
- Emily R. Cook — www.shadowlightphotos.com
- Marilyn Cornwell — www.marilyncornwell.com
- Bob Cournoyer — www.bobcournoyerphotography.com
- Mary Lou Dickson — www.betterphoto.com?mldickson
- Kerry Drager — www.kerrydragerphotos.com
- Terry Ellis — www.terryellisphotography.com
- Lori G. Folse — www.betterphoto.com?lfolse
- John Forrant — www.john-forrant-photography.com
- Elsa Gary — www.elsagaryphoto.com
- Paul F. Gero — www.betterphoto.com?paulfgero
- D. S. Gilmore — www.betterphoto.com?dsgilmore
- Cindy Hamilton — www.betterphoto.com?chamilt
- Debra Harder — www.drhimages.com
- Larry W. Holder — www.betterphoto.com?lwholder
- Mary Rafferty Iacofano — www.maryiacofano.com
- Randall Jackson — www.randalljacksonphotography.com
- Jennifer Jones — www.betterphoto.com?jenniferj
- Lewis Kemper — www.betterphoto.com?lewis
- Kitty Riley Kono — www.kittykono.com
- Jon M. Lamrouex — www.warpstreamimages.com
- Janice M. LeCocq — www.janice-lecocq-photography.com
- Kevin Lings — www.lingsimages.com
- Jacqueline McAbery — www.betterphoto.com?jmcabery
- Suzanne McGarity — www.betterphoto.com?suzanne

- Celeste McWilliams www.betterphoto.com?celeste
- Denise Miotke www.betterphotodenise.com
- Dianna Murphy www.diannamurphyphotography.com
- Kathe Nealon www.betterphoto.com?nealonk
- Mark Orlowski www.orlowskiphotography.com
- Susan M. Patton www.betterphoto.com?susanmp
- Ernest S. Pile www.photoartimages-espile.com
- JudyAnn Rector www.judyannscreativephotography.com
- Jacqueline Rogers www.betterphoto.com?jacque
- Carla Trefethen Saunders www.betterphoto.com?saunders
- Fran Saunders www.betterphoto.com?franny
- Leland N. Saunders www.lelandsaundersphotography.com
- Dawn L. Schwack www.imagesfromdawn.com
- Rob Sheppard www.betterphoto.com?robsheppard
- Graham D. Sher www.betterphoto.com?gdsher
- Laurie A. Shupp www.betterphoto.com?lshupp
- Dr. John L. Singleton www.mymindseyephotography.com
- Tony Sweet www.tonytsweet.com
- Brenda Tharp www.brendatharpphotography.com
- Jacqualyn A. Volker www.betterphoto.com?the_nutcracker
- Richard Waas www.richardwaasphotography.com
- Marian Wilson www.betterphoto.com?marianwilson
- Anne Young www.anneyoungphotos.com
- Jim Zuckerman www.corporatefineart.com

INDEX

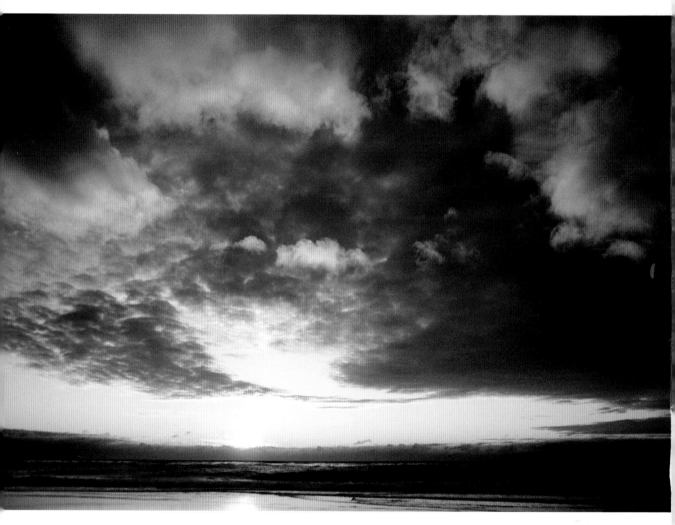

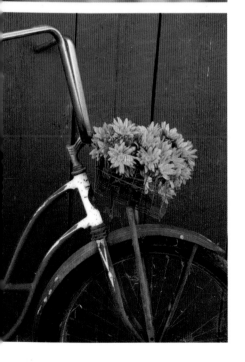

Absolutely anyone can take better photos!

If you can press a button, you can take great pictures. It's as simple as that. In *BetterPhoto Basics*, Jim Miotke, founder of the popular online photography school BetterPhoto.com, shares tips and tricks to improve your photos right away, no matter what camera you're using. Learn to compose knockout shots, make the most of indoor and outdoor light, and photograph twenty popular subjects, from sunsets and flowers to a family portrait. Those who want to go further get tips on controlling exposure and the secrets behind ten advanced creative techniques. And everyone will appreciate the easy fixes to make in Photoshop. No matter what your level of experience, you'll be amazed how easy it is to start taking photos like the pros.

JIM MIOTKE is a professional photographer and an online photo course instructor with BetterPhoto.com, a resource for photographers that he founded and runs. He is the author of the bestselling *BetterPhoto Guide to Digital Photography, BetterPhoto Guide to Digital Nature Photography,* and *BetterPhoto Guide to Photographing Children.*

AMPHOTO BOOKS

www.crownpublishing.com
www.amphotobooks.com

PRINTED IN CHINA

Cover design: Jess Morphew

Front cover photographs (clockwise from top left):
Jim Miotke, Susan Patton, Stacey A. Bates,
Jim Miotke, Graham Sher

Back cover photographs (clockwise from top left):
Jim Miotke, Jennifer Jones, Jacqueline Rogers

$22.99 U.S.A. / $29.99 CANADA
PHOTOGRAPHY

ISBN 978-0-8174-0502-1

52299

9 780817 405021